# WEARABLE ART
# 1900-2000

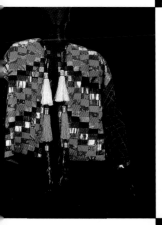

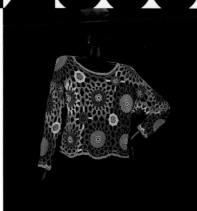

Shirley Friedland
Leslie Piña

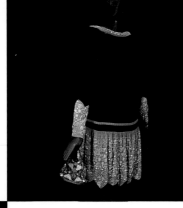

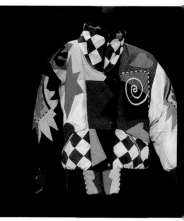

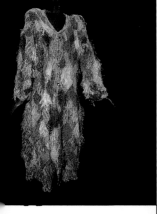

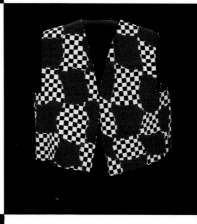

With Price Guide

Schiffer Publishing Ltd

4880 Lower Valley Road, Atglen, PA 19310

**Library of Congress Cataloging-in-Publication Data**

Friedland, Shirley.
    Wearable art, 1900-2000 / Shirley Friedland & Leslie
Piña.
        p. cm.
    Includes bibliographical references.
    ISBN 0-7643-0719-3 (hardcover)
    1. Wearable art. I. Piña, Leslie A., 1947-. II. Title.
NK4860.F75   1999
746.9'2--dc21                    98-31667
                                       CIP

Photography by Leslie & Ramón Piña
Designed by Leslie Piña
Layout by Bonnie M. Hensley
Type set in Van Dijk/Souvenir Lt BT

ISBN: 0-7643-0719-3
Printed in China

Published by Schiffer Publishing Ltd.
4880 Lower Valley Road
Atglen, PA 19310
Phone: (610) 593-1777; Fax: (610) 593-2002
E-mail: Schifferbk@aol.com
Please visit our web site catalog at **www.schifferbooks.com**
or write for a free catalog.
This book may be purchased from the publisher.
Please include $3.95 for shipping.

In Europe, Schiffer books are distributed by
Bushwood Books
6 Marksbury Rd.
Kew Gardens
Surrey TW9 4JF England
Phone: 44 (0)181 392-8585; Fax: 44 (0)181 392-9876
E-mail: Bushwd@aol.com

Please try your bookstore first.

We are interested in hearing from authors
with book ideas on related subjects.

dedicated to the memory of Rose Allen and her love
of beautiful things

# *Acknowledgments*

The authors would like to thank the many contributors who created and/or lent items to be photographed. Most are identified in the photo captions or before a grouping, as noted. If the line states "by someone," it means that the article was designed and constructed by that person. "Courtesy" means that the person named allowed us to photograph the article. Thanks to Lois Kates Arsham, Saieda Tajbakhsh Bahgery, Marisa Birnbaum estate, Jan Brostek of Pins and Needles, Zsuzsa Csepanyi Bawab, Lynn Landy Benade, Marilyn Bennett, Shirley Bernon, Lois Carroll, Jayanti Chuck, Ph.D., Linda Cohen, Katharine Moore Coss, Laura M. Croom, Lois Epstein, Miriam Glazer, Anna Greenfield, Carol L. Gross, Mari Stanek Hageman, Beverlee Hileman, Lillian Horvat, Robin Herrington-Bowen, Sue Hersh, Donna Kaminsky, Alice Kaye, Connie Korosec, Doreen Leaf, Emma Lincoln, Robyn Lynn, Ruth K. Marcus, Janet King Mednik, Clare Murray, Paula Ockner, Becky Olencki, Charlotte Paris, Pins and Needles instructors, Sharon Ramsay, Muriel & Fred Rivchun, Marilyn Ruckman, Susan Salkin, Arlene Schreiber, Goldie Schulman, Phyllis Seltzer, Barbara MacDonald Shenk, Anita Singer, Susanne Bodenger Skove, Judith Kessler Smith, Rebecca Smith, Liz Tekus of Fine Points, Carol T. Thorn, Ursuline College Historic Costume Study Collection, Donna Wasserstrom, Bonna Williams, Lorita Winfield, and Debra Beadles Youngs.

Special thanks to Paula Ockner for proofreading, Linda Cohen for assisting with the glossary, my editor, Jennifer Lindbeck, Bonnie Hensley for the layout, and all the staff at Schiffer Publishing.

# Contents

# Introduction

Wearable art is as difficult to define as many other forms of art; yet there are characteristics and partial definitions that many people can agree upon. The easiest part of wearable art is the "wearable." Whatever it is, it can be worn as apparel. We have divided this book into chapters based on conventional categories — dresses, separates, etc. Chapters are arranged visually, such as by similar styles or techniques. Vintage and contemporary articles are interspersed, but groups of vintage often wind up together, because of similarities in style.

Three of the chapter topics — vests, jackets, and knits — are not usually separate or distinct when found in books on vintage costume or fashion. But in the wearable art world, more artists design and make these items than any other categories. Hand knitted items with the design incorporated into the knit are in the knit chapter. Sweaters with embellishment as the decorative feature are included with separates, even though they are also knitted items.

Wearable art is designed and made by someone. Now, one might argue that all apparel is designed and made by someone, and that is true. But there is a line between what we are calling wearable art and most commercially-made clothing. It might be easier to first say what is definitely wearable art and what is definitely not wearable art. If someone with a well-developed sense of design and color plus experience and skill in both clothing design and construction makes a visually distinctive and hopefully, beautiful, item, then it is very likely to be wearable art. If this person begins with another artist's idea or pattern and adapts and modifies it so it becomes a completely different design, it is also wearable art. So, a definition might include criteria like original design or original adaptation of a design. Conceivably, even an unmodified good copy could be considered wearable art. A definition might also include skilled and original or interpretative use of traditional methods of construction and decoration.

These descriptions apply to most of the quilted, patched, knitted, painted, beaded, embroidered, appliquéd, and decoratively stitched clothing that can be seen at shows and in specialty boutiques, galleries, and even museums. There are how-to books, classes, organizations, and even television programs aimed at levels of talent and expertise ranging from the beginning hobbyist to serious artists. Some elite organizations include internationally recognized designers. We have tried to show a representative sample of the kind of wearable art that is being made by instructors and other experienced and talented artists, who are leading, rather than following, in this growing field. Moreover, rather than just for decoration or for exhibit, all of the items have been made to wear and to enjoy.

We are also presenting vintage wearable art, some of which dates from the early part of this century when items were typically made or decorated by hand and with painstaking detail. Earlier wearable art, which often has additional historic and/or symbolic value, is not included here. Early twentieth-century beaded garments, for example, were originally made and sold commercially, and were intended to be wearable, but probably not art. Today, these beautifully designed and crafted garments

are also considered by many to be wearable *and* art. And why not? Must an item be one-of-a-kind to be considered art? Of course not. For example, prints are not unique like paintings; yet they are not reproductions, but rather, multiple originals. Mass produced furniture or glassware or other decorative art is no less desirable because there are multiple copies. A designer chair from the 1950s might be more significant as a work of modern design than another one made by hand, and it might be far more collectible and costly than even a much older one.

Because there may be exceptions, it is a bit more difficult to determine what to exclude from the category of wearable art. Does all new commercially made apparel fall outside of our definition? No, but most of it probably does. In other words, the definition must be flexible and able to incorporate the unexpected. As long as an item is well designed and well made with a conscious effort to be as visually appealing as it is functional, it could be eligible. Any potential article of wearable art must be judged on its own merits. It is not for us to determine what all wearable art is or is not. What we hope to do is to present some good and some extraordinary ex-

amples of recent creations that can be called wearable art by most any definition. We also want to suggest that some categories of vintage fashion and even some commercially made clothing legitimately fall within these flexible boundaries.

Commercial manufacture is still the exception, and most of what we are calling wearable art is made by an individual by hand or by a combination of hand and machine work—its construction, decoration, or both. There are many different techniques used to make these articles. Most photo captions include materials and techniques in list form, and the glossary includes these terms with general definitions for additional explanation. But this is not a how-to book—it is a visual sampling of some of the wearable art that is available today. And because so much of it is unique, in the time it has taken this book to come into print, it is likely that many different innovative ideas and techniques have emerged. It is precisely this dynamic quality that makes the concept and the developing field of wearable art so exciting, and we hope that the readers will agree.

# Value Guide

## Vintage

All categories of vintage wearable art can be found for sale. The following is a list of general value ranges for the categories represented in this book. Values vary from one region of the country to another—large coastal cities usually being the highest. Condition is extremely important, and the listed ranges are for items in undamaged, excellent condition (even if the example featured in this book is not perfect). The guide is simply a general idea of what retail prices at shops, shows, auctions, or on-line might be. The benefit of consulting a guide is not to find an exact price, but to find out which items are rare or very desirable, and therefore expensive. It is also to learn which are more common and less collectible or less valuable. Generally, the more intricate the design, the detail, and the workmanship, the more costly an item will be. For example, with beaded garments, the smaller the beads and more complex the design, the more desirable the item. As long as buyers and sellers know this distinction, there will be no major errors. However, *neither the authors nor the publisher are responsible for any of the outcomes that result from consulting this guide.* The only guarantee we can make is that similar items will be found *outside* of our suggested range.

The following are examples of some categories of vintage wearable art:

Dresses
  With some beading or embellishment $50-200
  Moderately beaded dresses, such as from the 1920s $200-300
  Heavily beaded and embellished antique dresses $400 and up
  Late, commercially beaded dresses $75-250
  Designer dresses, beaded and embellished $300 and up
  Top designers, heavily embellished $1000 and up
  Embroidered dresses, 1930 $100-250
  Embroidered dresses, Mexican, 1970s $75-125

Separates
  Victorian lace blouses $75-200
  Beaded and embellished sweaters and vests $75-200
  Jean jackets with some jewels and embellishment, 1970s $50-150
  Jackets with embellishment, before 1950 $100-200
  Heavily embellished, beaded jackets $300-500
  Embroidered vests $75-150
  Heavily embroidered vests $150-300

Embroidered jackets/coats $100-200
Heavily embroidered jackets/coats $250-600

## Contemporary

One-of-a-kind items made recently for sale in specialty shops and shows range in price from moderate to very high. Some wearable artists are more interested and aware of the market and what it will bear, and they price their work accordingly. Others become very attached to items—no wonder, since it can take months to complete one—and price items less realistically. Individuals should ask less than a retail outlet that must include a markup or commission; this, however, is not always the case. Like any other category of art or craft, unless there is a recurring market for similar items, a transaction could be a one-time event. Yet there are some general categories and trends, and this is what we are pointing out in the following guide. If pricing of vintage wearable art is difficult, then a price guide for contemporary work is next to impossible, so please take this with a proverbial grain of salt. In addition, there is no established secondary market, and as yet, no implied investment value as with some vintage items. If wearable art is purchased for the enjoyment of owning and wearing something beautiful and perhaps unique, then it will fulfill its purpose.

Patchwork vests, simple $75-150
        complex $150-400
Patchwork jackets, simple $125-250
        complex $250-600 and up
Kimonos, simple design $200-300
Kimonos, complex design $700 and up
Hand knitted sweaters $250-700
Hand knitted coats $800 and up
Commercial knits $75-200
Painted silk separates $100-300
Iranian remade costumes, ornate $800 and up
Tie-dye separates $25-50

# Chapter 1 : Dresses

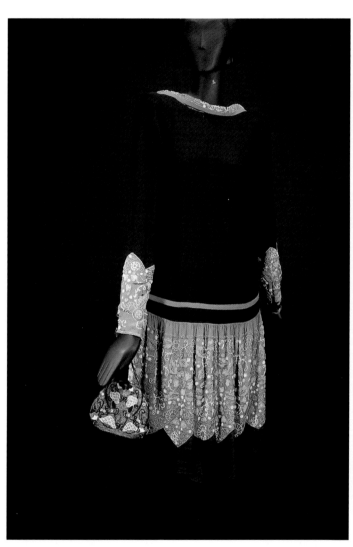

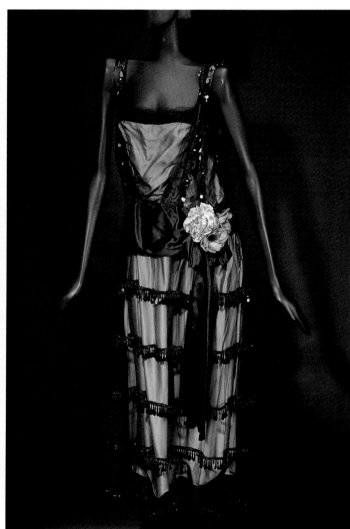

Black bask, white, and tan seed beads on green silk skirt and sleeves, scalloped hem, c.1920s. *Courtesy Ursuline College Historic Costume Study Collection*

Green silk gown with rows of black bead drops on overlay skirt, with rose at hip, c.1920s. *Courtesy Ursuline College Historic Costume Study Collection*

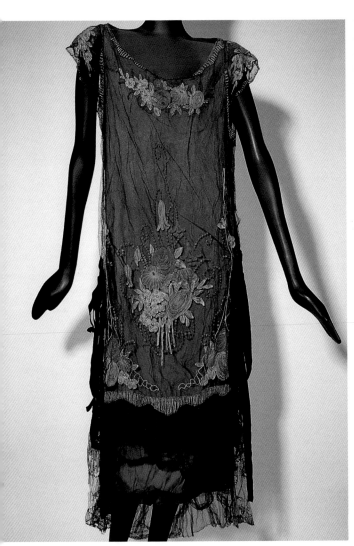

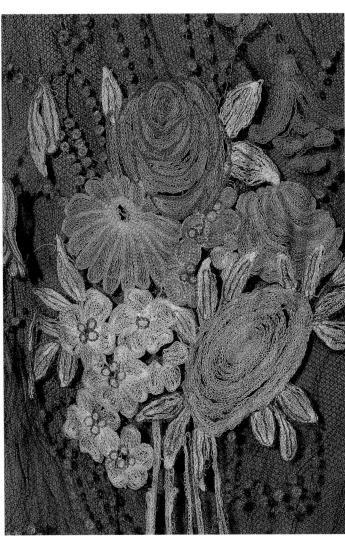

Teal green silk overlaid with black tulle, with silk flowers using tambour stitched silk thread, c.1918. *Courtesy Dureen Leaf*

Detail.

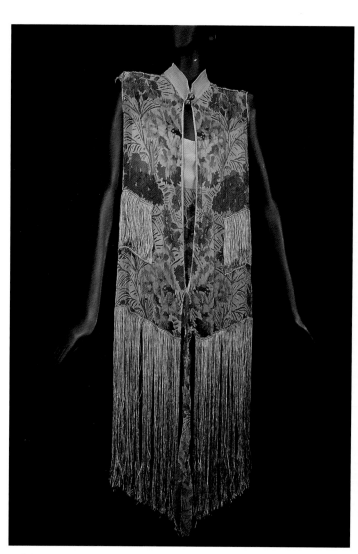

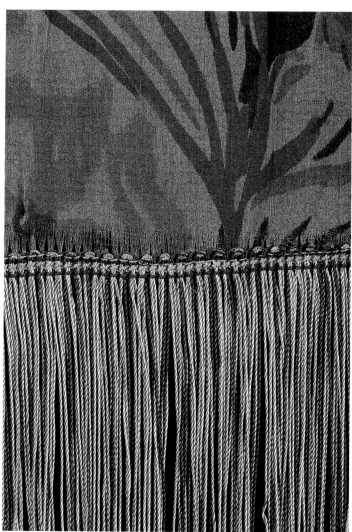

Silk chiffon printed dress and coat, with matching long silk fringe, c.1920s. *Courtesy Anna Greenfield*

Detail.

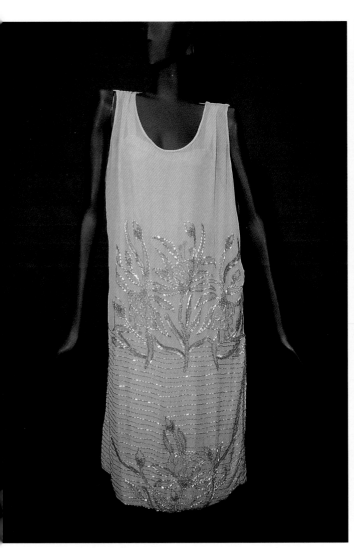

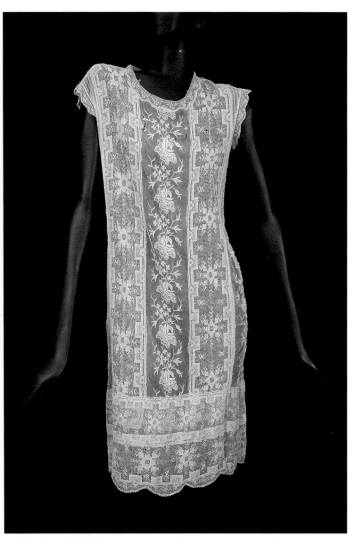

Silk chiffon chemise dress with gold and silver glass beads, c.1920s. *Courtesy Janet King Mednik*

Heavily re-embroidered vertical lace and mesh panels, bottom edged in horizontal panels, c.1920s. *Courtesy Anna Greenfield*

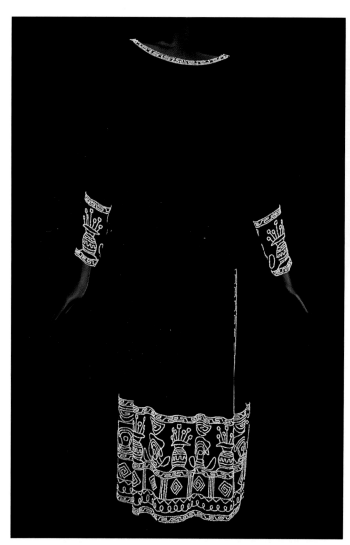

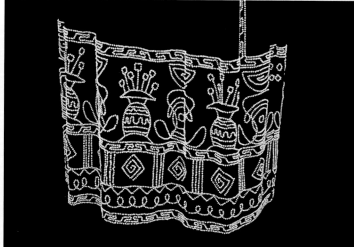

Detail.

Black chiffon with tambour beading in white flower pot and geometric design on bottom of sleeves and skirt, c.1920s. *Courtesy Anna Greenfield*

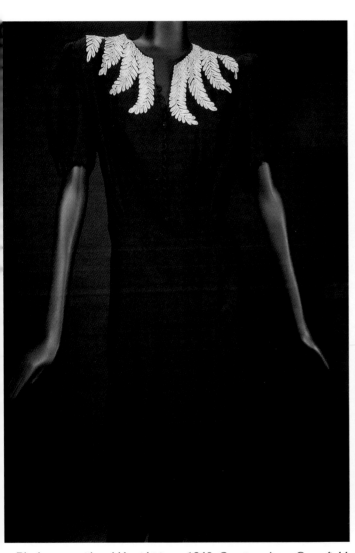

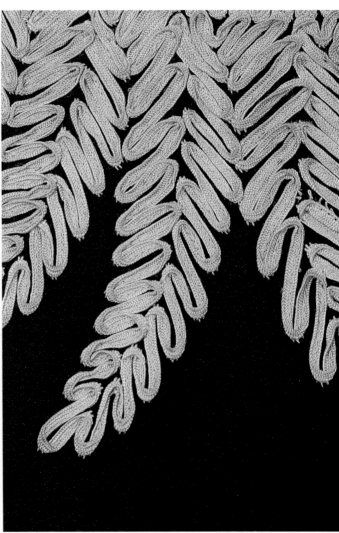

Black crepe with gold braid trim, c.1940. *Courtesy Anna Greenfield*    Detail.

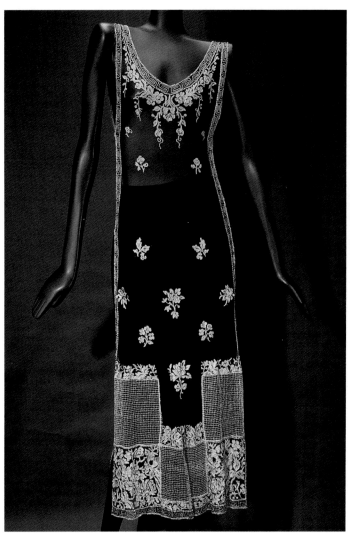

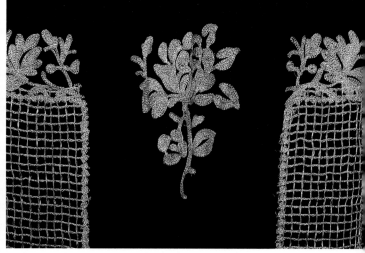

Detail.

Long net tunic with metallic wrapped yarns forming
openwork, c.1930. *Courtesy Barbara MacDonald Shenk*

Back view of black crepe appliquéd with machine stitched gold leather, couched with gold thread, c.1940. *Courtesy Anna Greenfield*

Detail.

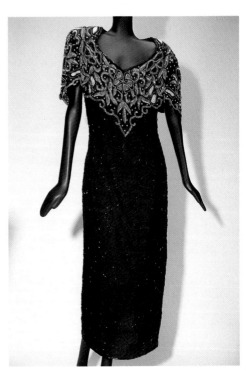

Long black fitted dress, sprinkled with beads, cape-like bodice encrusted with beads and sequins. *Courtesy Mari Stanek Hageman*

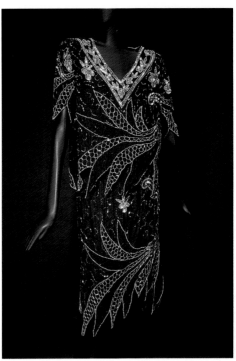

Black silk cocktail dress with black and silver bugle beads forming large leaf motif extending to the irregular hem, 1980s. *Marisa Birnbaum estate*

Black polyester chiffon cocktail dress with diagonal placement of nesting circles and leaves of white beads and sequins, 1980s. *Marisa Birnbaum estate*

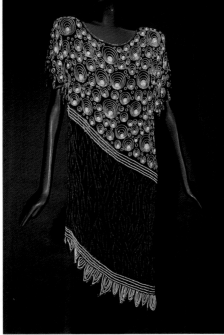

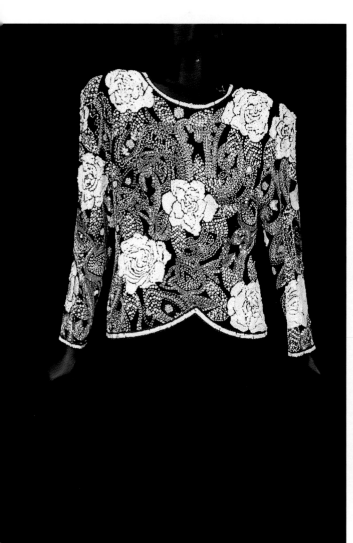

Black evening dress, with top completely covered in white beaded and sequined floral pattern, 1990. *Courtesy Anna Greenfield*

Detail.

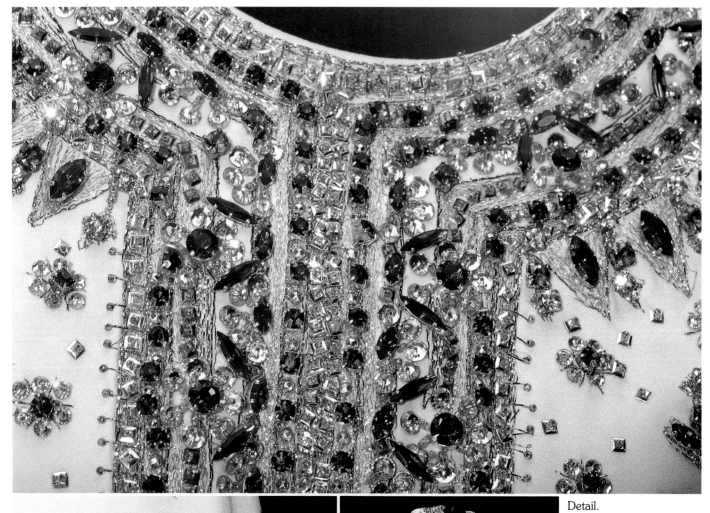

Detail.

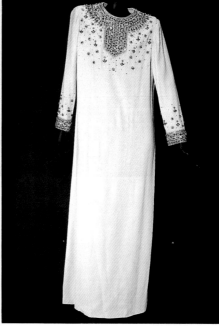

Long evening gown, white silk, lined in silk, heavily jeweled on cuffs and neckline front and back, with faceted colored stones, designed by Karen Stark for Harvey Berin, c.1960s.

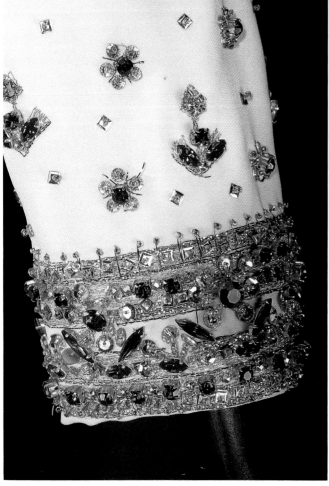

Detail.

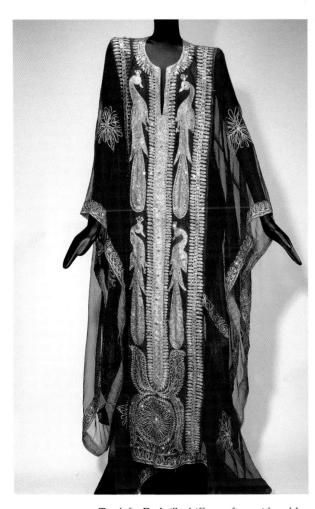

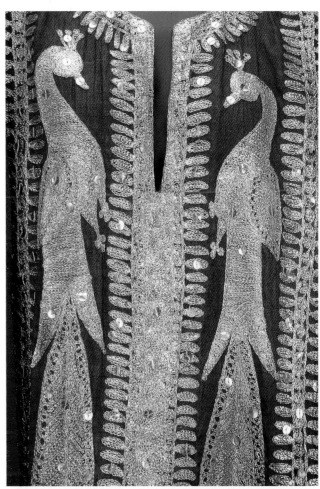

Top left: Red silk chiffon caftan with gold embroidered peacocks and trim, c.1984. *Courtesy Zsuzsa Csepanyi Bawab*

Top right: Detail.

Bottom right: Long pale blue linen with hand-painted gold and blue panel down the center, c.1960s. *Courtesy Ursuline College Historic Costume Study Collection*

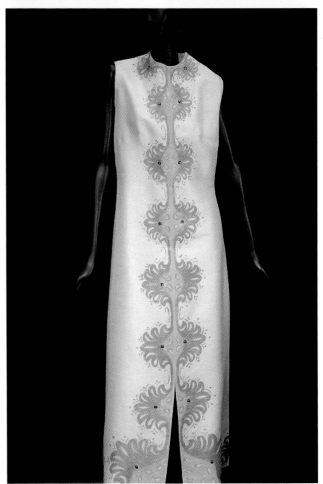

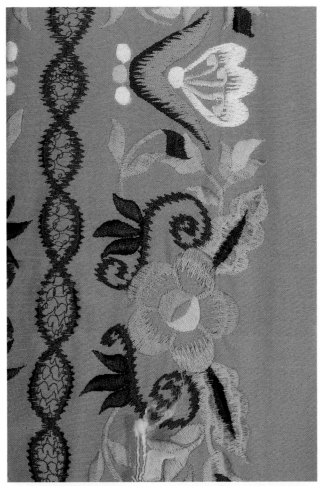

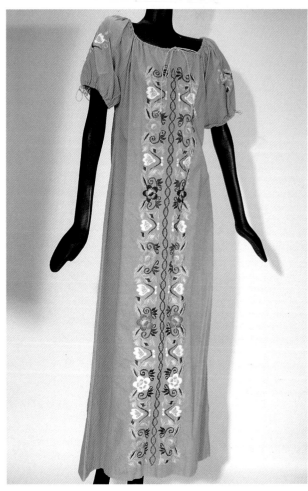

Top left: Detail.

Top right: Mexican hot pink cotton gown with colorful embroidery down the front, 1970. *Courtesy Bunnie Union*

Bottom left: Guatemalan natural cotton gown with lace overlays and hand-embroidered traditional bird and flower motifs. *Courtesy Muriel Rivchun*

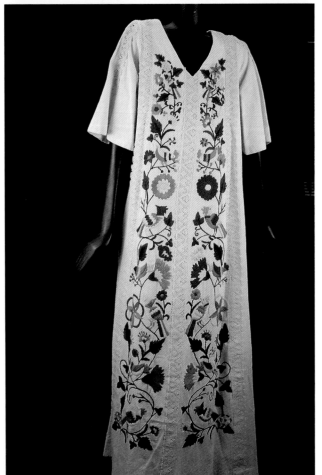

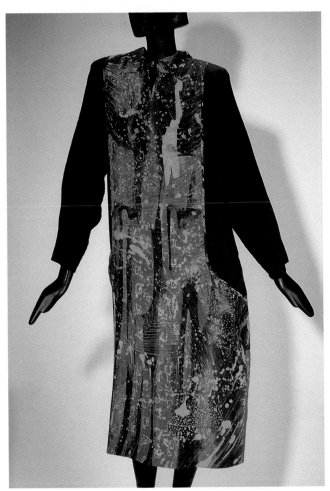

Top left: Hand-painted silk broadcloth jumper, using Japanese paste resist and discharge dyeing of fiber reactive dye. *By Lynn Benade*

Top right: Detail.

Bottom right: "Strada," long dress of rayon challis, hand dyed using Japanese paste resist and discharge dyeing of fiber reactive dye. *By Lynn Benade*

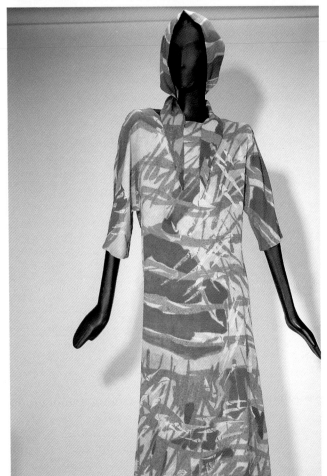

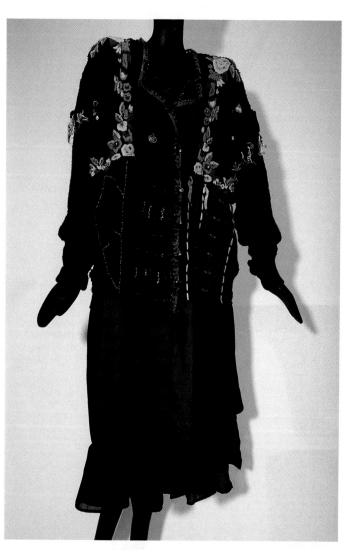

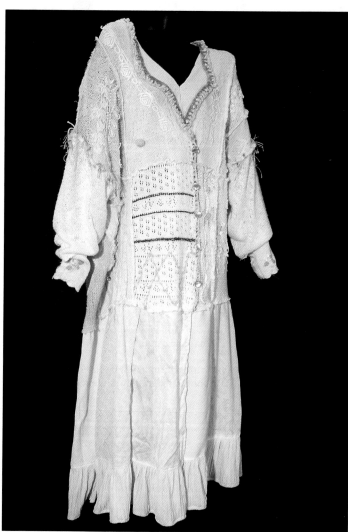

Black fabrics and sweater knits in various textures, combined in collage effect, embellished with colorful embroidery. *By Liz Tekus, of Fine Points*

White fabrics, sweater knits, and laces in various textures, combined in collage effect. *By Liz Tekus, of Fine Points*

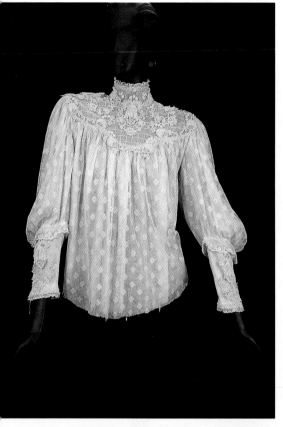

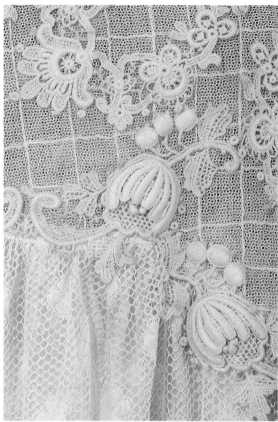

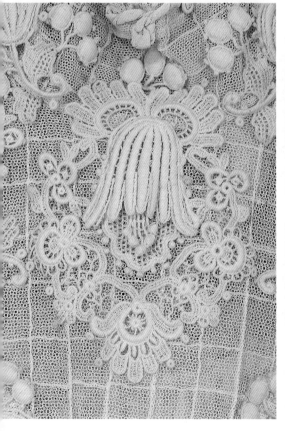

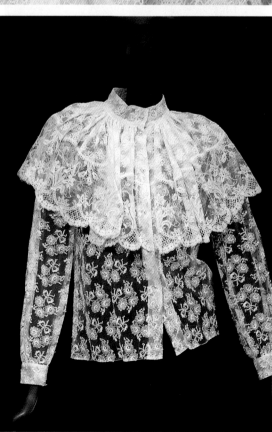

Top left: Ecru point d'esprit blouse with lace embroidery, c.1900. *Courtesy Anna Greenfield*

Top right: Detail.

Bottom left: Detail.

Bottom right: Lace blouse with pearl studded Bertha collar, interpretation of turn-of-the-century style, designed by Russell Trusso, c.1980s. *Courtesy Ursuline College Historic Costume Study Collection*

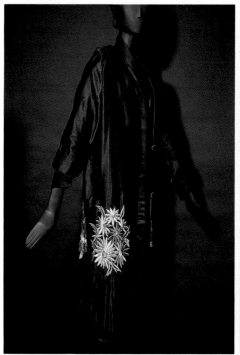
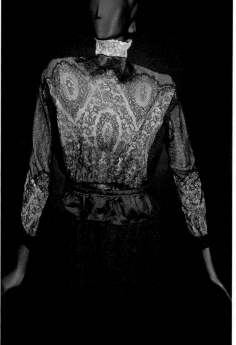
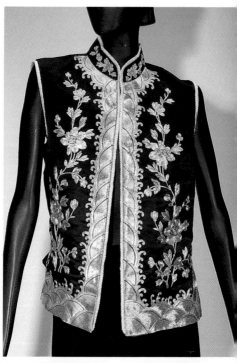
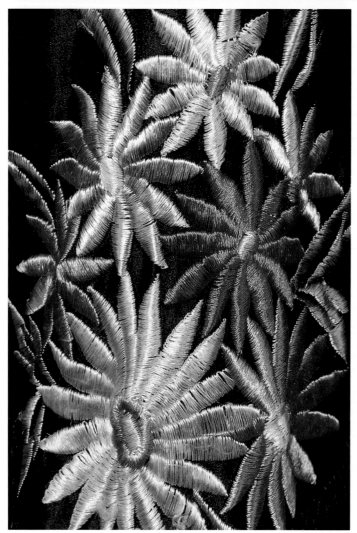
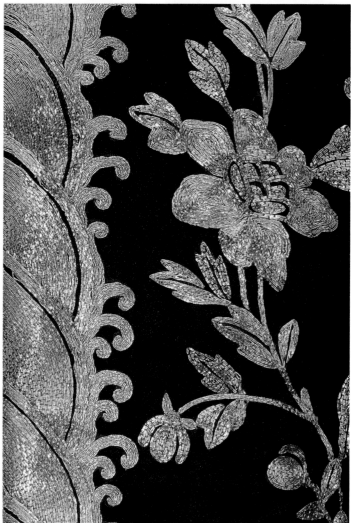

Top left: Black silk dress with matching coat, machine embroidered flowers, fringe on coat hem, c.1930s. *Courtesy Anita Singer*

Top center: Blouse of black lace over net and ecru lace, c.1900. *Courtesy Anna Greenfield*

Top Right: Oriental blouse, black silk with silver and gold embroidery, 1980s. *Courtesy Lillian Horvat*

Bottom left: Detail.

Bottom right: Detail.

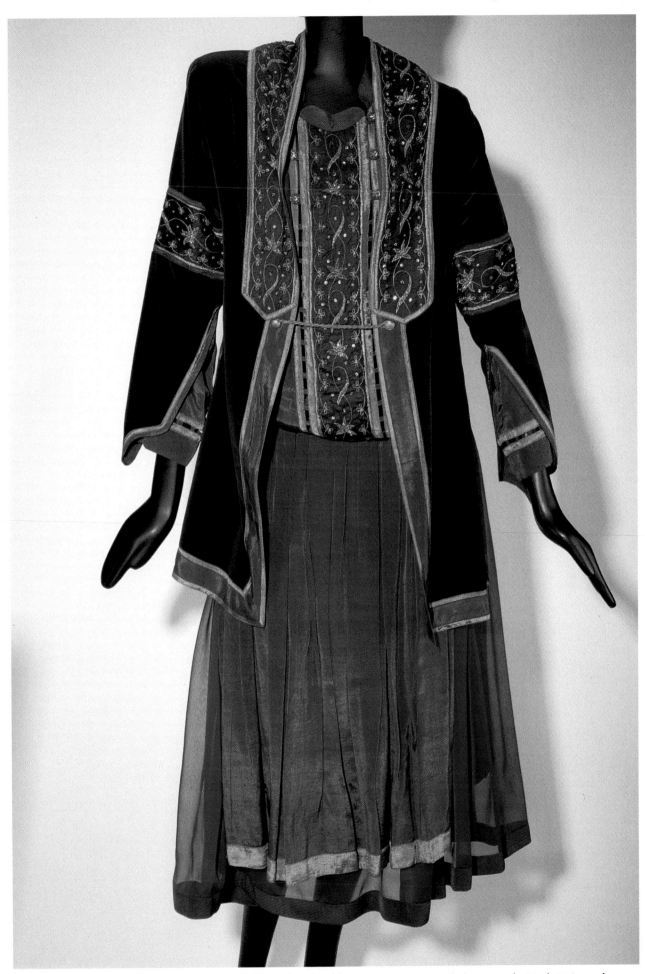

Antique Iranian traditional costume, remade and updated for contemporary use: dark green velvet jacket trimmed with bands of embroidered green silk and metallic; lace skirt over plum silk. *Courtesy Saieda Tajbakhsh Baghery*

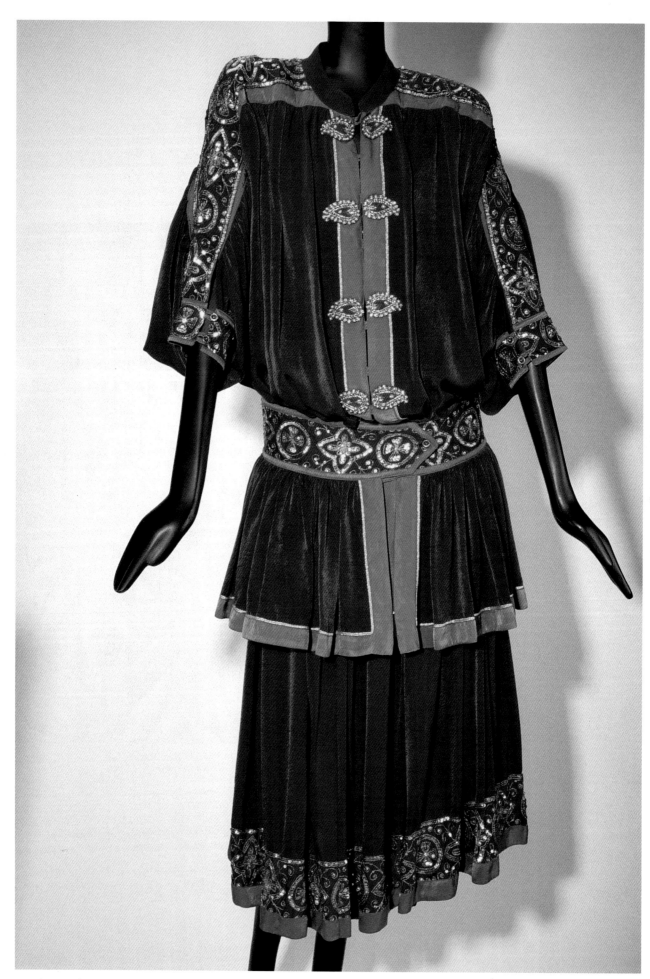

Antique Iranian traditional costume, remade and updated for contemporary use: purple silk two-piece dress, with embroidered and decorated gold bands with turquoise borders, metallic closures. *Courtesy Saieda Tajbakhsh Baghery*

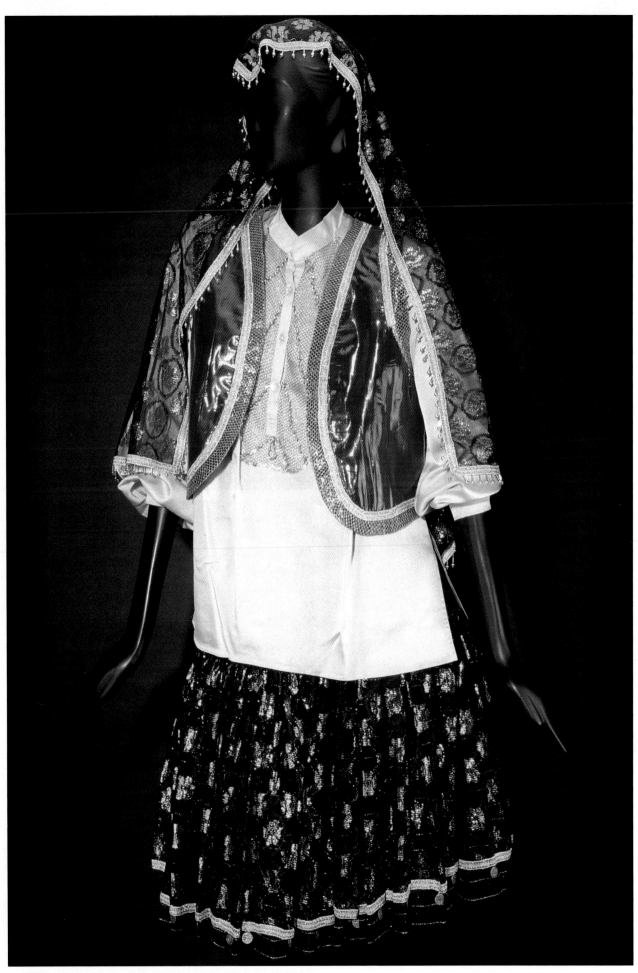

Antique Iranian traditional costume, remade and updated for contemporary use, made of silk and gold thread: black lace scarf with gold thread, red high sheen silk balero with gold trim, blouse with gold trim, full skirt with gold flowers and lace overlay. *Courtesy Saieda Tajbakhsh Baghery*

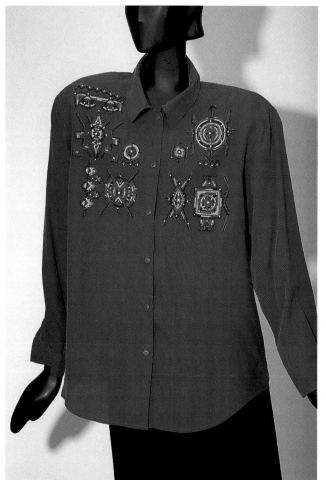

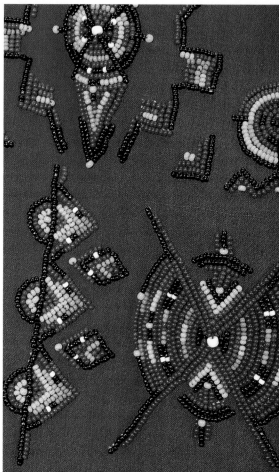

Top left: Blue silk shirt/jacket with hand beaded Amerindian decoration. *Courtesy Arlene Schreiber*

Top right: Detail.

Bottom left: Mexican huipil, off-white with red hand-embroidered flowers, 1970s. *Courtesy Lillian Horvat*

Bottom right: Mexican huipil, off-white with orange hand-embroidered flowers, 1970s. *Courtesy Lillian Horvat*

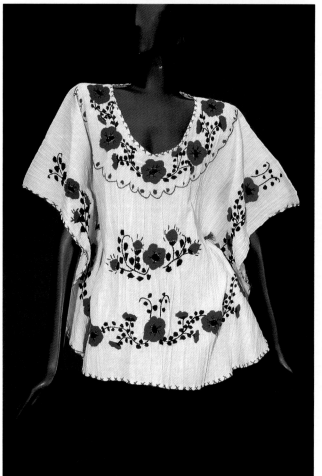

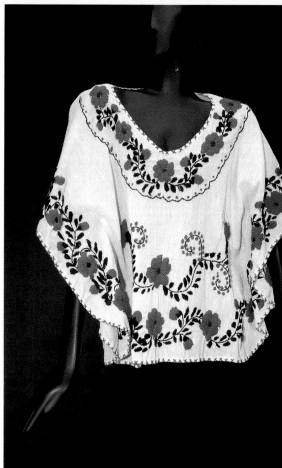

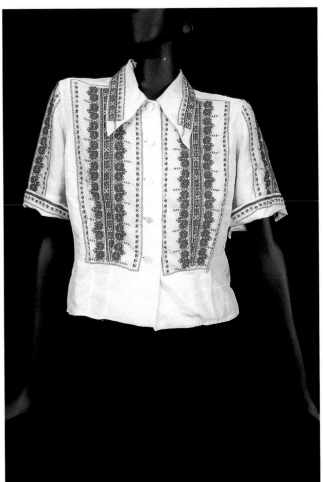

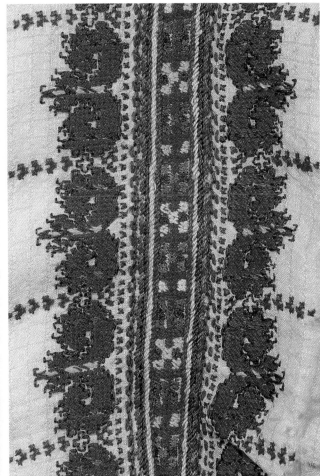

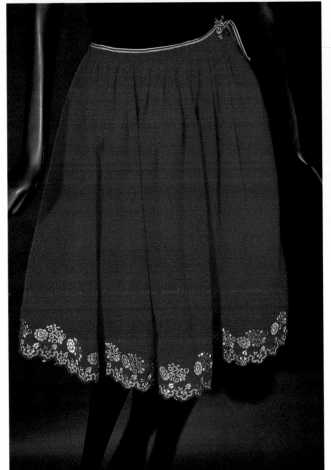

Top left: Czech blouse, hand-embroidered with cross-stitched floral motif, c.1940s. *Courtesy Anna Greenfield*

Top right: Detail.

Bottom left: Red felt skirt with scalloped bottom and floral embroidery, from Ecuador. *Courtesy Linda Cohen*

Bottom right: Detail.

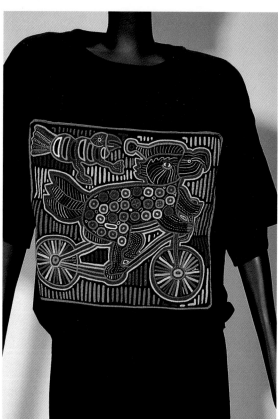

Black knit blouse, with mola appliqué, from the San Blas Islands.

Detail.

Detail.

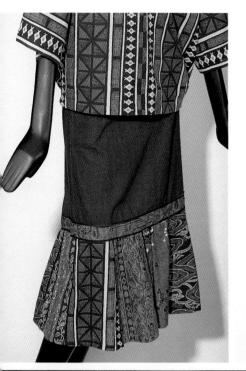
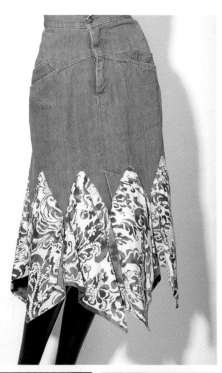
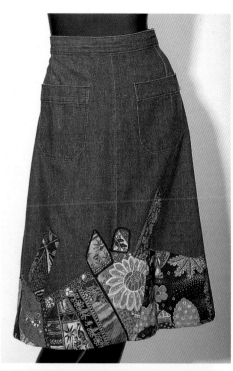
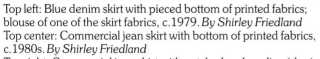
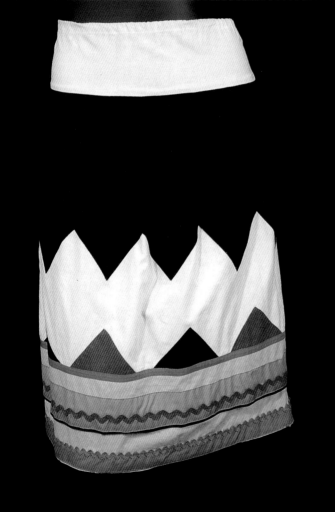
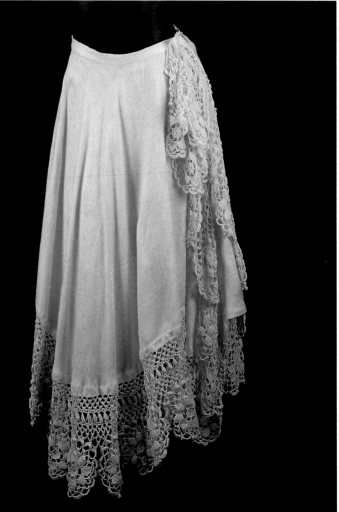

Top left: Blue denim skirt with pieced bottom of printed fabrics; blouse of one of the skirt fabrics, c.1979. *By Shirley Friedland*

Top center: Commercial jean skirt with bottom of printed fabrics, c.1980s. *By Shirley Friedland*

Top right: Commercial jean skirt with patched and appliquéd printed fabrics, c.1970s. *By Shirley Friedland*

Bottom left: Imported skirt with colorful bands added, c.1980s. *By Shirley Friedland*

Bottom right: White circular skirt made from vintage tablecloth (by Shirley Friedland), of embossed linen, with elaborate hand-crocheted border.

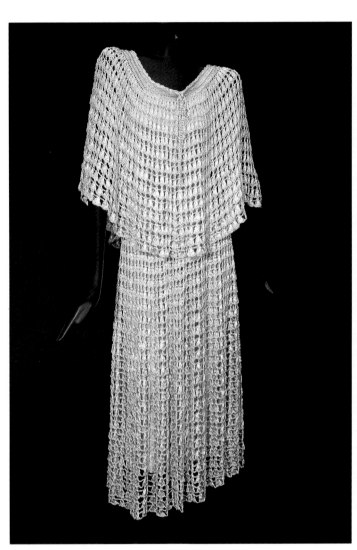

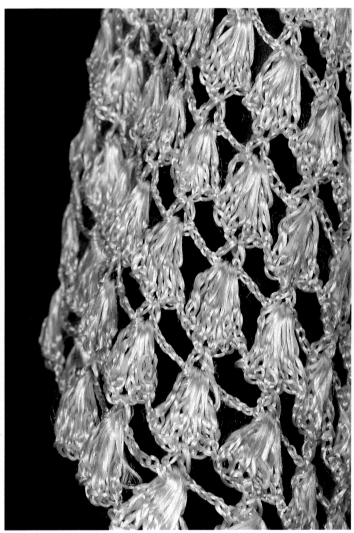

Hand-crocheted pearl gray two-piece caped dress, made in India,
1970s. *Marisa Birnbaum estate*

Detail.

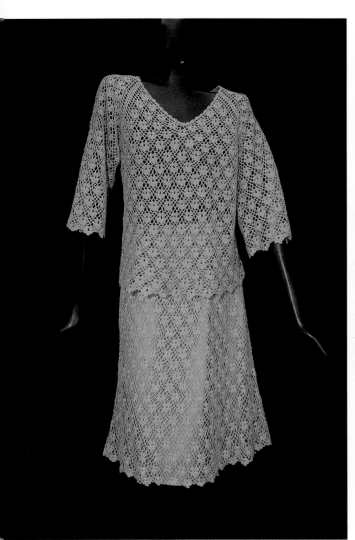

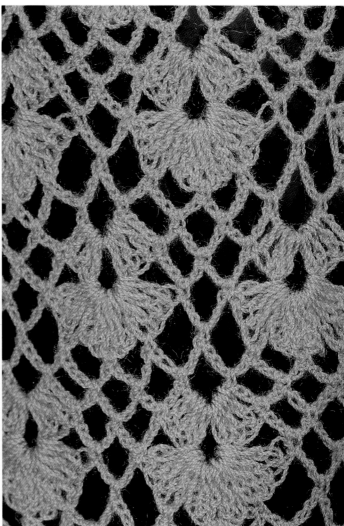

Hand-crocheted two-piece dress, turquoise, made in India, 1970s.
*Marisa Birnbaum estate*

Detail.

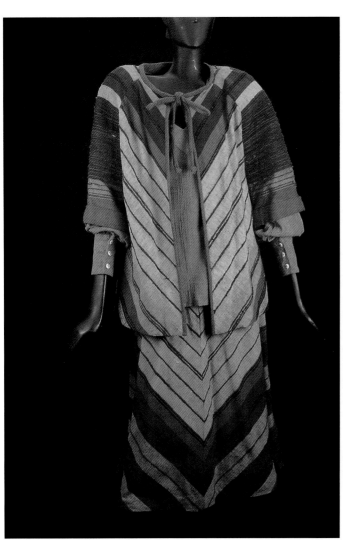

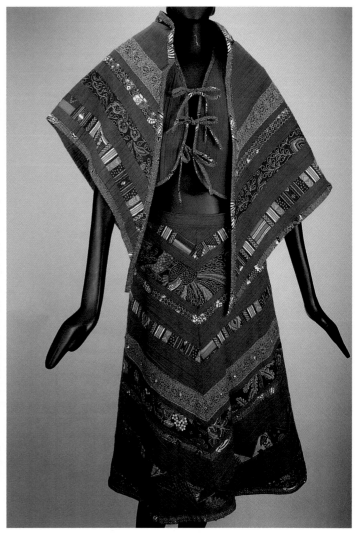

Jacket and skirt made from hand-loomed Pakistanian bedspread, c.1970s. *By Shirley Friedland*

Three-piece blue crinkle outfit, with multiple rows of appliquéd fabric and lace with jewels, c.1970s. *By Shirley Friedland*

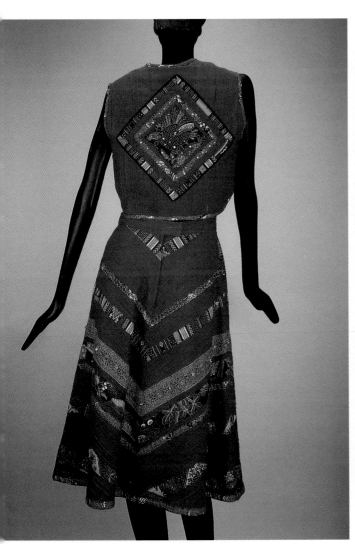

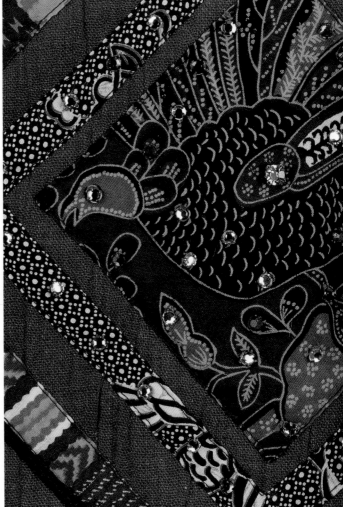

Back view showing trapunto work on vest.

Detail.

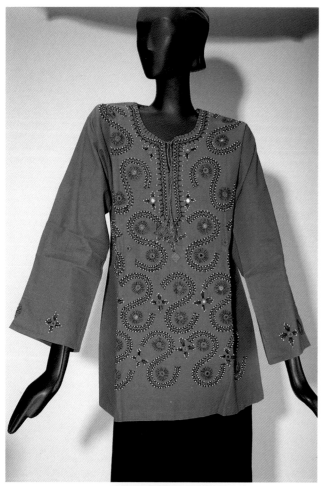

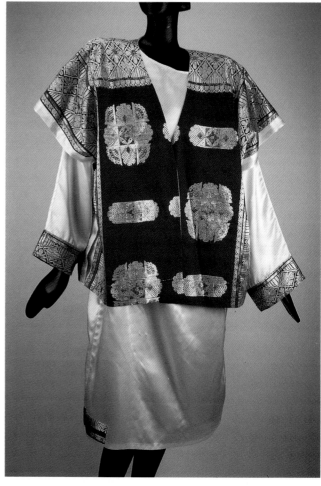

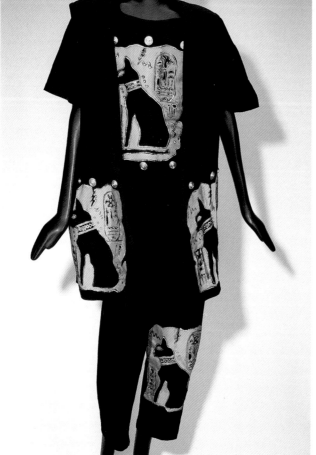

Top left: Iranian tunic with embroidered mirror decoration. *Courtesy Saieda Tajbakhsh Baghery*

Top right: White satin dress with sleeveless jacket made from Indian sari of purple silk decorated with silver. *By Jayanti Chuck*

Bottom left: Black cotton knit blouse, pants, and sleeveless jacket, with painted gold Egyptian cat motifs, labeled Scribbles.

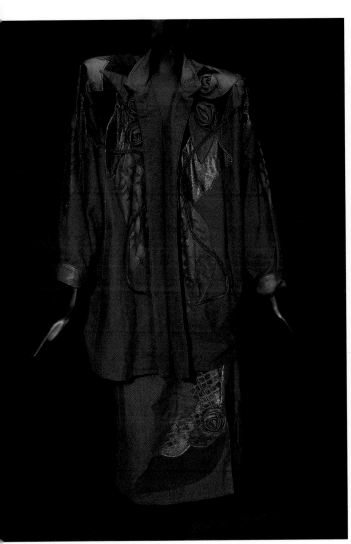

Purple jacket and skirt with leather appliqués and trim, 1980s.
*Courtesy Lillian Horvat*

Detail.

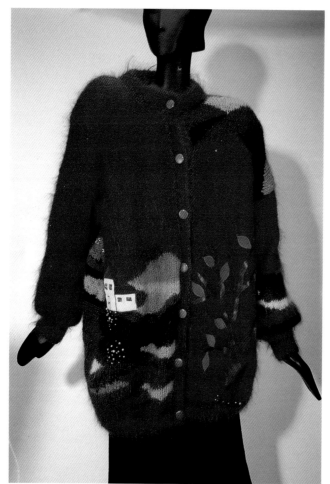
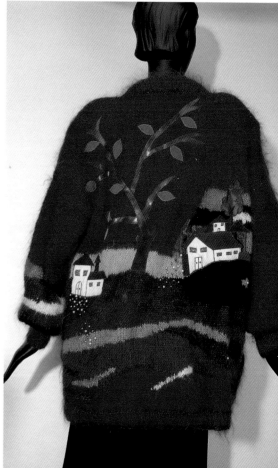

Top left: Mohair sweater/jacket of red and multicolor knit, with leather branches, suede leaves, and beads accenting village motif. *Courtesy Rebecca Smith*

Top right: Back view.

Bottom left: Purple sweater appliquéd with abstract shapes and some beading.

Bottom right: Detail.

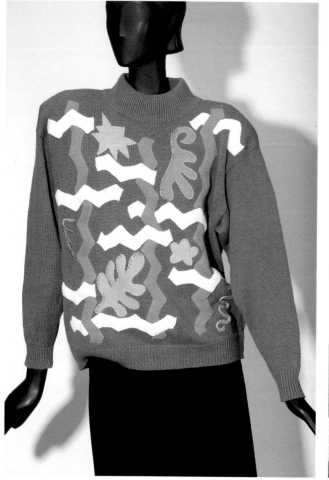
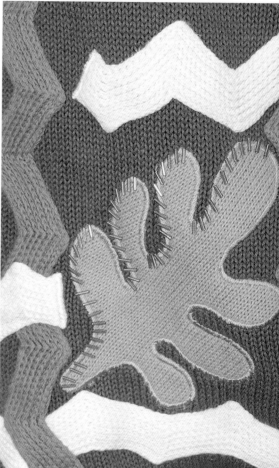

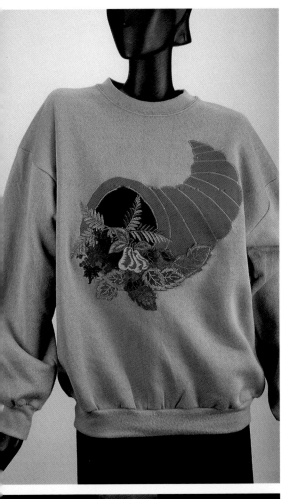

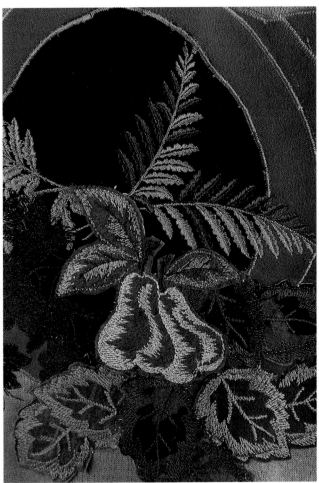

Top left: Sweatshirt with cornucopia appliqué and machine embroidery. *Courtesy Beverlee Hileman*

Top right: Detail.

Bottom left: White cotton knit overblouse with rows of zebra printed fabric and lace bands. *By Shirley Friedland*

Bottom right: Beige silk blouse with appliqués of desert cactus and sand dunes, labeled I.B. Diffusion.

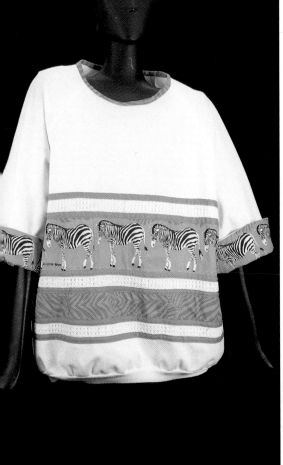

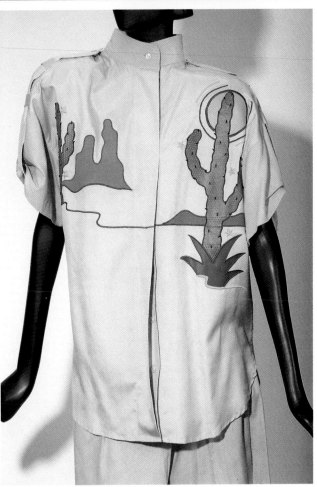

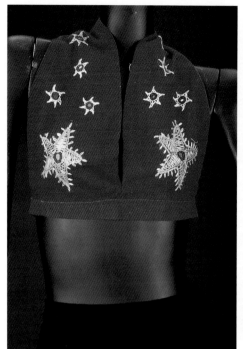

Burgundy cotton halter top with Indian mirror embroidery, c.1970s, label Geeta.

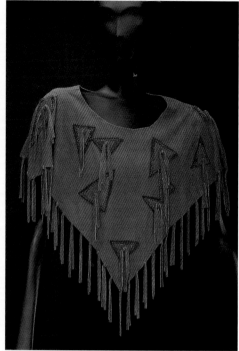

Midriff capelet, tomato red suede with suede appliqués and knotted fringe. *Courtesy Lorita Winfield*

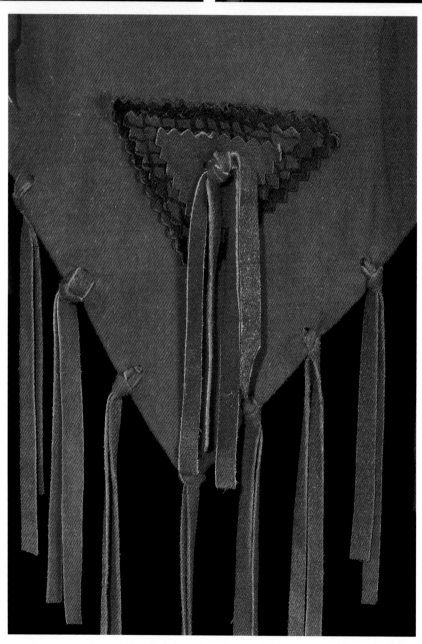

Detail.

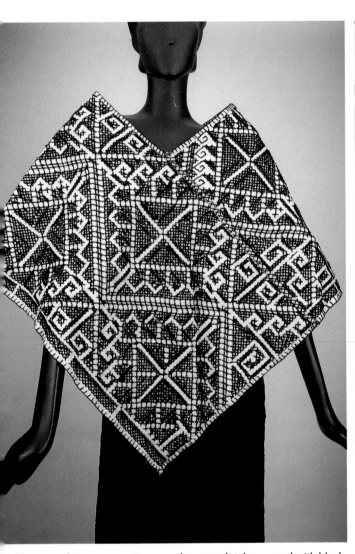

Mexican white woven cotton poncho, completely covered with black cross-stitched pattern. *Courtesy Sharon Ramsay*

Detail.

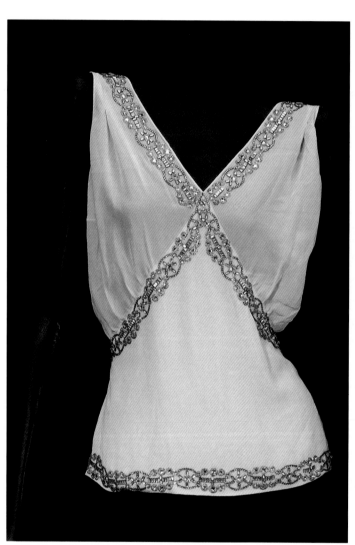

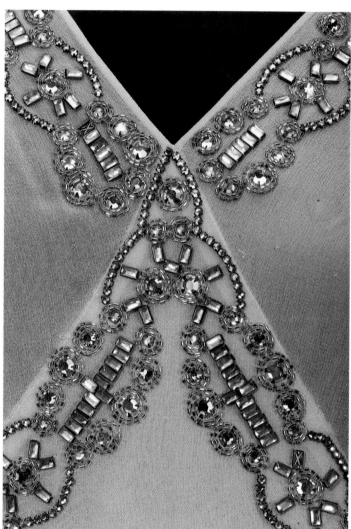

Long silk chiffon sleeveless blouse with rhinestone and beaded Art Deco trim on bodice and hem, c.1920s. *Courtesy Ursuline College Historic Costume Study Collection*

Detail.

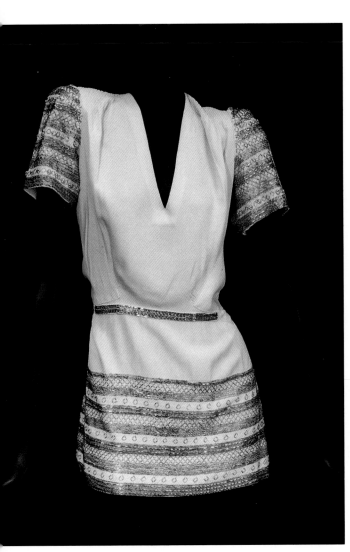

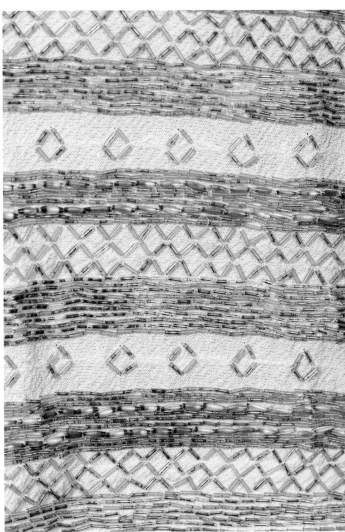

Cream rayon V-neck tunic, beaded geometric design trim, c.1940s.
*Courtesy Ursuline College Historic Costume Study Collection*

Detail.

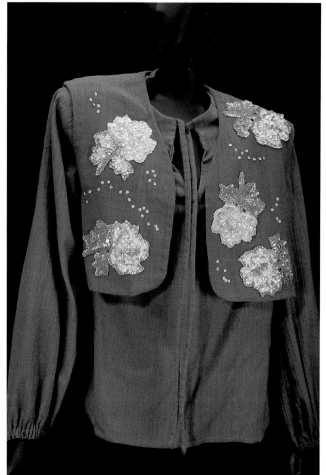
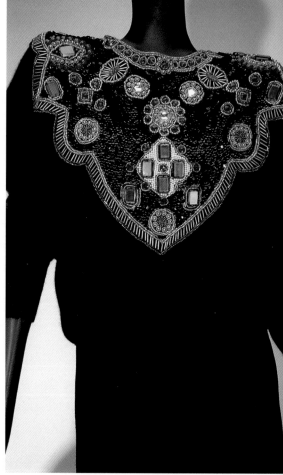

Top left: Green gauze blouse (matching skirt not shown), bolero with pink sequined flower appliqués, c.1970s. *By Shirley Friedland*

Top right: Black angora and lambswool sweater, heavily decorated with black sequins, gold beads, and colored jewels, 1980s, label Semplice. *Courtesy Lillian Horvat*

Bottom left: Lambswool and angora sweater, heavily beaded and sequined over floral pattern, made in Hong Kong, 1950s. *Courtesy Ursuline College Historic Costume Study Collection*

Bottom right: Detail.

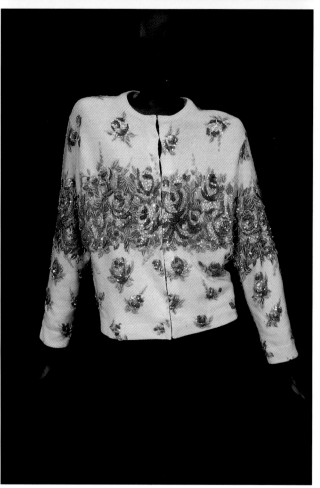
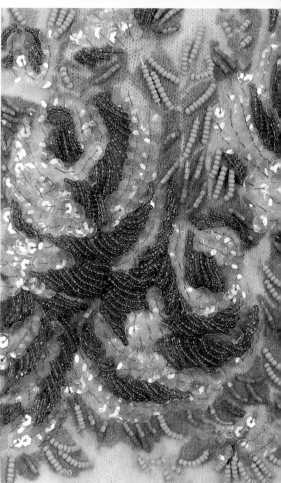

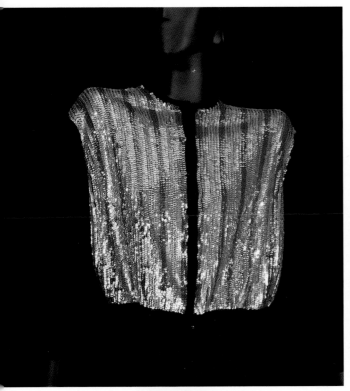

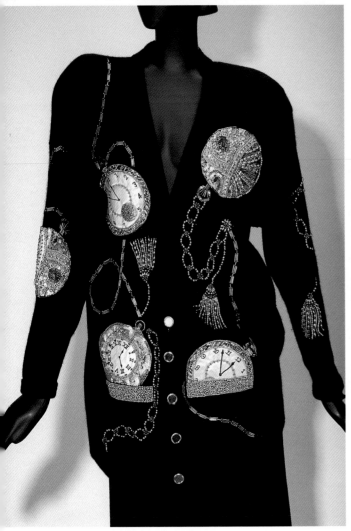

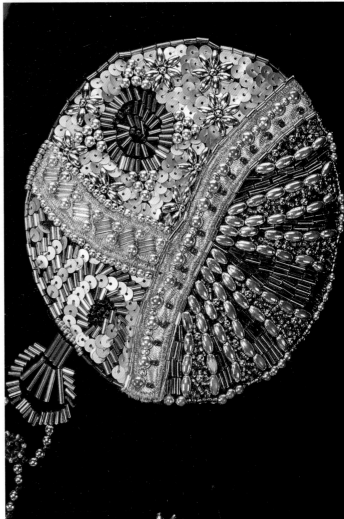

Top left: Black cashmere sweater with hot pink, chartreuse, and silver palettes, c.late 1950s. *Courtesy Anna Greenfield*

Top right: Detail.

Bottom left: Black sweater, appliqués of white satin clocks decorated with embroidery, sequins, and beads. *Courtesy Lillian Horvat*

Bottom right: Detail.

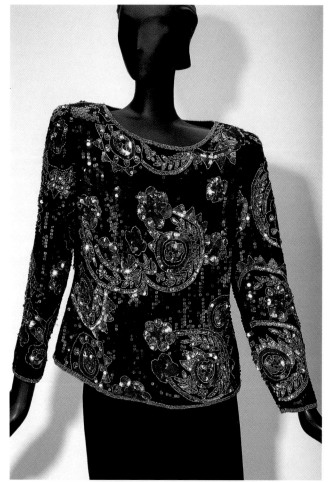

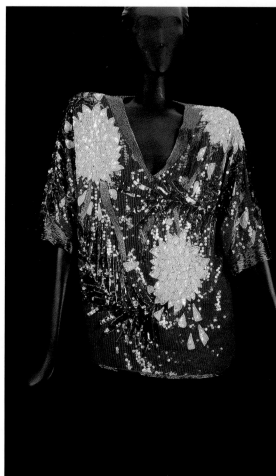

Top left: Black silk blouse, sequined and beaded in red and gold floral design, 1980s, labeled Laurence Kazan, New York. *Marisa Birnbaum estate*

Bottom left: Detail.

Top right: Silk overblouse, completely sequined and beaded in bold floral pattern on dark red, labeled I.B. Diffusion. *Courtesy Alice Kaye*

Bottom right: Back view.

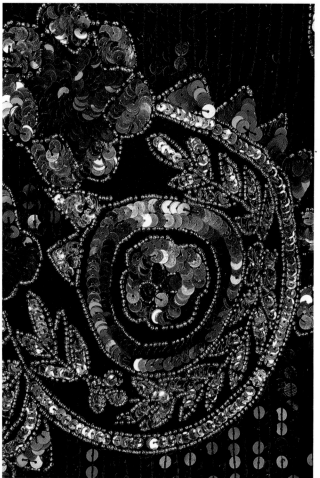

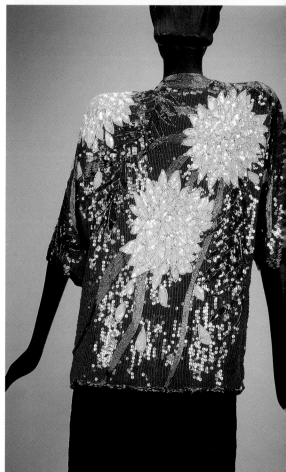

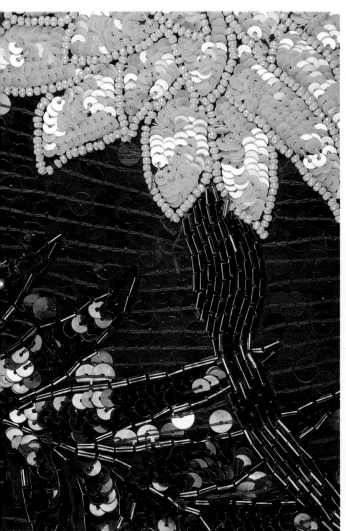

Detail.

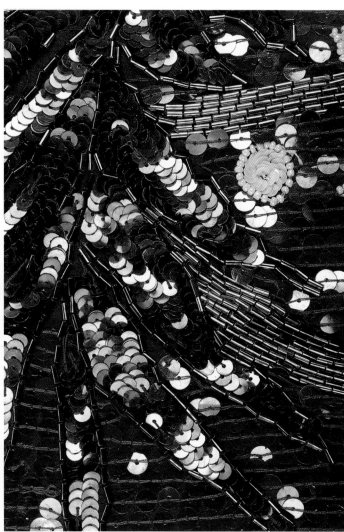

Detail.

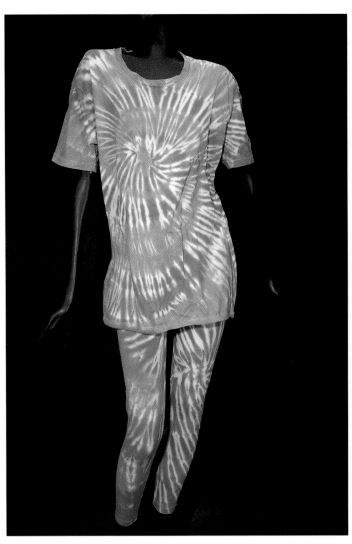

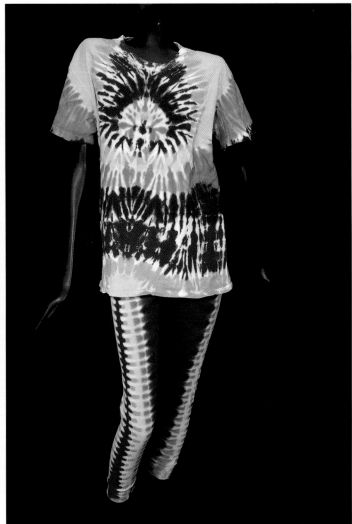

Cotton knit tee-shirt and pants in green and blue tie-dye by Roger's Tie-Dye.

Cotton knit tee-shirt and pants in multicolor tie-dye by Roger's Tie-Dye.

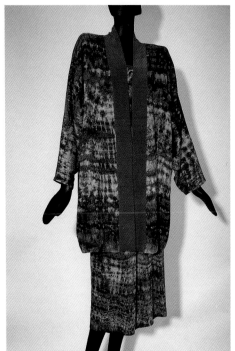

Hand dyed silk ensemble in the Japanese Shibori tradition: jacket with fiery orange lapels over blouse and skirt. *By Robyn Lynn*

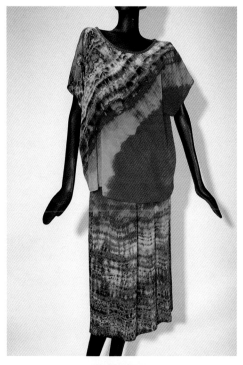

Without jacket.

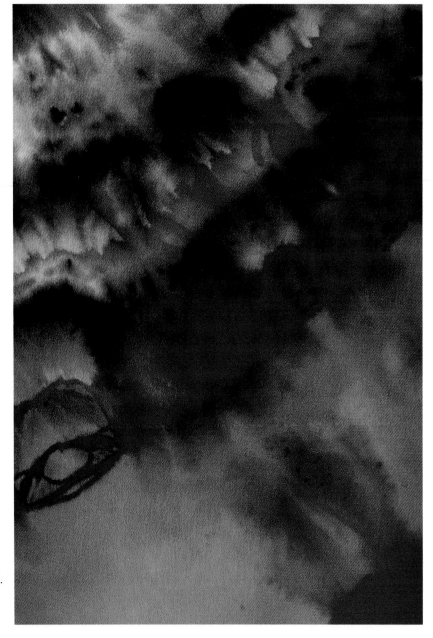

Detail.

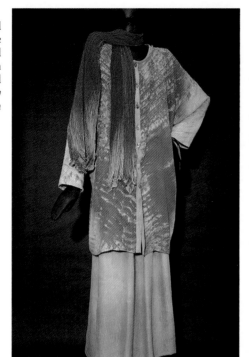

Hot pink, vivid yellow, and beige Shibori hand dyed silk ensemble with accordion pleated (Arashi) scarf. *By Robyn Lynn*

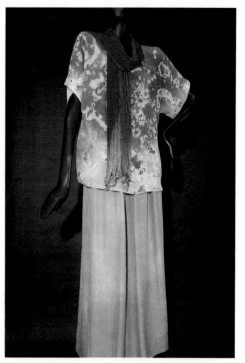

Skirt, top, and scarf without jacket.

Detail of scarf.

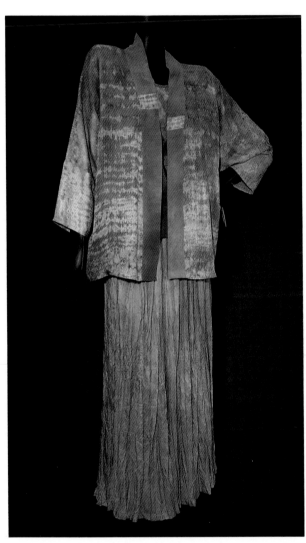

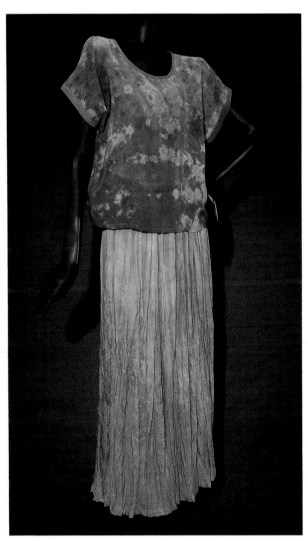

Shibori hand dyed silk ensemble: jacket with orchid lapels over blouse and Arashi pleated skirt. *By Robyn Lynn*

Without jacket.

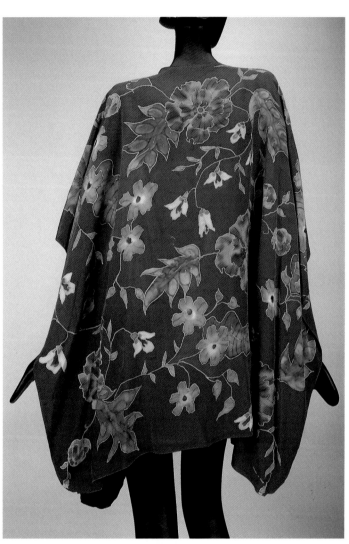

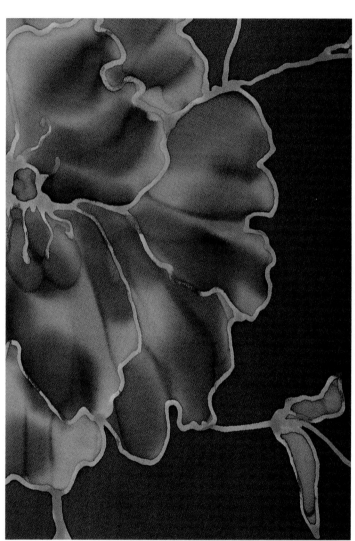

Hand-painted silk cape in plum with large contrasting flowers, in Gutta technique. *By Susanne Bodenger Skove*

Detail.

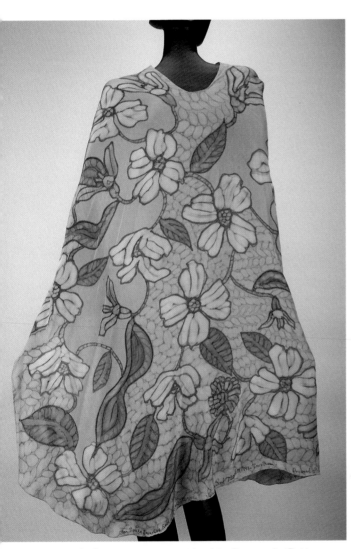

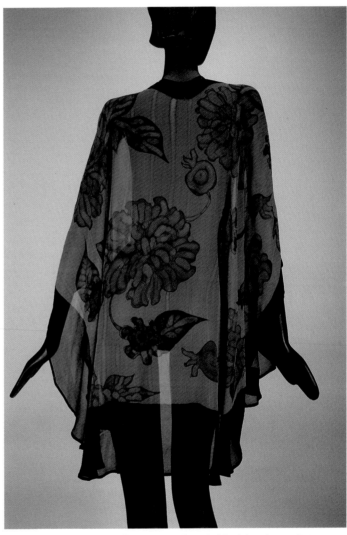

Hand-painted silk cape in mauve with white flowers, in Gutta technique. *By Susanne Bodenger Skove*

Hand-painted silk chiffon cape with wide black border and giant flowers, in Gutta technique. *By Susanne Bodenger Skove*

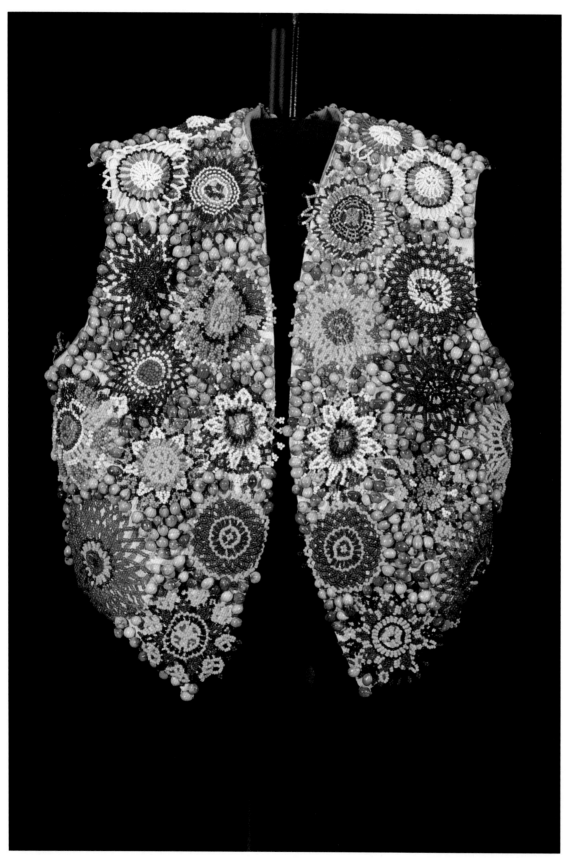

Pale yellow cotton covered with multi-colored beaded medallions and coffee bean fillers, hand made in Africa, c.1970s. *Courtesy Charlotte Paris.*

Opposite page:
Top: Detail.

Bottom: Identical African beaded medallions ready to be made into wearable art.

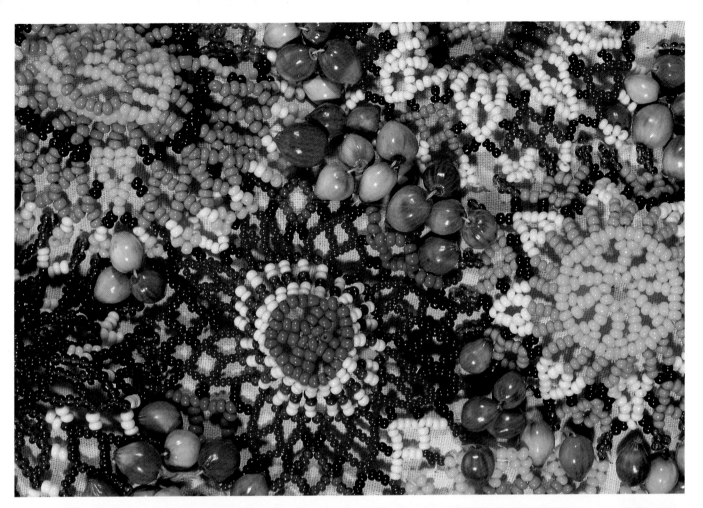

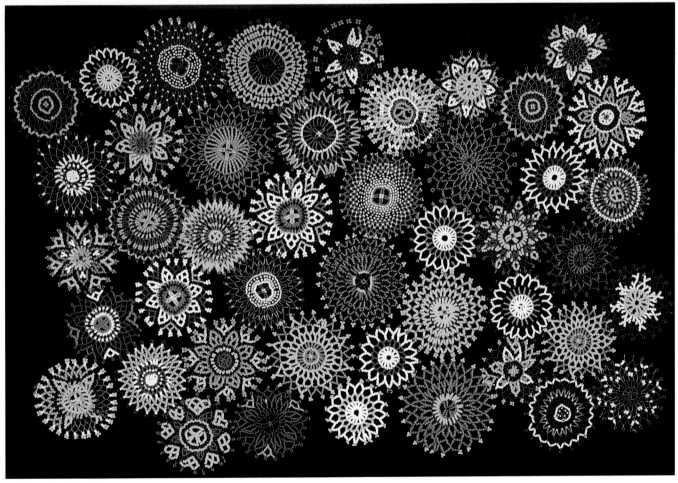

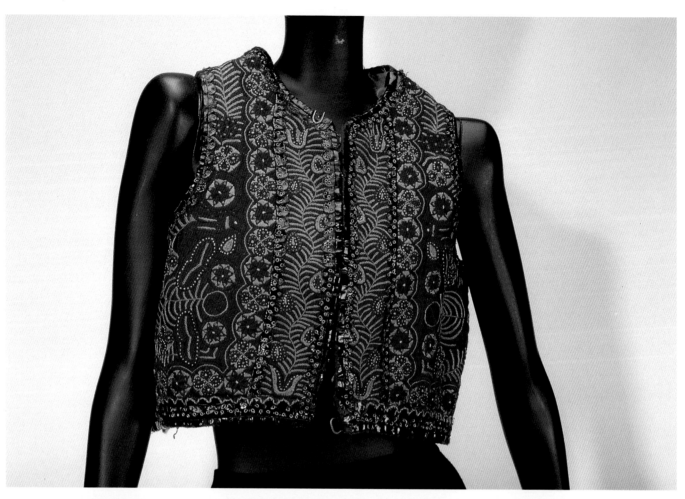

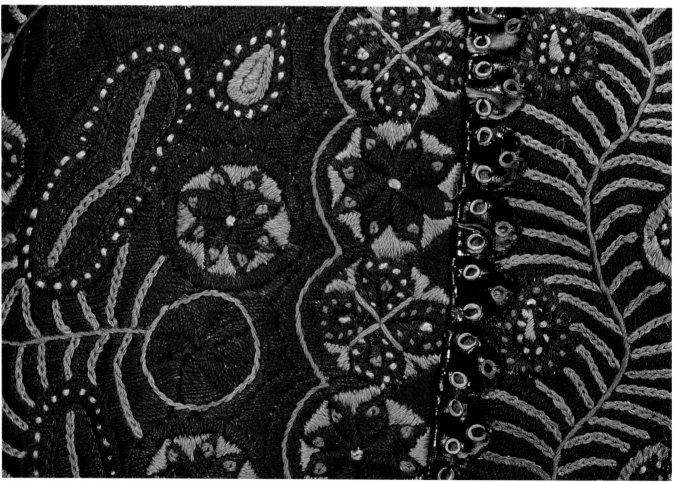

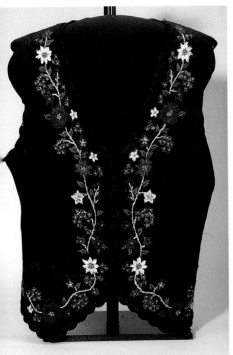
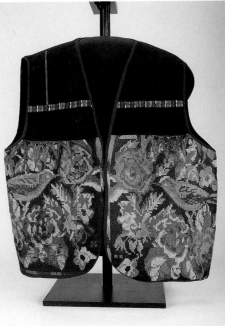
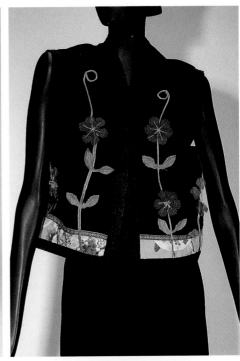
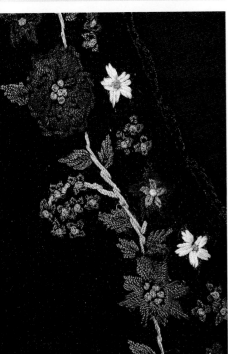

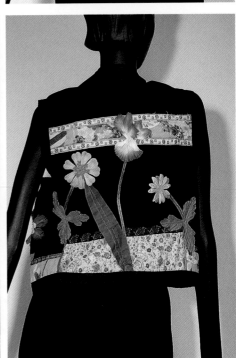

Top left: Ramie and cotton, trimmed with embroidery, made in China. *Courtesy Sue Hersh*

Top center: Vest of needlepoint style fabric; made in Guatamala. *Courtesy Linda Cohen*

Top right: Velveteen with applied silk flowers and pictorial fabric appliqué, 1970s. *Courtesy Lillian Horvat*

Bottom left: Detail.

Bottom center: Detail.

Bottom right: Back view.

Opposite page:
Top: Bolero vest covered with solid embroidery in maroon and gold, with scalloped black leather trim. *Courtesy Zsuzsa Csepanyi Bawab*

Bottom: Detail.

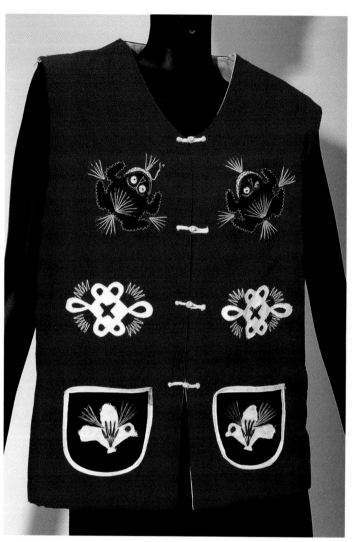

Cotton with 3-dimensional felt frog appliqués; made in China, 1970s. *Courtesy Lois Epstein*

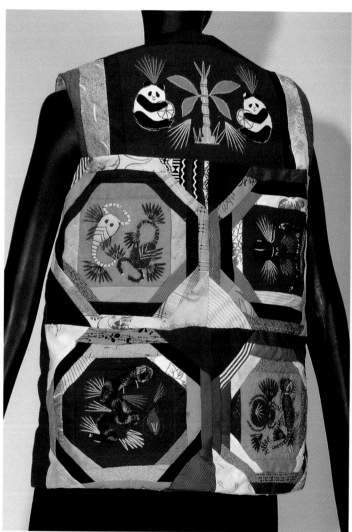

Back view with patchwork and animal appliqués.

Oppostie page: Detail showing 3-D.

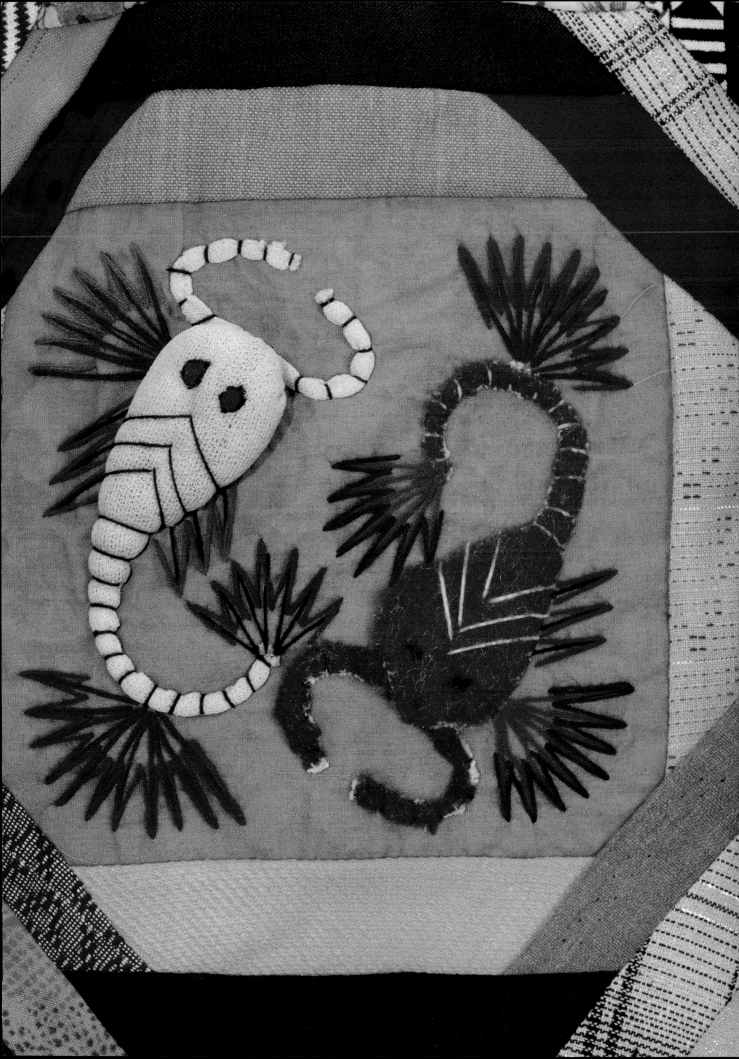

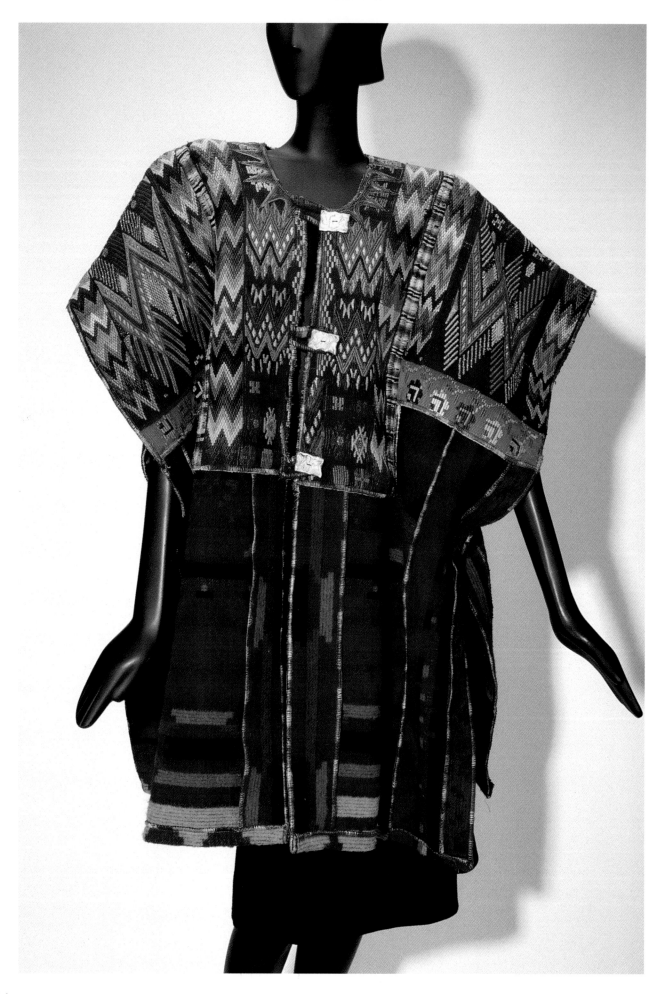

62

Opposite page: Guatamalan huipil, handwoven wool and cotton in bright primary colors, geometric patterns.
*Courtesy Susan Salkin*

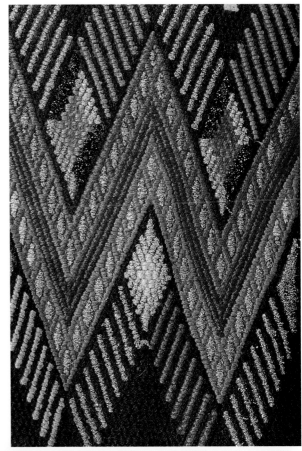

Detail.

Detail.

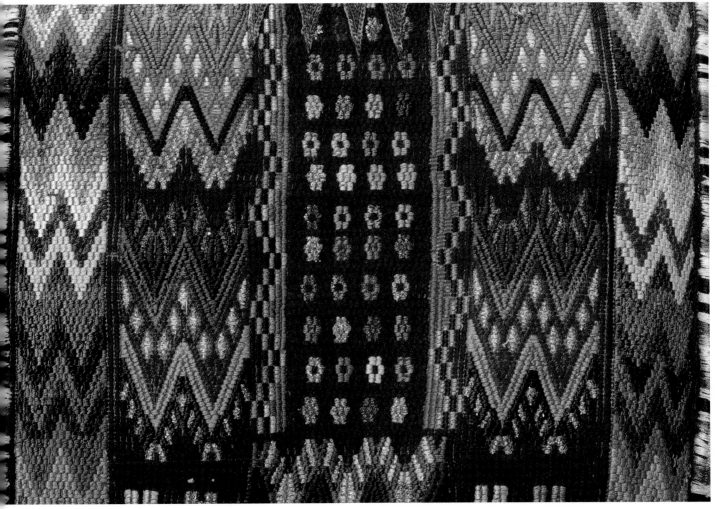

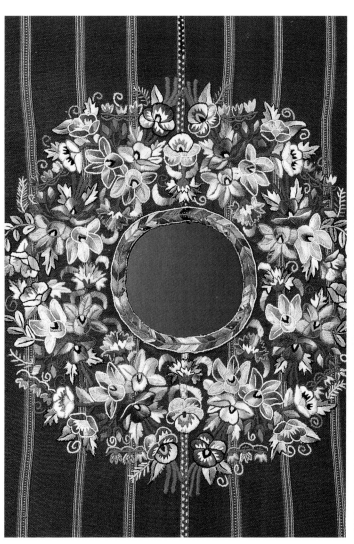

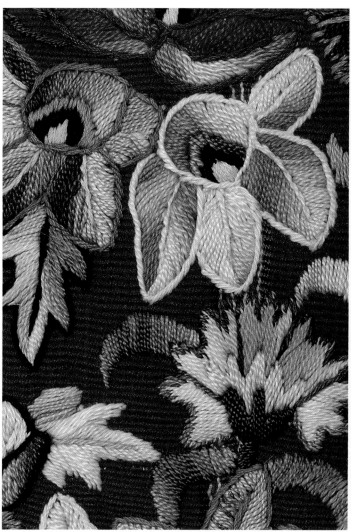

Mounted Guatamalan huipil showing hand-embroidered neckline.
*Courtesy Linda Cohen*

Detail.

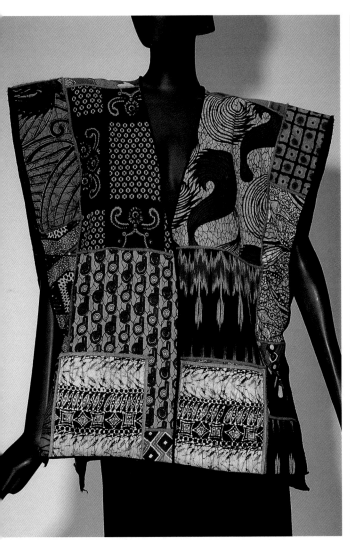

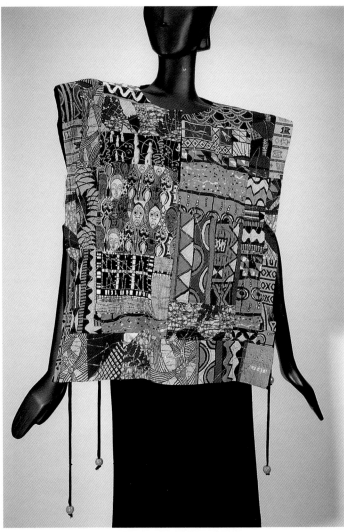

African fabric sewn together to make huipil-type vest. *Courtesy Susan Salkin*

Pancho-vest, made with three layers, using African prints as top layer of patchwork, then stitched with various metallic threads, and washed to give a crinkled effect. *By Shirley Friedland*

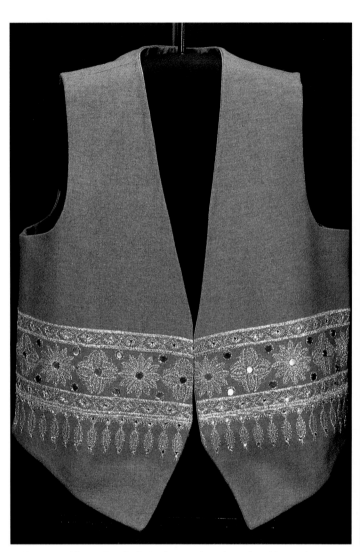

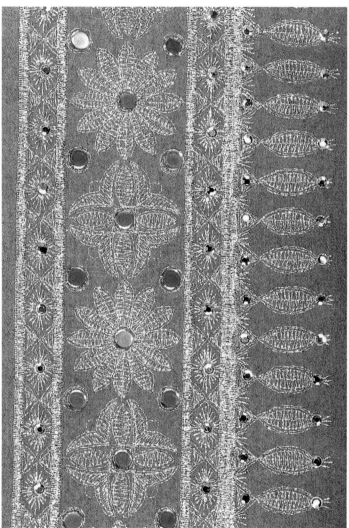

Grey wool flannel embellished with silver thread and large clear rhinestones. *By Shirley Friedland, courtesy Miriam Glazer*

Detail.

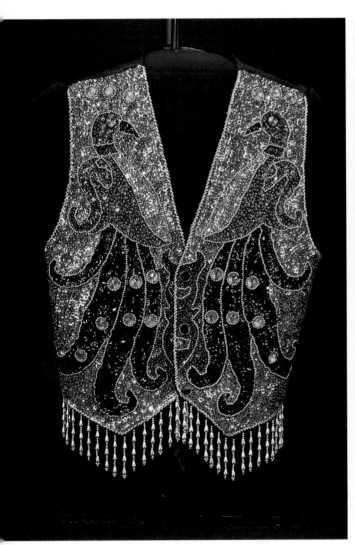

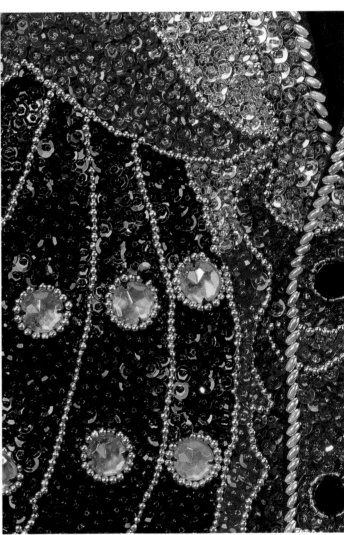

Solid sequined peacock design with yellow faceted glass stones and beaded fringe. *Courtesy Donna Kaminsky*

Detail.

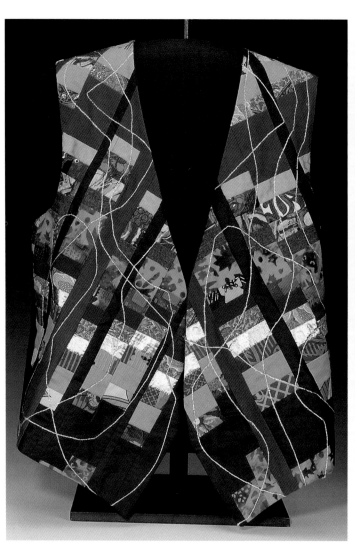

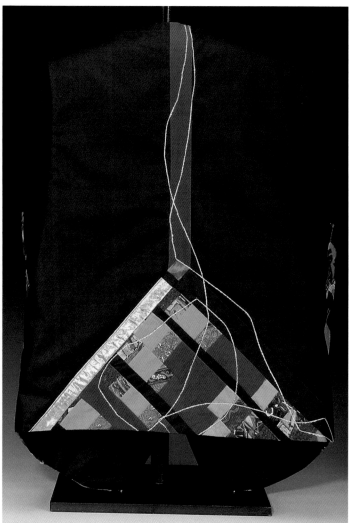

Cotton and silver metallic fabric in random bargello patchwork.
*By Shirley Friedland*

Back view.

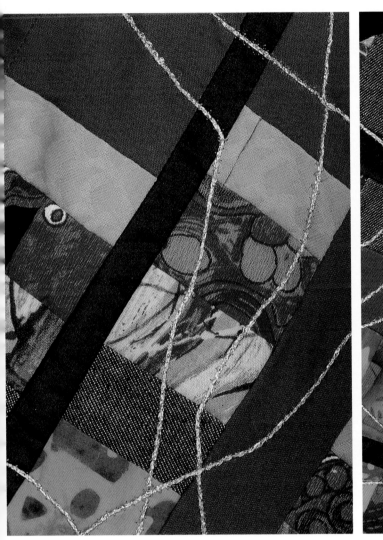

Detail.

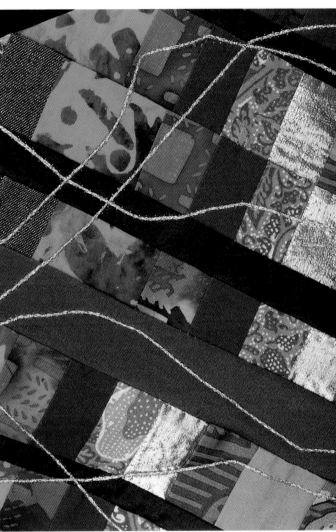

Detail.

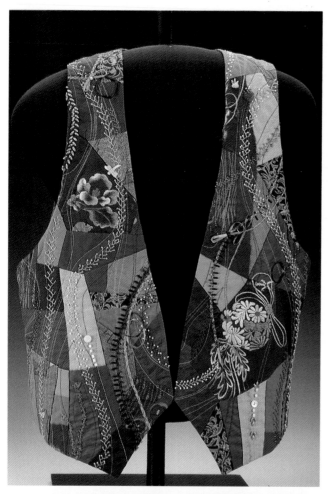
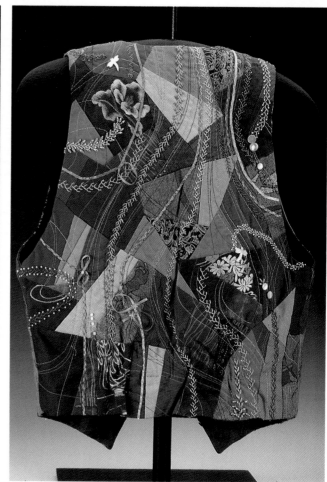
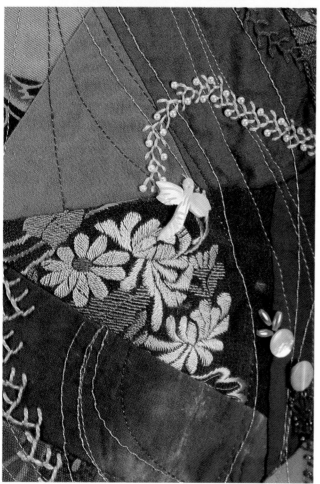
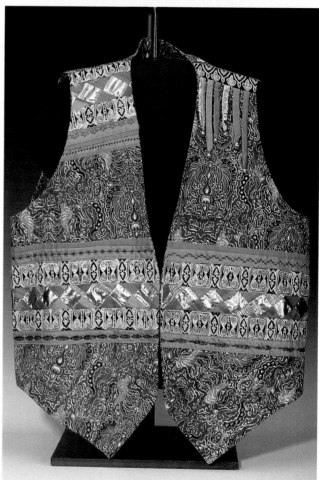

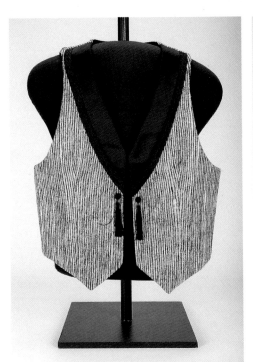

Silk and metallic textured fabric with black braided neckline and tassel. *By Sharon Ramsay*

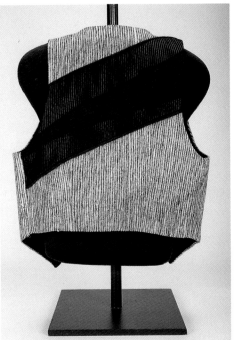

Back view with extreme contrast black abstract design.

Opposite page:
Top left: Irregular patchwork embellished with antique silk ribbon, beads, and embroidery. *By Judith Kessler Smith*

Top right: Back view.

Bottom left: Detail.

Bottom right: Cotton batik, Balinese fabric inserts, and metallic fabric in seminal patchwork. *By Shirley Friedland, courtesy Ruth Marcus*

Detail.

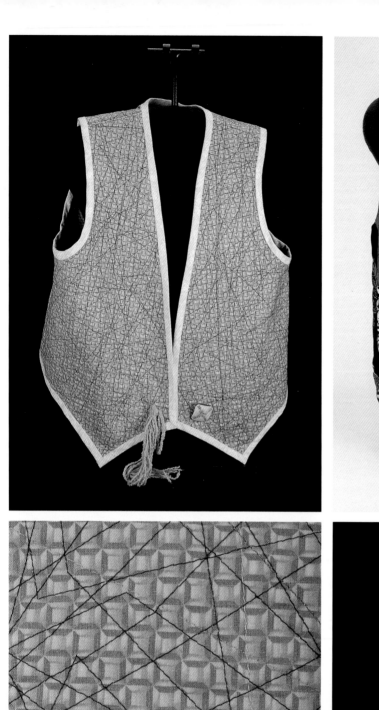

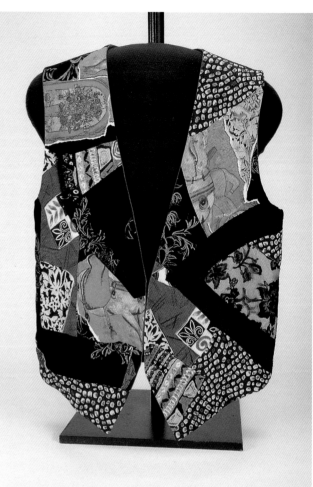

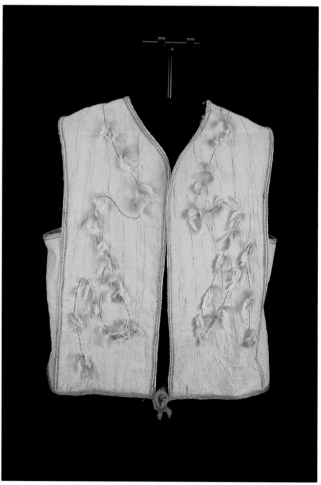

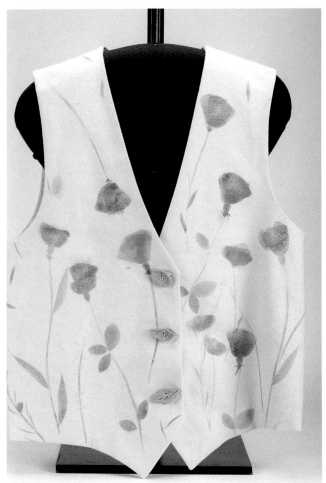

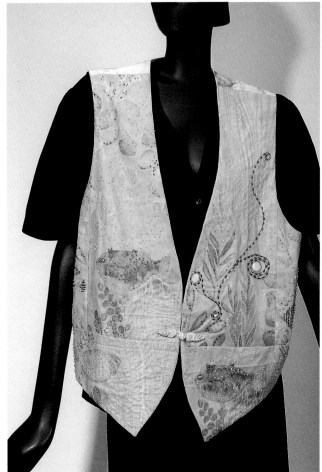

Top left: Cotton canvas, hand stenciled with acrylic paint, leaf-shaped buttons. *By Becky Olencki*

Top right: Commercial hand-screened fabric, beaded with glass seed beads, hand-painted lining and back. *By Lois Carroll*

Right: Detail.

Opposite page:
Top left: Layered cotton with top stitching random pattern and binding. *By Linda Cohen*

Bottom left: Detail.

Top right: Random patchwork of black, brown, and beige silks and laces. *By Shirley Friedland, courtesy Shirley Bernon*

Bottom right: Crinkle muslin on backing, with couching and yarn trim. *By Carol Thorn*

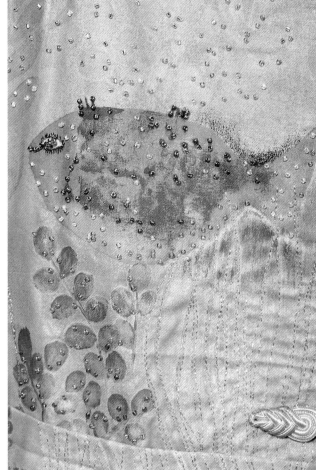

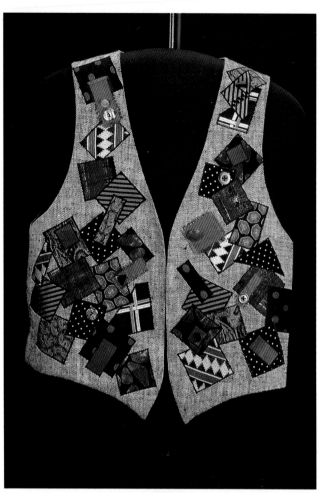

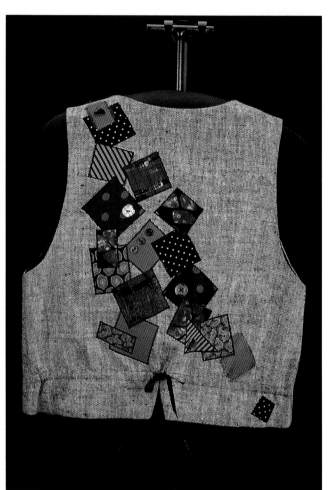

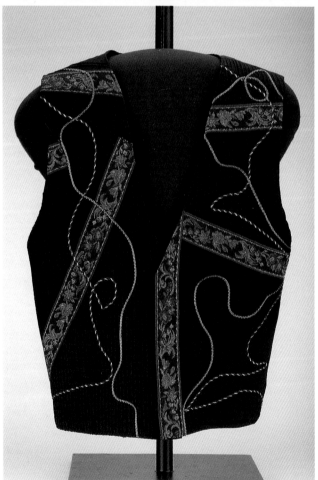

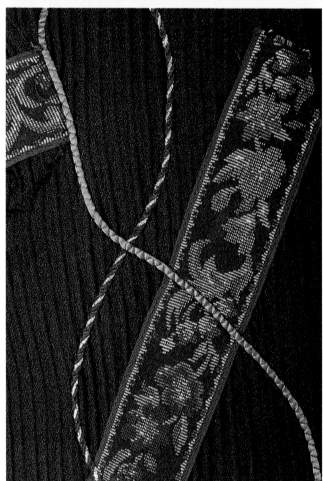

Pinks and wines, achieved by discharge dye method, with pintucked accents, porthole, and matching polymer clay buttons. *By Becky Olencki*

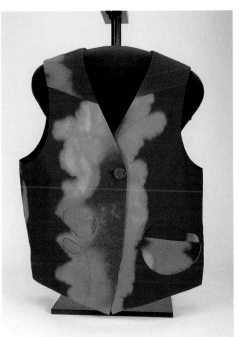

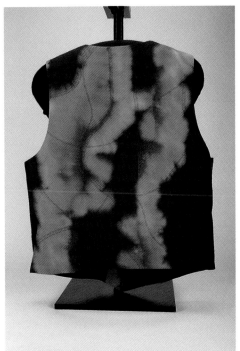

Back view.

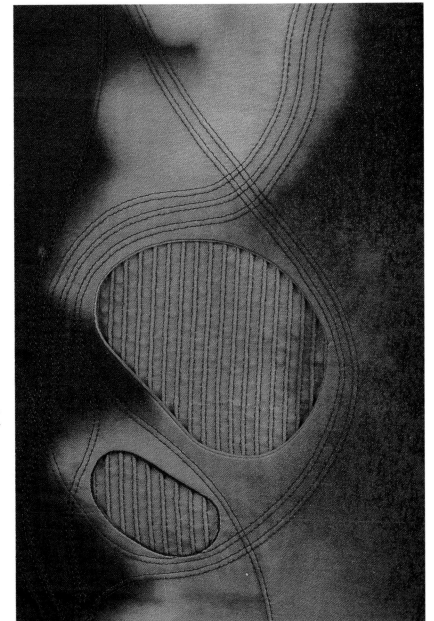

Opposite page:
Top left: Traditional and fringed appliqués of silks and neckties; variation of a design by Marinda Stewart. *By Sharon Ramsay*

Top right: Back view.

Bottom left: Floral ribbon appliqué and cording applied in random pattern, on corded black fabric. *By Beverlee Hileman*

Bottom right: Detail.

Detail.

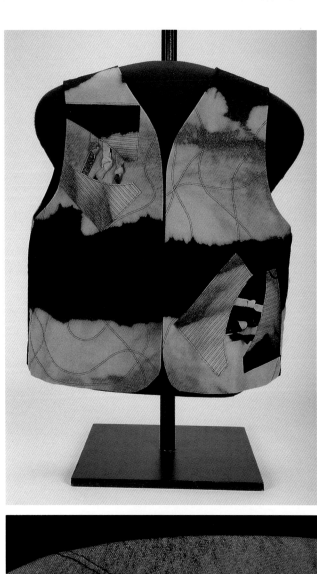
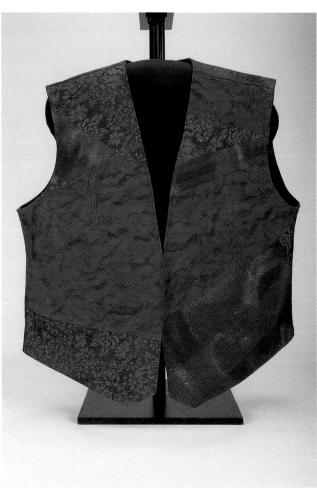

Opposite page:
Top left: Black and tan, achieved by discharge dye method, with pintucked fabric appliqué. *By Carol Thorn.*

Bottom left: Detail.

Top right: Patchwork in earth tones, with pintucking and twin needle stitching. *By Linda Cohen*

Bottom right: Detail.

Beige striped and grid patterned silk, with asymmetrical closing. *Courtesy Linda Cohen*

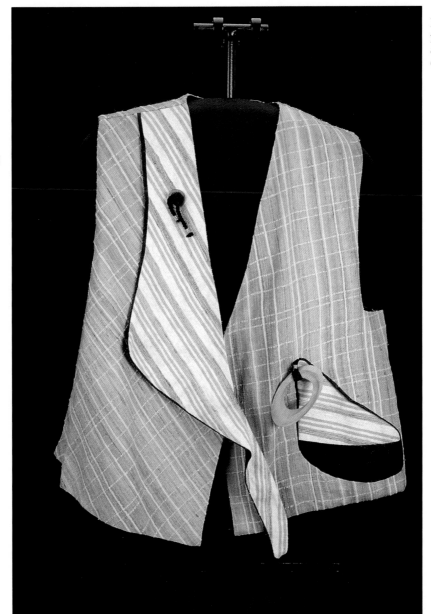

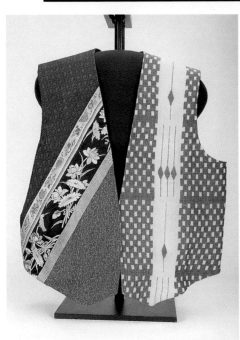

Variety of fabrics, with antique Oriental silk embroidery inset. *By Linda Cohen*

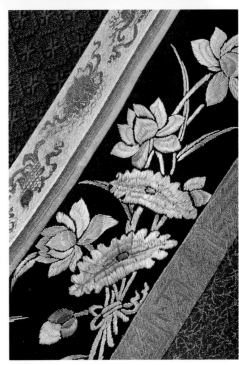

Detail.

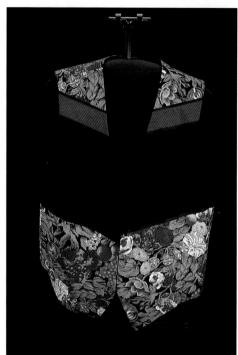

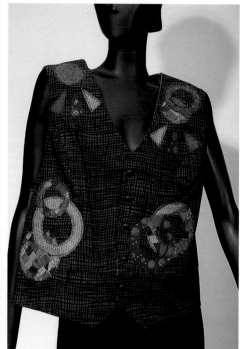

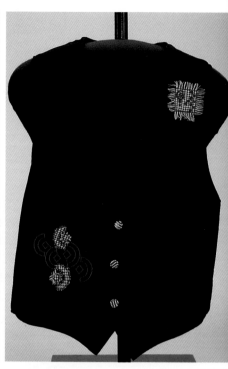

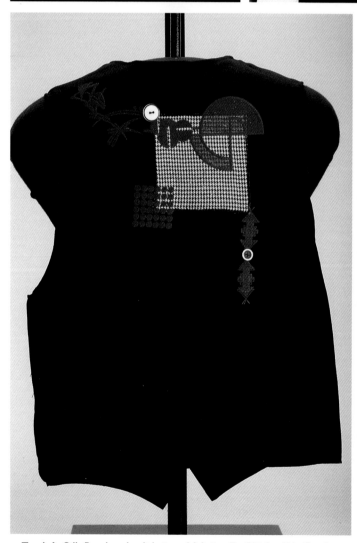

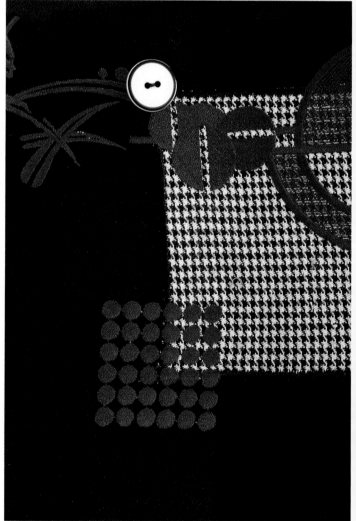

Top left: Silk floral and solid pieced fabrics. *By Shirley Friedland, courtesy Charlotte Paris*

Top center: Rings of colored patchwork and small checkerboard patch. *By Lois Carroll*

Top right: Fabric appliqués, machine embroidery, coordinated checkered buttons. *Beverlee Hileman*

Bottom left: Back view

Bottom right: Detail.

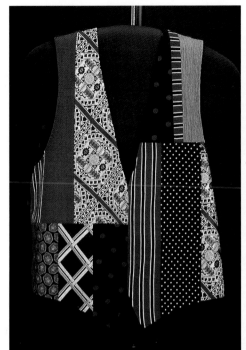

Color blocking, patchwork of bold black, red, and white silk necktie fabric from father's collection. *By Sharon Ramsay*

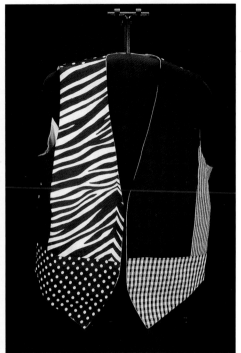

Pieced black and white fabrics in bold contrast, reversible. *By Shirley Friedland*

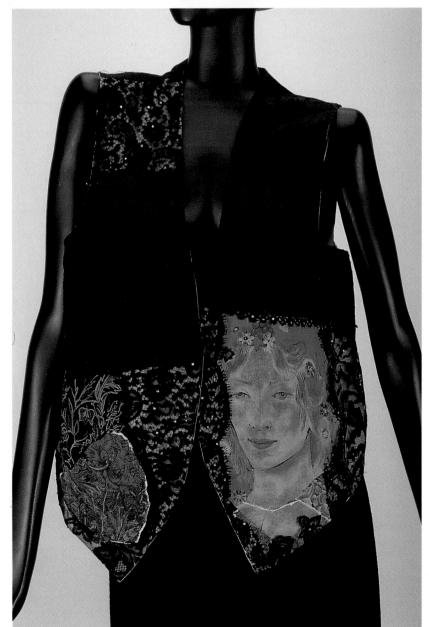

Silks in black with lady's face as focal point, lace over blue organza embellished with rhinestones. *By Shirley Friedland, courtesy Carol Gross*

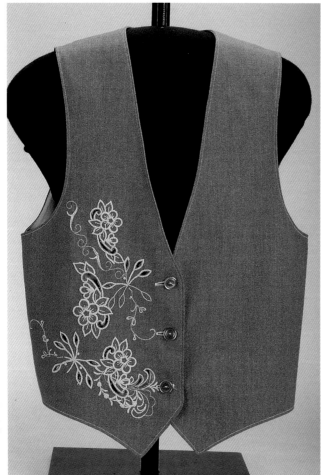

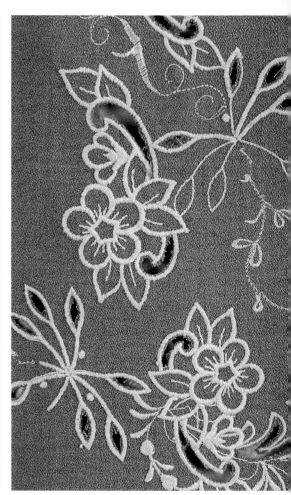

Top left: Tan with machine embroidered flowers with partial cutouts. *By Beverlee Hileman*

Top right: Detail.

Bottom left: Back of off-white vest with machine embroidery and appliqué. *By Beverlee Hileman*

Bottom right: Detail.

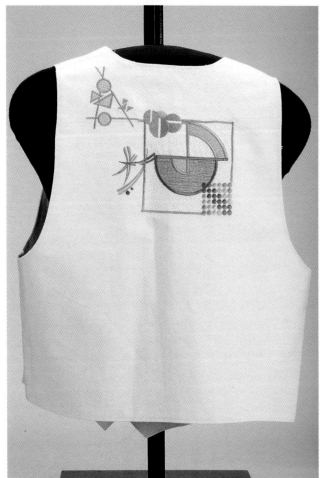

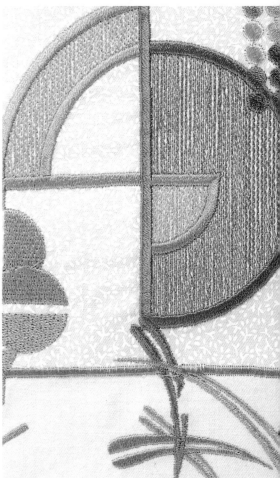

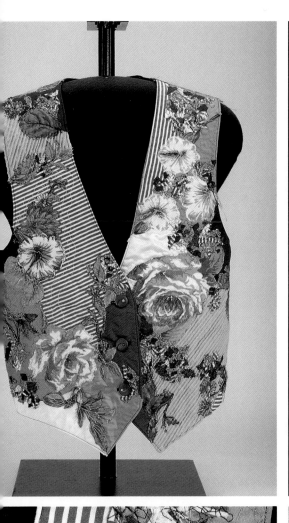

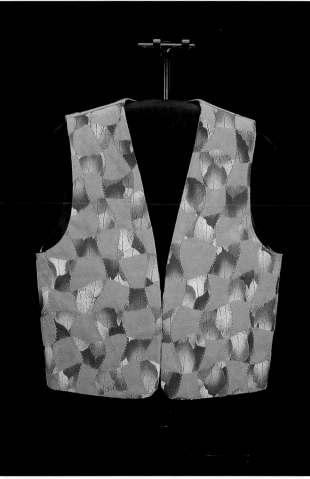

Top left: Collage of fabrics, using outline of printed flowers as appliqué edges, with overlay stitching. *By Beverlee Hileman*

Bottom left: Detail.

Top right: Abstract patchwork, using strip weaving of ultra-suede and cotton print, with decorative machine top stitching. *By Becky Olencki*

Bottom right: Detail.

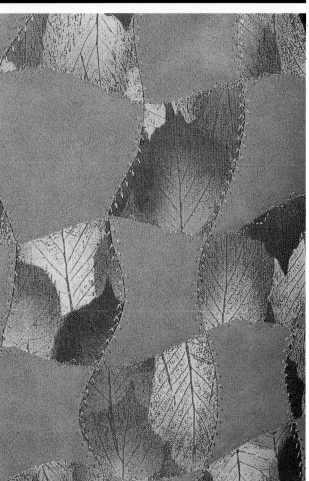

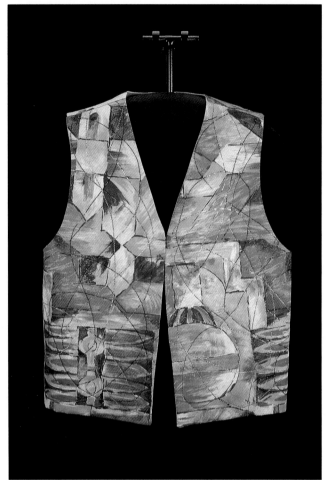

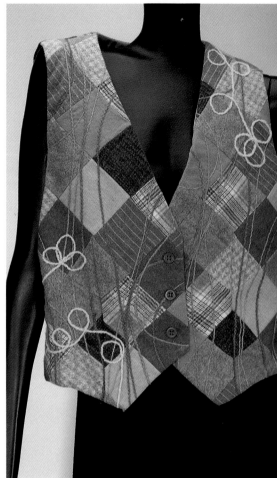

Top left: Jab fabric with painterly print, couched with gold and silver threads. *By Shirley Friedland*

Top right: Recycled wool patched with couched threads. *Judith Kessler Smith*

Bottom left: Recycled denim from two decades of jeans, patched, with flower appliqué. *Judith Kessler Smith*

Bottom right: Diagonal strip patches in navy prints and peach tones, lined to be reversible. *By Shirley Friedland, courtesy of Shirley Bernon*

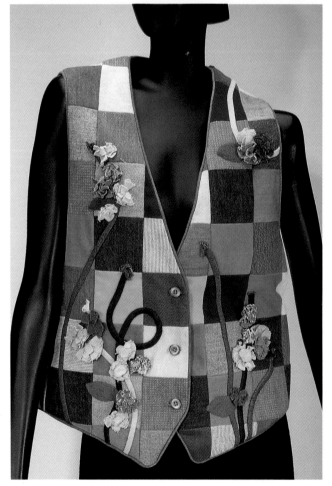

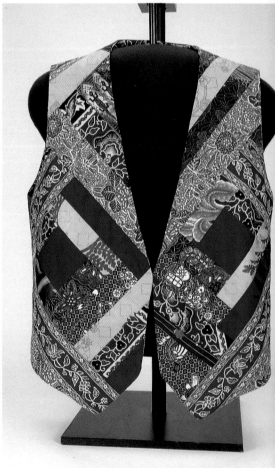

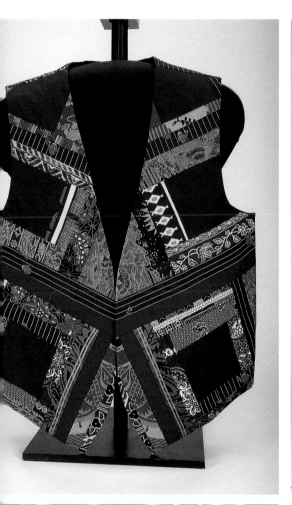

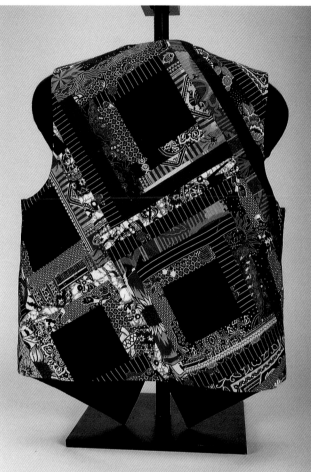

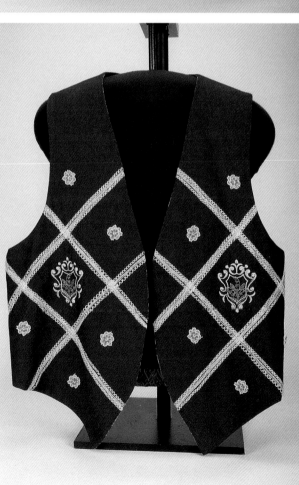

Top left: Patch-work in predominantly navy and red batiks and other prints and solids, reversible. *By Shirley Friedland*

Top right: Back view.

Bottom left: Detail.

Bottom right: Navy denim with machine embroidery on diagonal lines, small cotton string flowers painted and applied. *By Shirley Friedland*

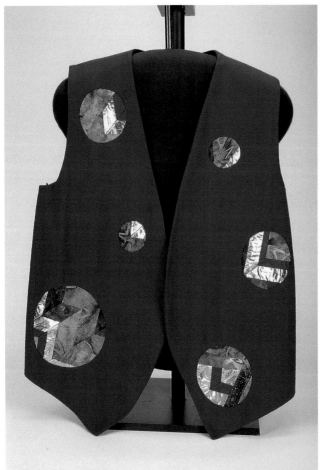

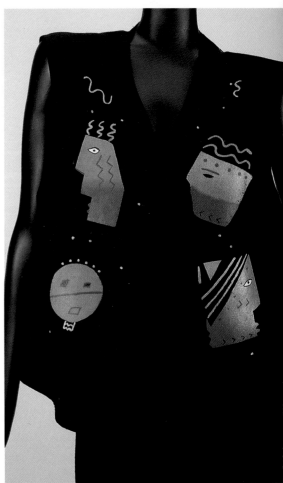

Top left: Heavy navy cotton with portholes displaying seminole patchwork of metallic and colorful fabrics. *By Shirley Friedland*

Bottom left: Detail.

Top right: Black with silk screened abstract faces by Sabrina Capune, Canada. *Courtesy Robin Herrington-Bowen*

Bottom right: Detail.

*84*

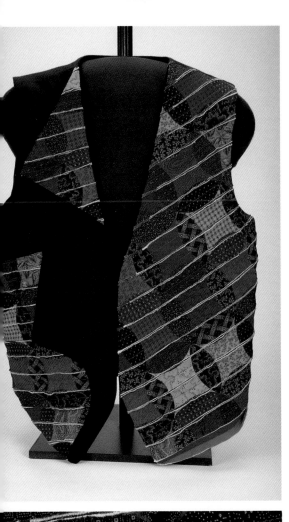

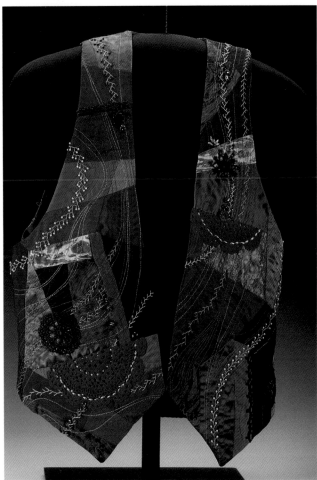

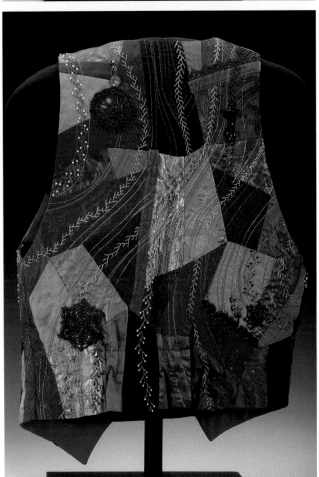

Top left: Five layers of stitched and spliced fabric, top layer on left side interrupted by abstract bound black sections. *By Shirley Friedland*

Top right: Patched satins and cottons, with applied ribbons, beads, silk crochet, and antique buttons. *By Judith Kessler Smith*

Bottom left: Detail.

Bottom right: Back view.

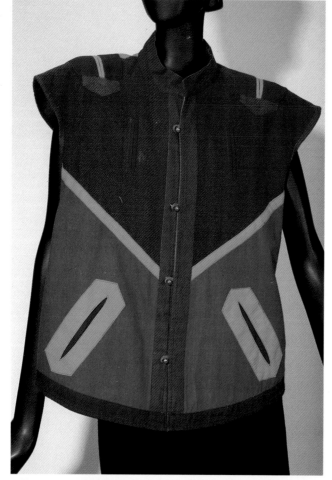

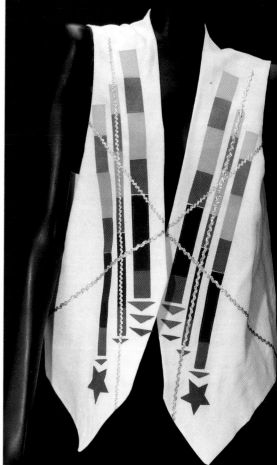

Top left: Multi-colored pieced reversible vest, commercially made, imported.

Top right: White linen with pieces of ultra-suede individually machine stitched and embellished with silver braid. *By Shirley Friedland, courtesy Lois Kates Arsham*

Bottom left: Back view of vivid cotton waffle-type fabrics pieced in abstract design. *By Shirley Friedland, courtesy Ruth Marcus*

Bottom right: Detail.

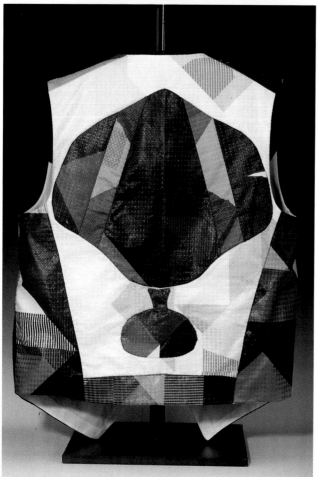

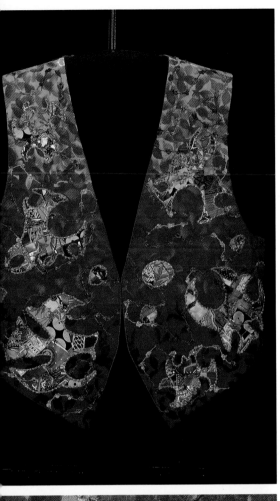

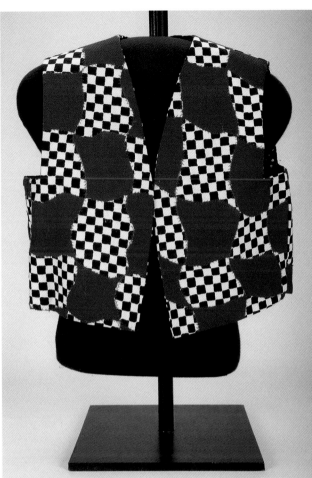

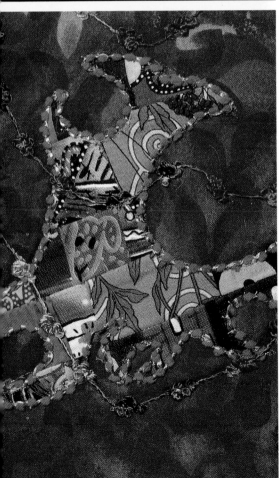

Top left: Machine pieced images, couched on cotton fabric, overlaid with decorative yarn. *By Lois Carroll*

Bottom left: Detail.

Top right: Strip woven cotton checker alternating with solid red. *By Carol Thorn*

Bottom right: Detail.

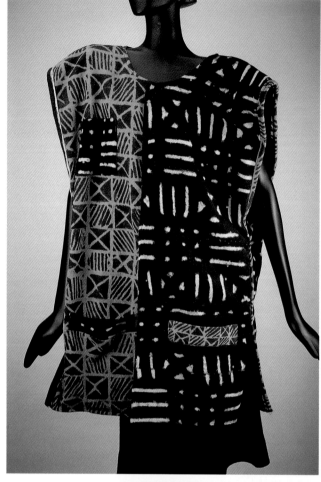

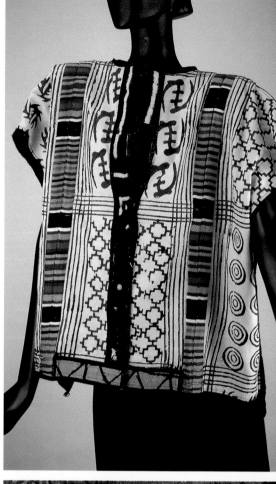

Top left: Mud cloth of black with white pattern, made in Mali in West Africa, combined with other African fabric. *By Jayanti Chuck*

Top right: Woven strips of kente cloth, made by the Ashanti, inserted in hand-painted black and natural tone fabric. *By Jayanti Chuck*

Bottom left: White fabric covered in areas with black filmy material, overlaid pattern of metallic threads. *By Jayanti Chuck*

Bottom right: Detail.

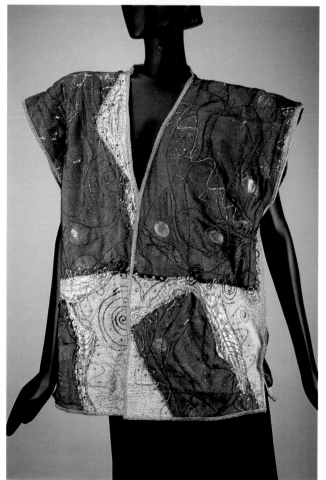

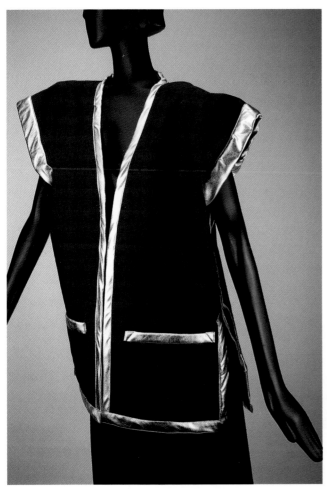

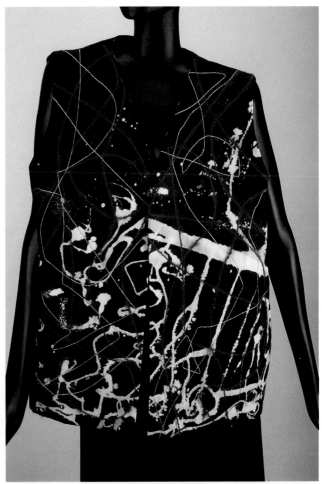

Top left: Maroon and black polyester trimmed in silver metallic fabric. *By Jayanti Chuck*

Top right: Bleached abstract pattern in black and white, couched in silver and red threads. *By Shirley Friedland*

Right: Cream colored polyester decorated with silks from Japanese obis. *By Jayanti Chuck*

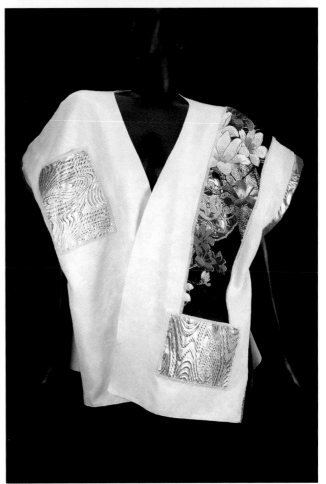

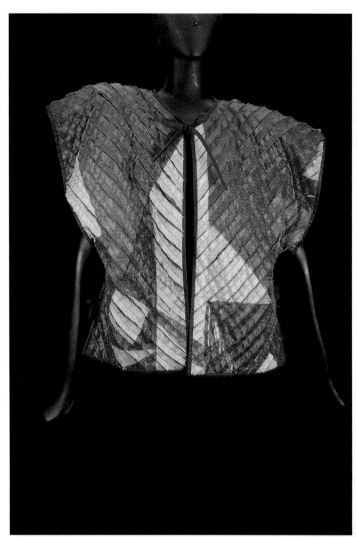

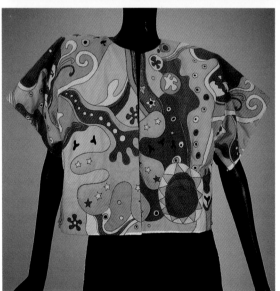
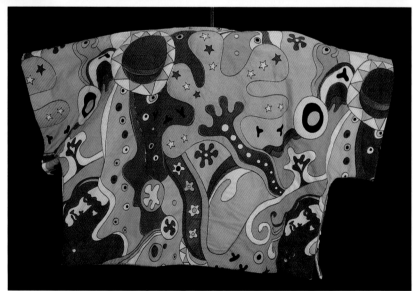

Top left: Top layer of Jab fabric with textured weave, with five additional layers, spliced and hand bound. *By Shirley Friedland*

Top right: Detail.

Bottom left: Pucci or Peter Max style print, three layers, stitched and puffed with trapunto technique. *By Shirley Friedland*

Bottom right: Back view.

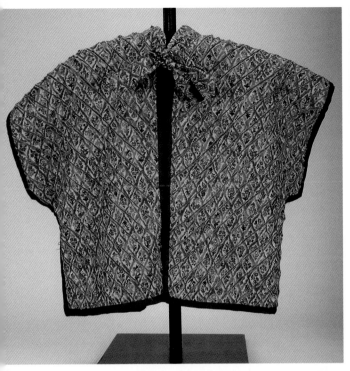
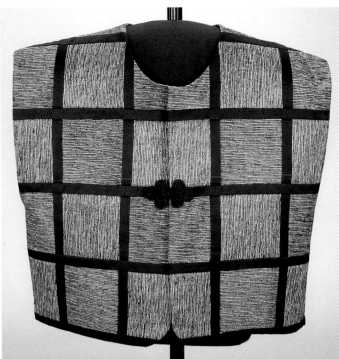

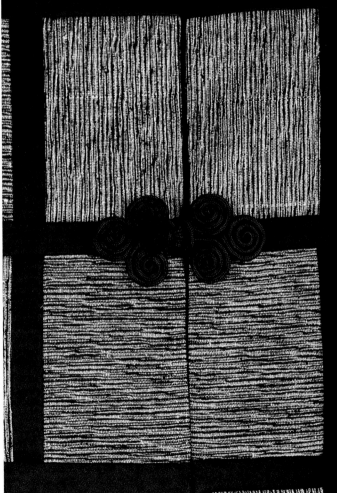

Top left: Multi-layered stitched and spliced, top layer in blues with metallic gold accents. *By Shirley Friedland*

Bottom left: Detail.

Top right: Patched metallic fabric with applied black grid of matka silk satin, black frog closures. *Sharon Ramsay*

Bottom right: Detail.

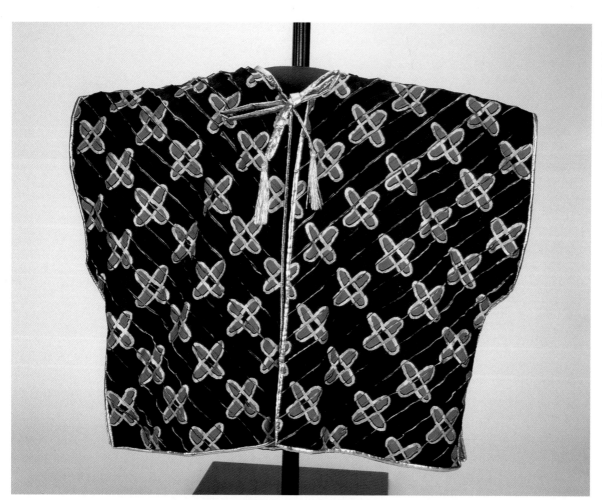

African fabric design for top layer, with multiple layers stitched and spliced, and bound in metallic fabric. *By Shirley Friedland*

Detail.

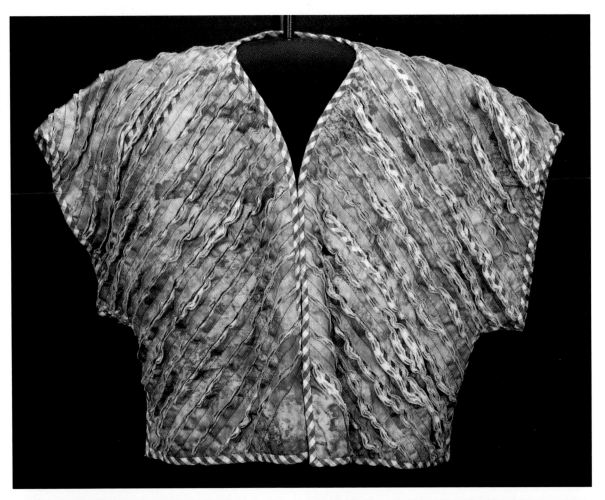

Multi-layered stitched and spliced, top layer in faux marble print, all bound in gingham. *By Shirley Friedland, courtesy Miriam Glazer*

Detail.

Strip pieced patches of black, red, yellow, and white prints and solids, reversible. *By Shirley Friedland, courtesy Shirley Bernon*

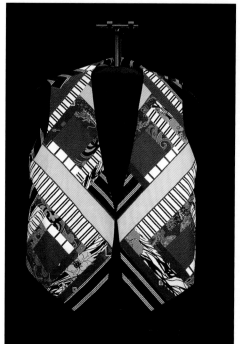

Back view.

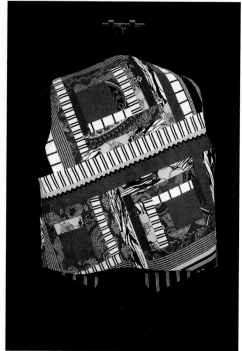

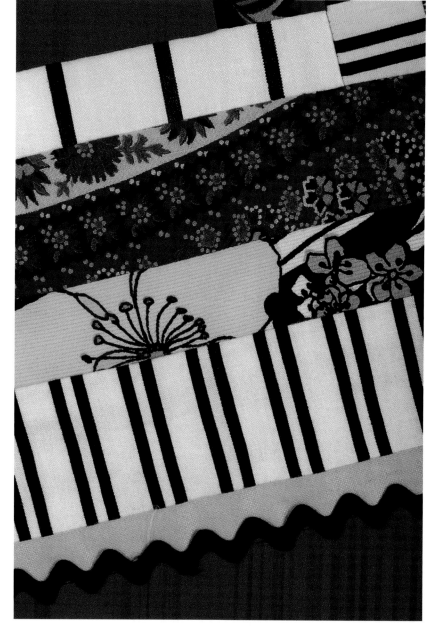

Detail.

94

Strip pieced patches of multi-color prints, reversible. *By Shirley Friedland*

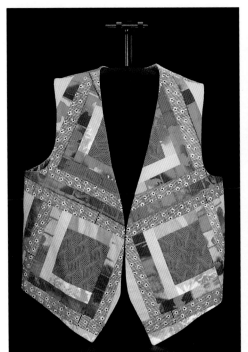

Back view.

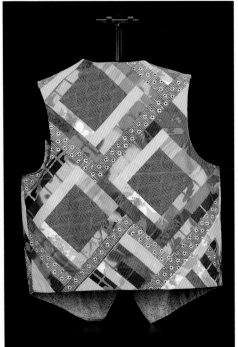

Detail.

95

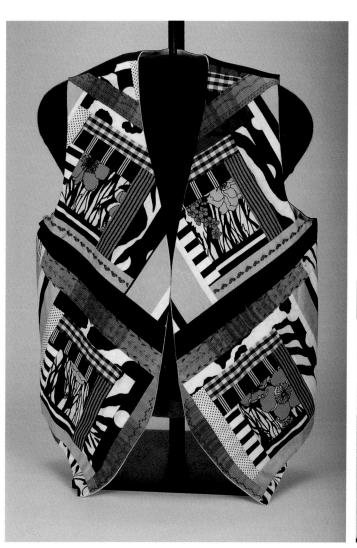

Strip pieced patches of black and white prints with orange strips and decorative stitching, reversible. *By Shirley Friedland*

Detail.

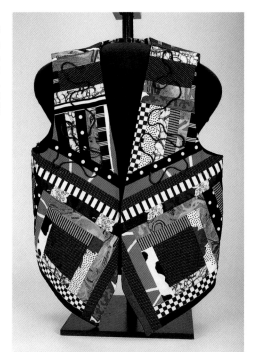

trip pieced patches of stripes, polka dots, and prints, couched with satin cording, reversible. *By Shirley Friedland*

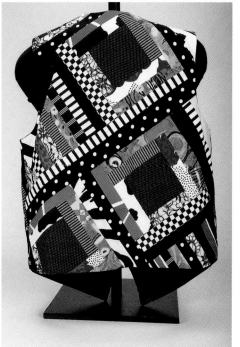

Back view.

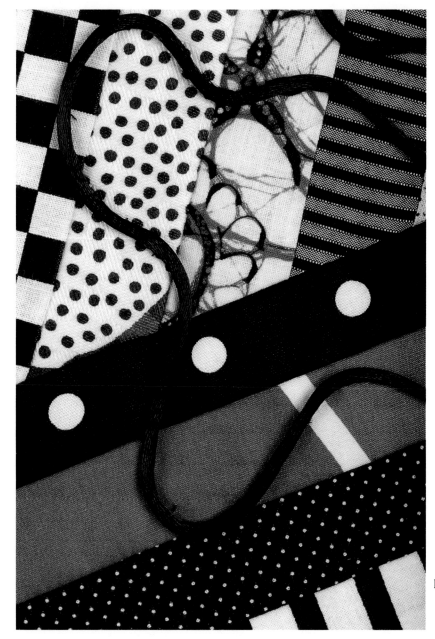

Detail.

97

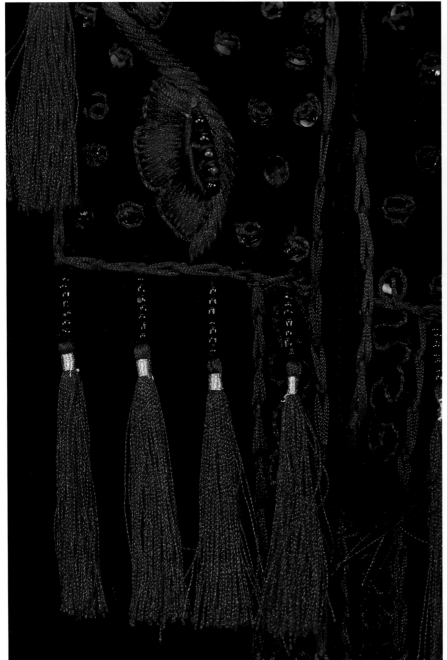

Detail.

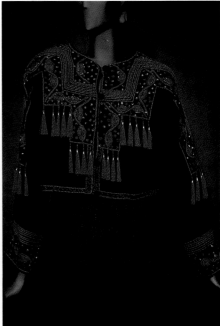

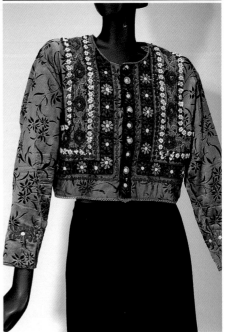

Top: Short black velvet jacket with red silk tassels, embroidery, and beading, 1990.
*Courtesy Anna Greenfield*

Bottom: Short jacket of green silk, heavily embroidered and beaded in floral patterns.
*Courtesy Zsuzsa Csepanyi Bawab*

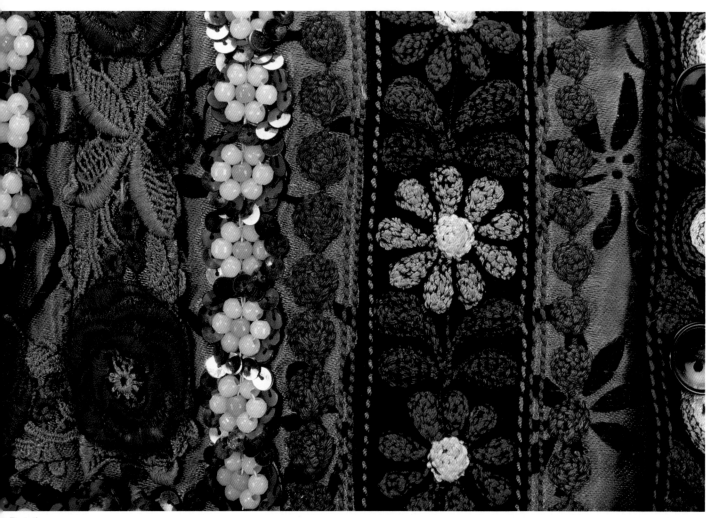

Detail.

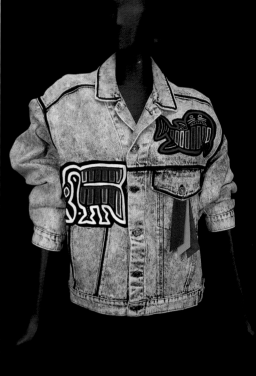

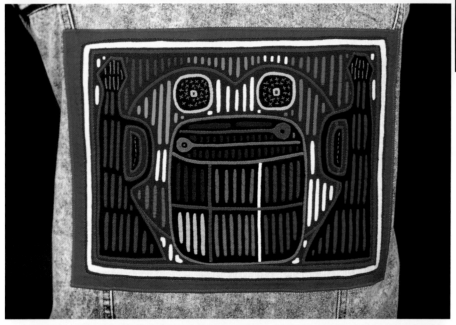

Top left: Detail.

Top right: Washed denim jacket, trimmed with portions of Molas made by the Cuna Indians in the San Blas Islands. *By Sharon Ramsay*

Center left: Detail of Mola on back.

Bottom left: Detail.

Top left: Mexican wool felt jacket, appliquéd and embroidered white traditional motifs, c.1950s. *Courtesy Lynn Benade*

Top right: Yellow silk Chinese jacket, embroidered with traditional motifs, black silk frog closures, 1982.

Bottom left: Back view.

Bottom right: Blue satin Chinese jacket, with embroidered flowers, frog closures, c.1950s. *Courtesy Ursuline College Historic Costume Study Collection*

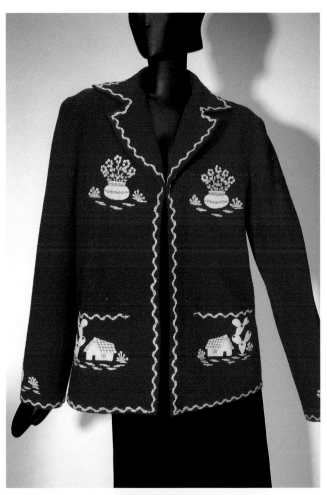

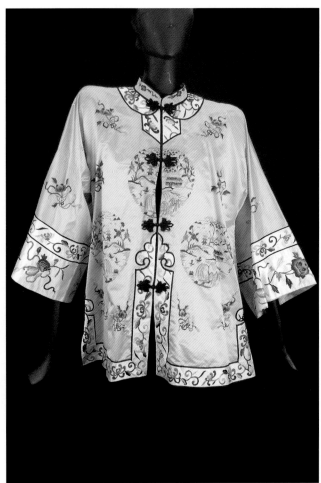

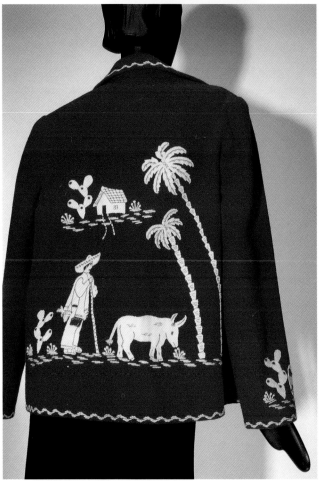

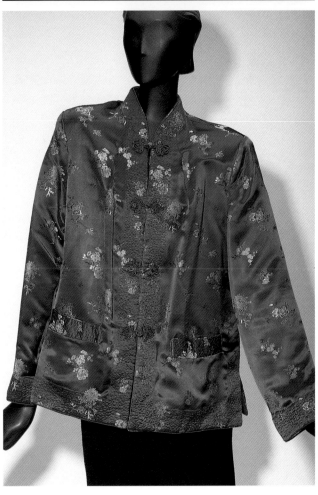

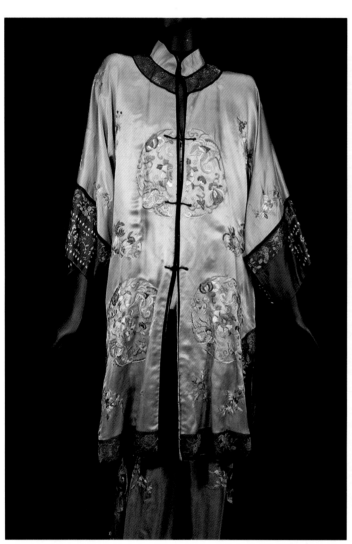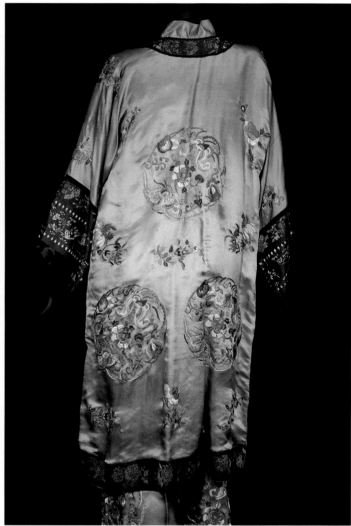

Light green Chinese silk robe, with elaborate embroidery borders and decoration, with matching pajama pants, c.1920s. *Courtesy Anna Greenfield*

Back view.

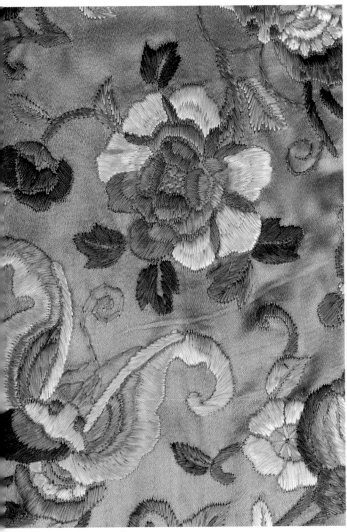

Detail.

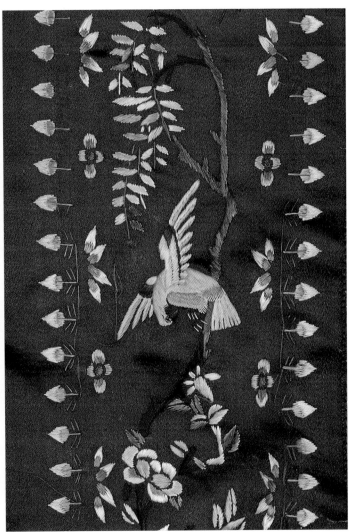

Detail.

Purple silk Chinese robe with flamboyant silver bird, clouds, and mythological creatures embroidered on front and back, c.1940s. *Courtesy Marilyn Bennett*

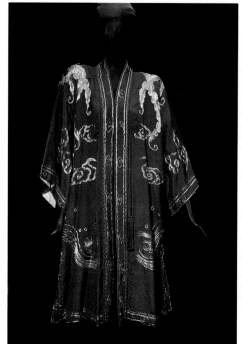

Back view.

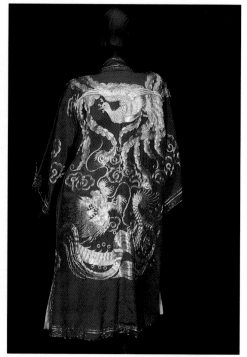

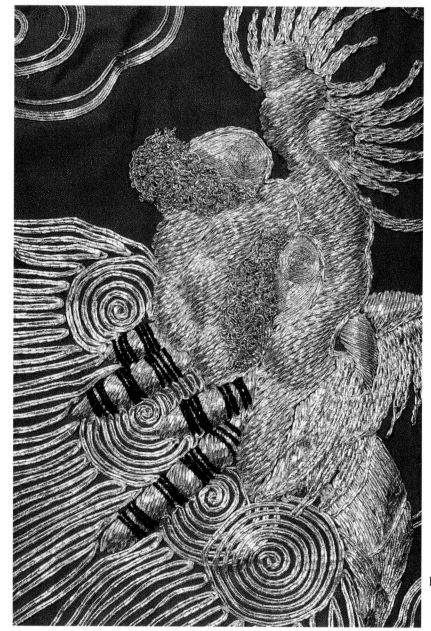

Detail.

104

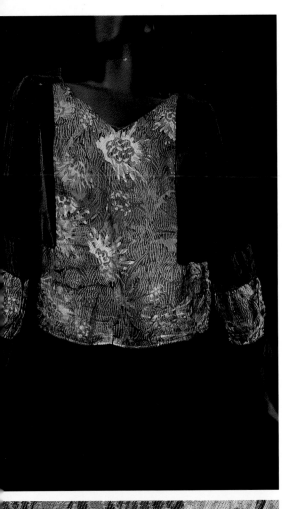

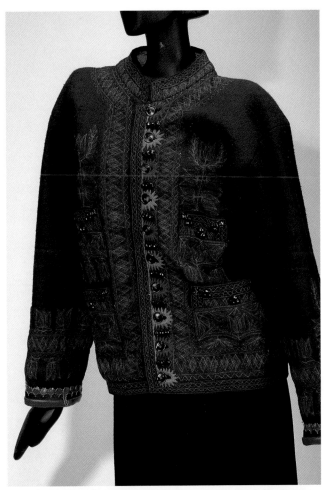

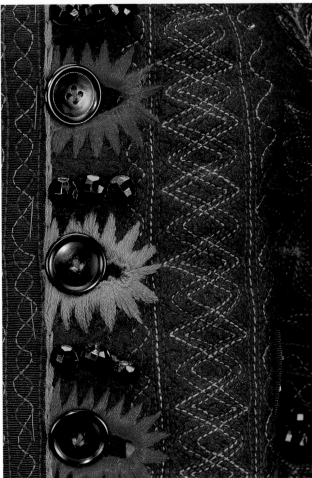

Top left: Brown
silk velvet blouse
with brocade front
and cuffs.
*Courtesy Anna
Greenfield*

Top right: Wool
jacket with
embroidered
flower buttonhole
and embellished
with multiple top
stitching. *Courtesy
Zsuzsa Csepanyi
Bawab*

Bottom left: Detail.

Bottom right:
Detail.

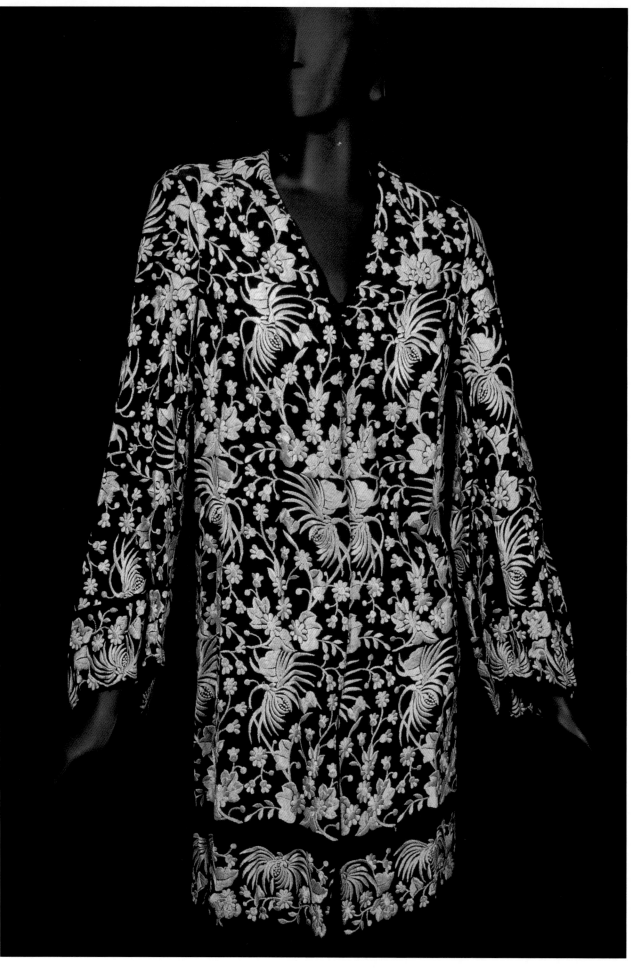

Black crepe coat, heavily embroidered with gold silk
threads, c.1930s. *Courtesy Anna Greenfield*

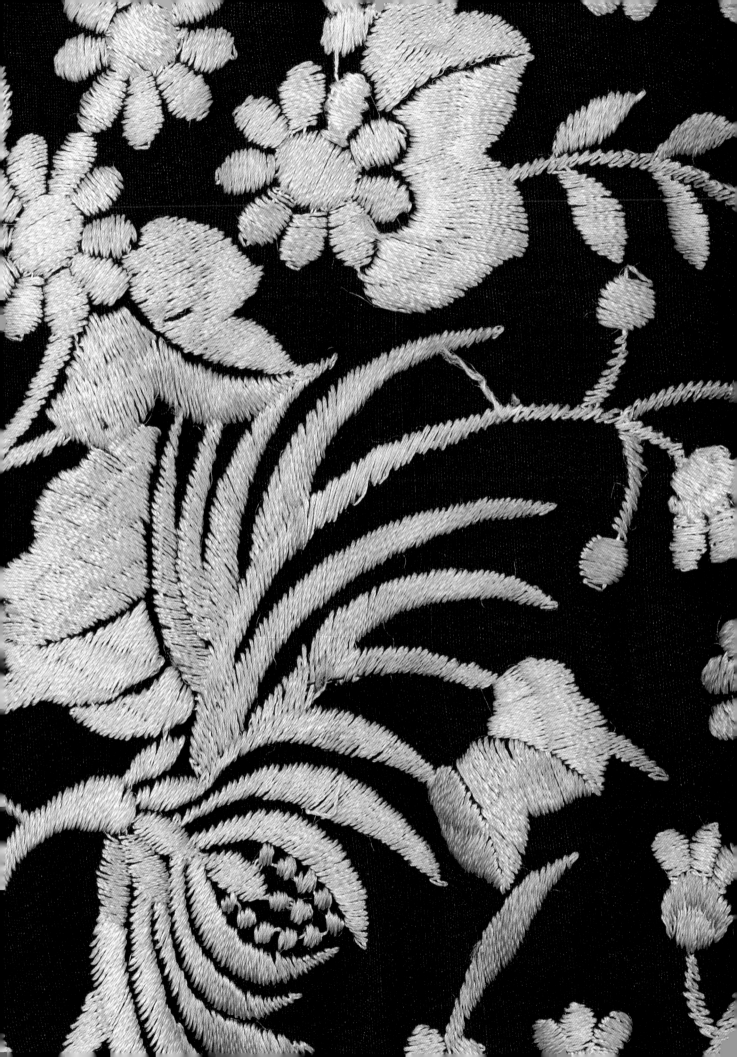

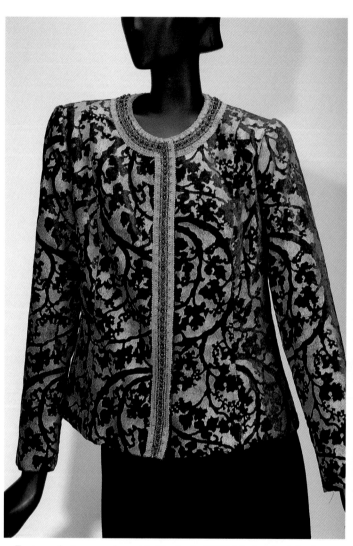

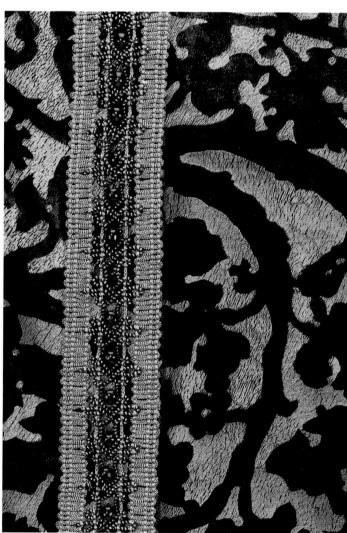

Fortuny design, purchased in Venice in 1989: black velvet shadow dyed in rust brown, hand embossed with gold. *Courtesy Phyllis Seltzer*

Detail.

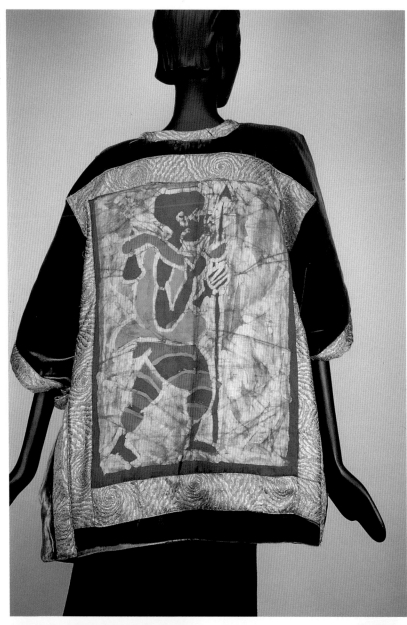

Olive green velvet jacket trimmed in greenish-gold lamé, with West African batik panel on back. *By Jayanti Chuck*

Blue rayon Chinese robe with multi-color dragon embroidery, back view, 1982.

Fabric of large red roses with muted checkerboard pattern, couched in gold threads. *By Shirley Friedland*

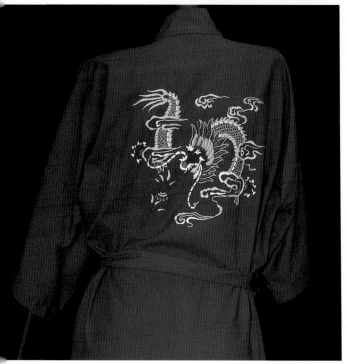

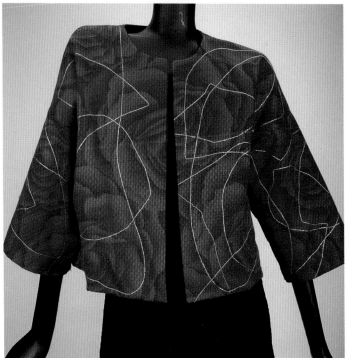

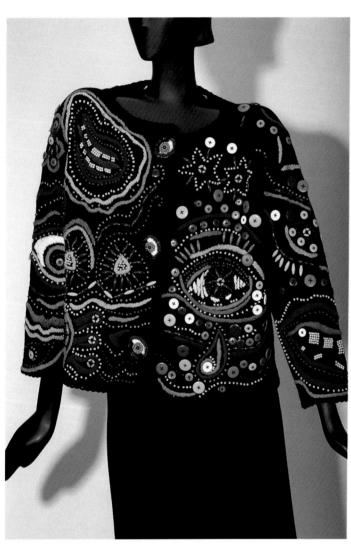

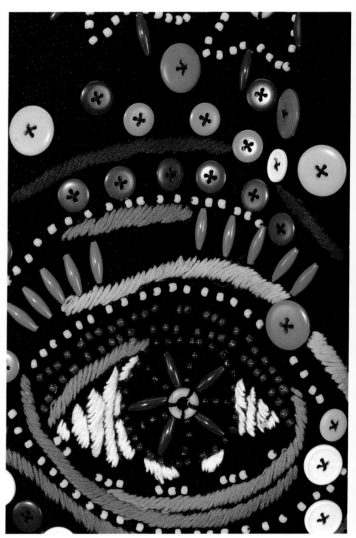

Black knit, completely embellished with colorful embroidery, buttons, and beads, 1980s. *Courtesy Arlene Schreiber*

Detail.

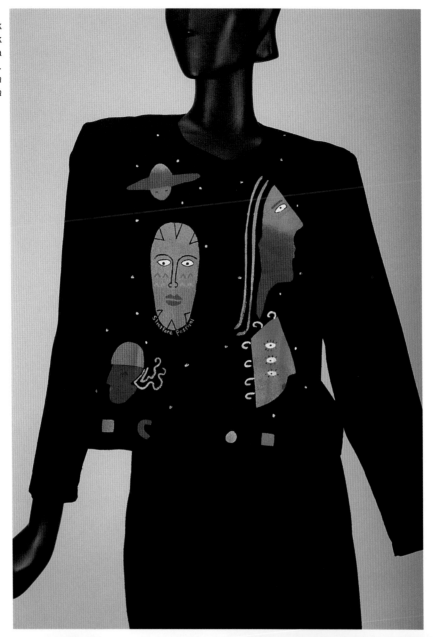

"The Audience," black jacket, decorated with silk screened faces, by Sabrina Capune, Canada.
*Courtesy Robin Herrington-Bowen*

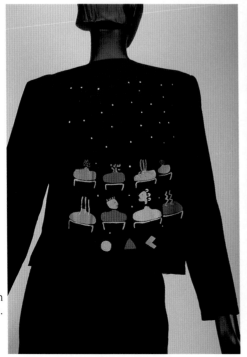

Back view with curtain down.

Detail with curtain up.

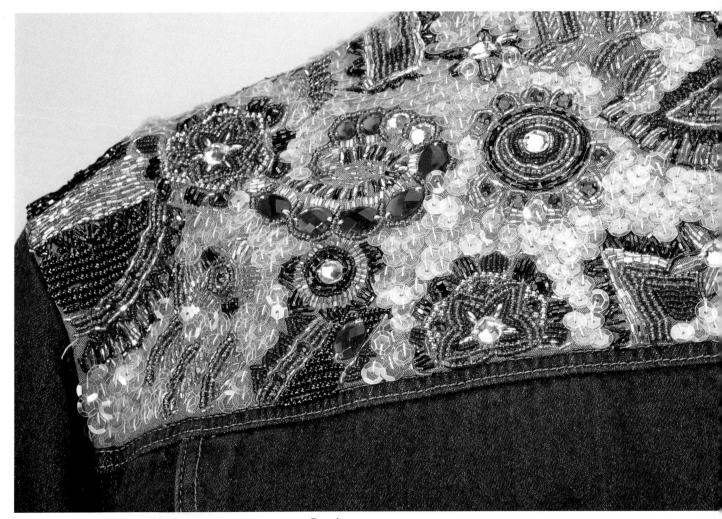

Detail.

Blue jean jacket with shoulders encrusted with sequins, beads, and glass stones; label I.B. DIFFUSION. *Courtesy Arlene Schreiber*

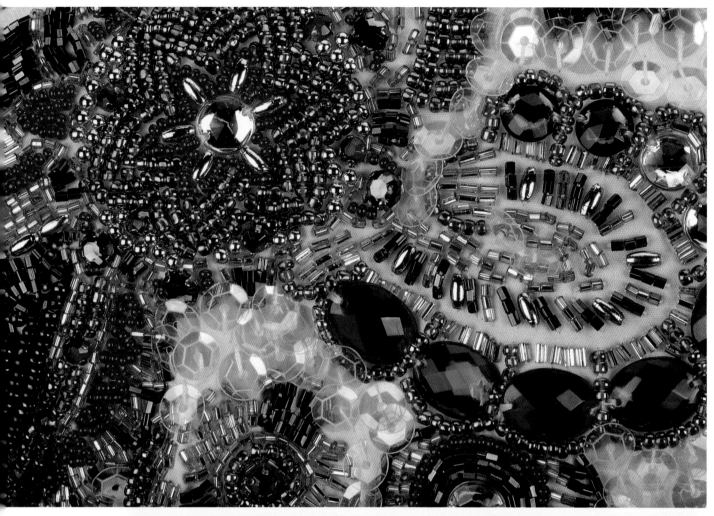

Top: Detail.

Bottom left: White jean jacket with sequins, beads, and glass stones; label I.B. DIFFUSION.

Bottom right: Back view.

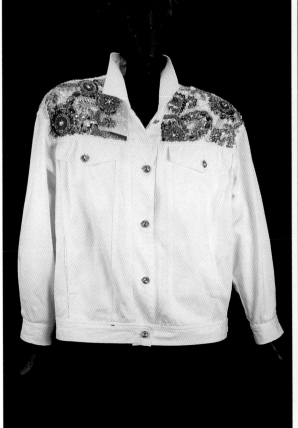

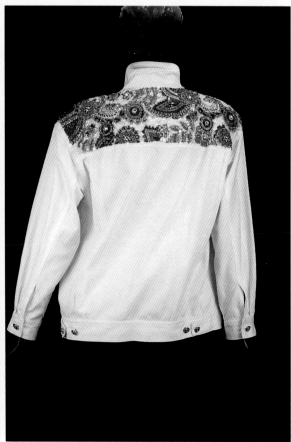

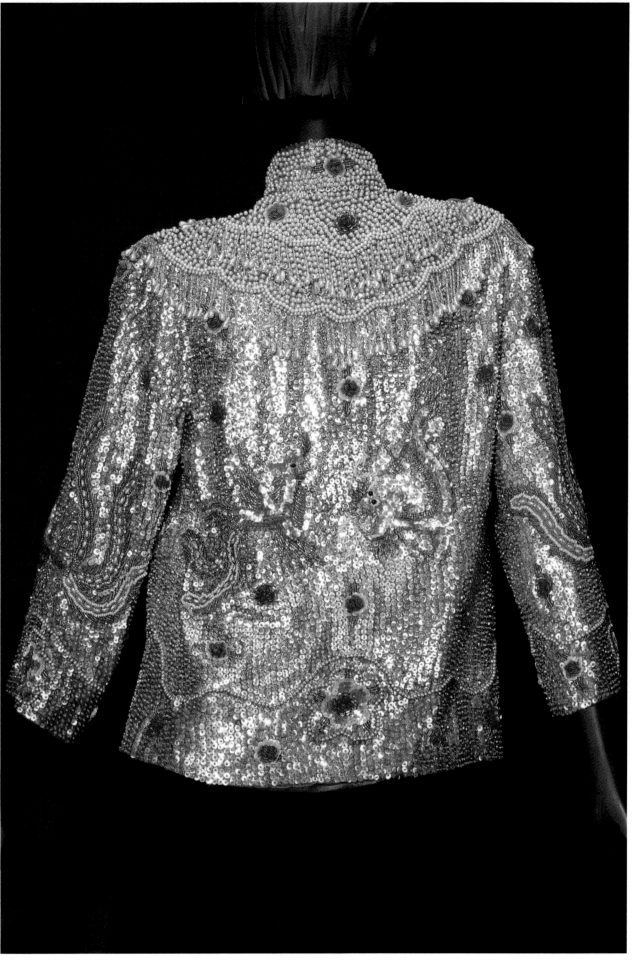

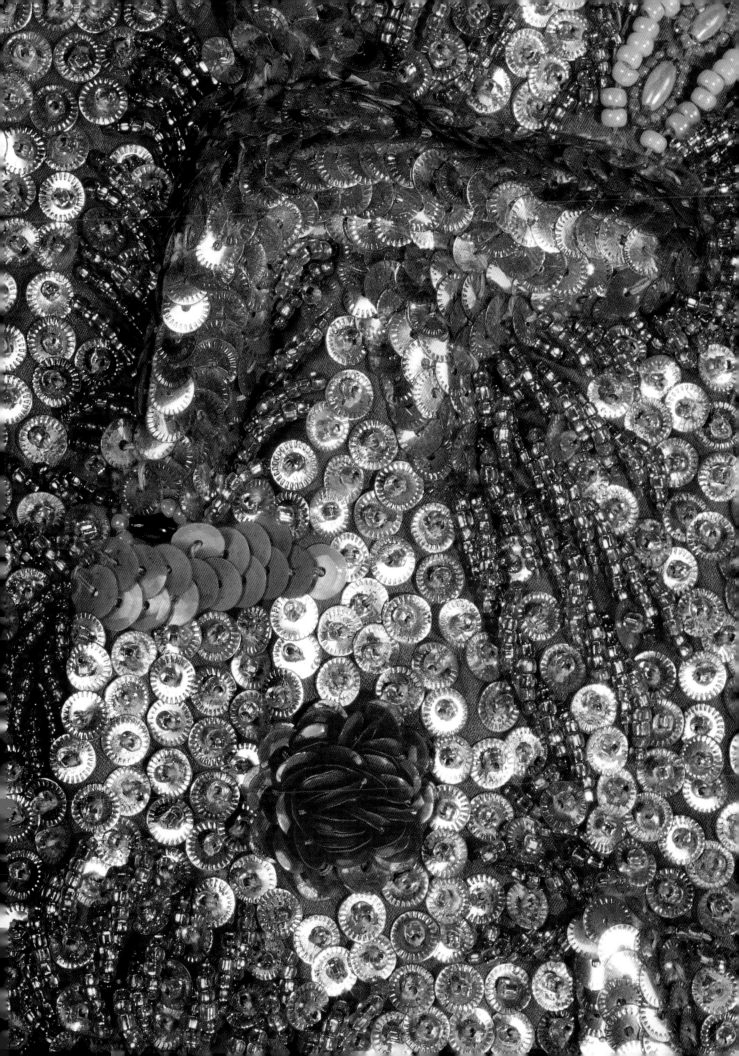

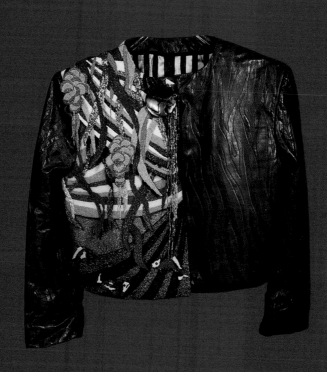

Navy blue leather jacket, one side completely beaded in multicolor
abstract pattern, 1989. *By Donna Wasserstrom*

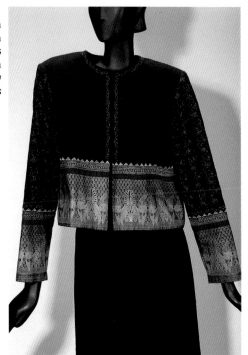

Black jacket with exotic batik design stitched on sleeves and bottom with metallic threads. *By instructors at Pins and Needles.*

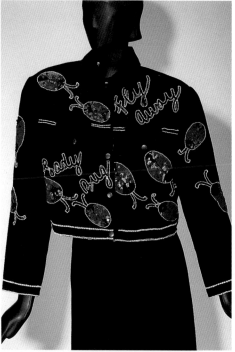

Black jacket decorated with ladybugs of red and black sequins and white beads, 1990s; label Modi. *Courtesy Marilyn Ruckman*

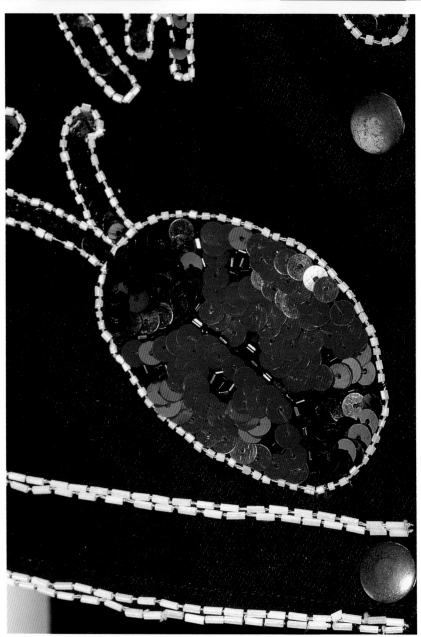

Detail.

Detail.

Vibrantly colored patches applied in abstract pattern, with black and white checkerboard fabric, down-filled, 1989; label Gallery. *Courtesy Lorita Winfield*

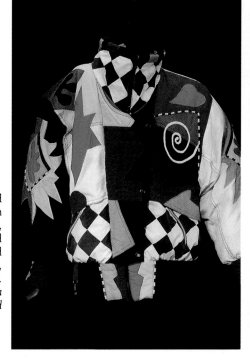

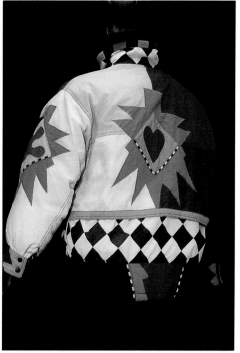

Back view.

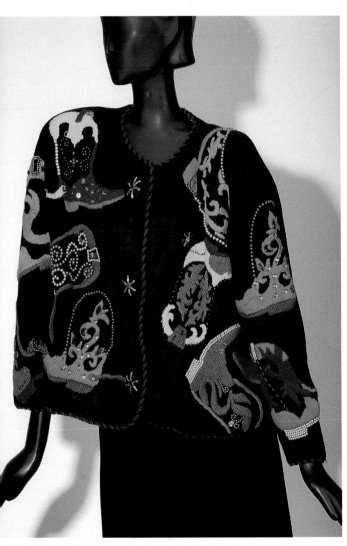

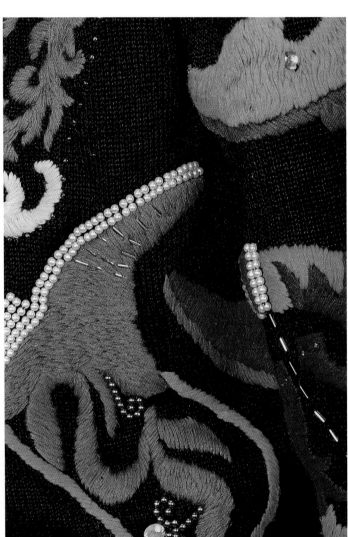

Black knit jacket covered with colorful embroidered cowboy boots, with pearls, glass beads, and stones, 1990s. *Courtesy Arlene Schreiber*

Detail.

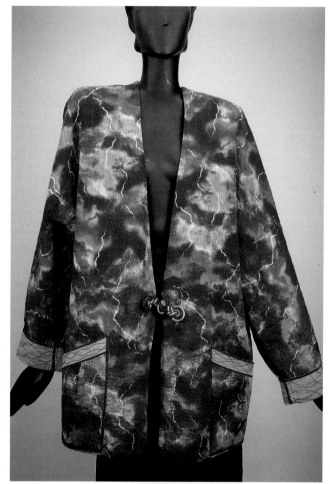

Top left: Random stitched jacket, using twin needle technique on three layers of cotton fabric, followed by machine washing and drying, hand made frog closure. *By Becky Olencki*

Top right: Detail.

Bottom left: Patches of multicultural fabrics, lined and bound in navy and white Indonesian print, 1976. *By Shirley Friedland*

Bottom right: Back view.

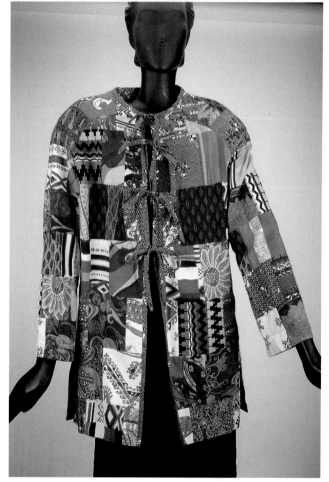

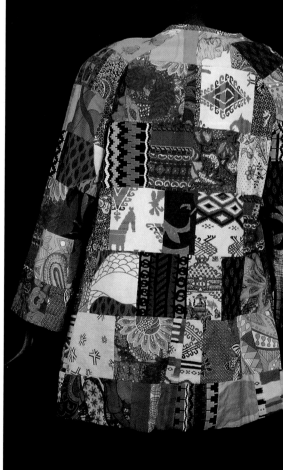

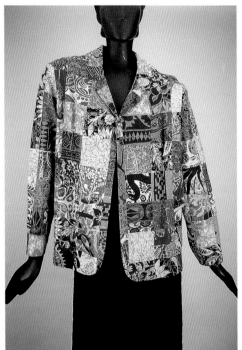

Patchwork blazer of Indonesian or Indonesian-style batiks, fabric purchased in Mexico in 1973. *By Shirley Friedland*

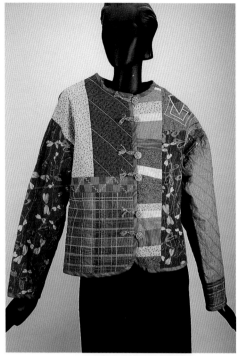

Jacket using color block technique, couching with embroidery floss, free motion quilting, with braided floss closures on coordinated buttons. *By Debra Beadles Youngs*

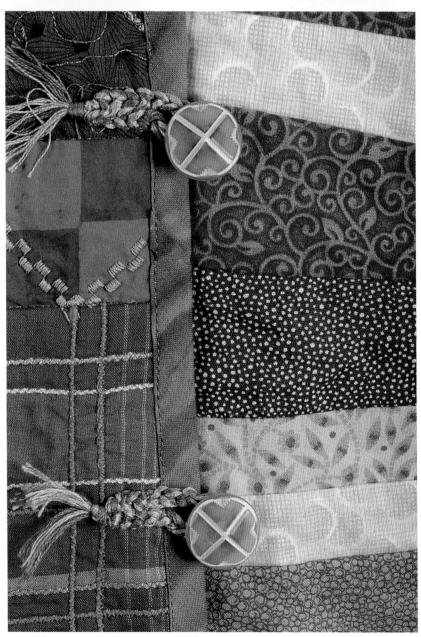

Detail.

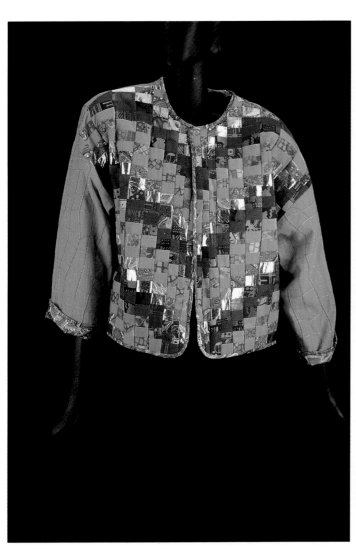

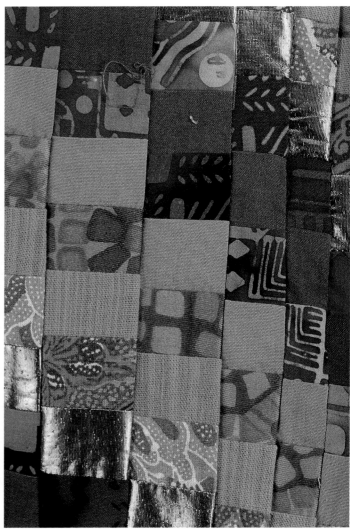

Bargello patchwork jacket of cotton and metallic fabric, with twin needle stitching on sleeves and back. *By Shirley Friedland, courtesy Ruth Marcus*

Detail.

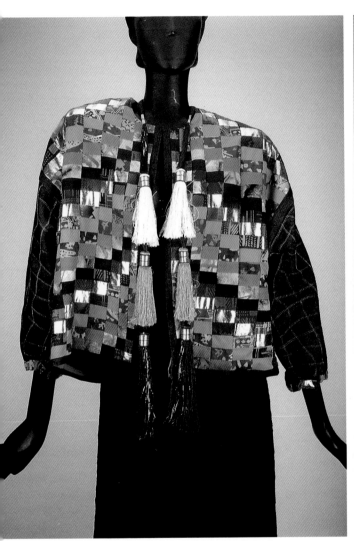

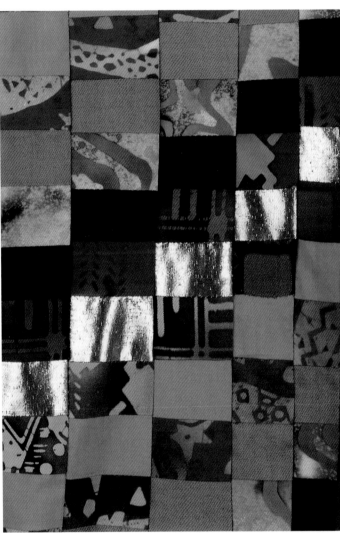

Front of jacket: bargello patchwork of cotton and metallic fabric, denim back and sleeves with twin needle stitching, tassels down front. *By Shirley Friedland*

Detail.

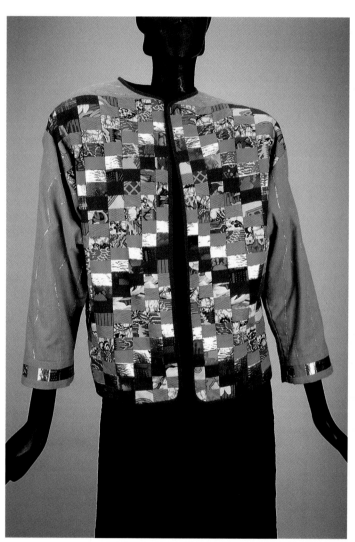

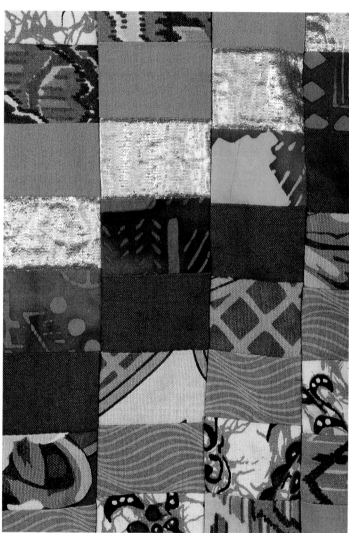

Front of jacket: bargello patchwork of cotton and metallic fabric, back and sleeves of blue chambray with silver thread couching. *By Shirley Friedland*

Detail.

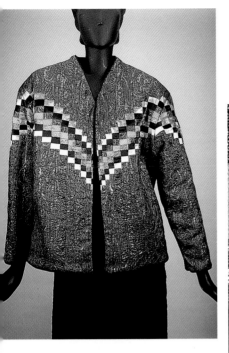

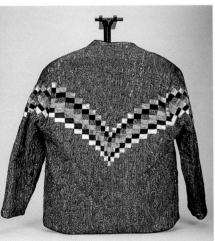

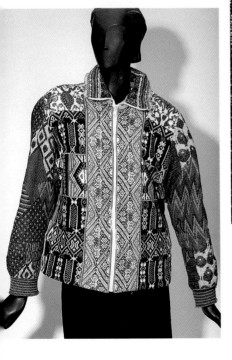

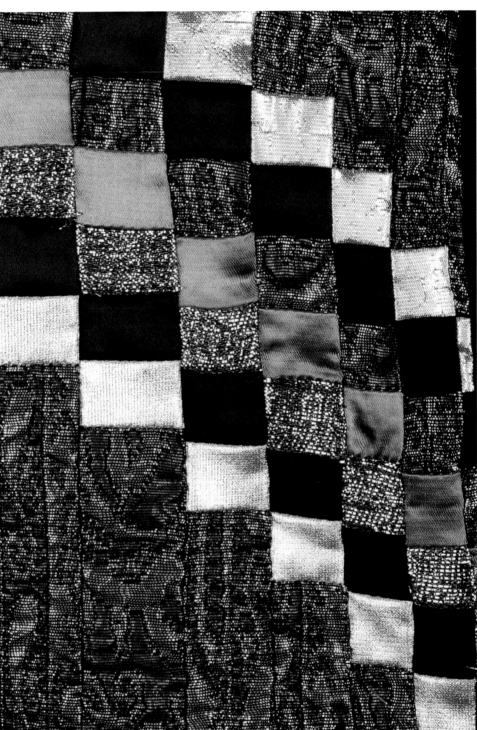

Top left: Metallic and brocade fabric with inserts of bargello patchwork across front and sleeves. *By Carol Thorn*

Center left: Back view.

Bottom left: Winter jacket covered with pieced fabric of geometrics patterns. *By Shirley Friedland*

Above: Detail.

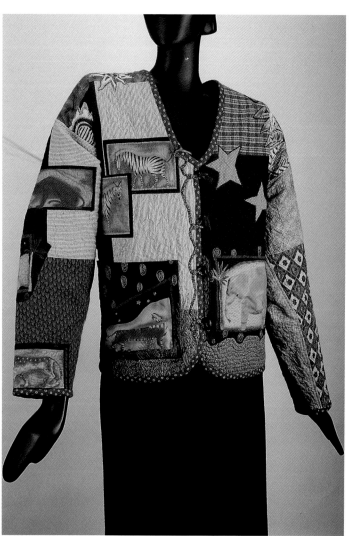

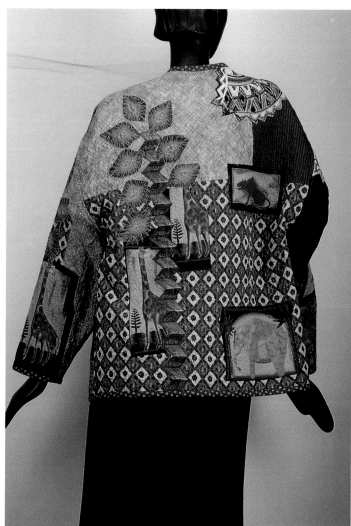

Safari jacket with texture created by quilting fabric to muslin and then shrinking, decorated with edge-stitched appliqués and patches of animal print fabrics. *By Debra Beadles Youngs*

Back view.

Opposite page: Detail.

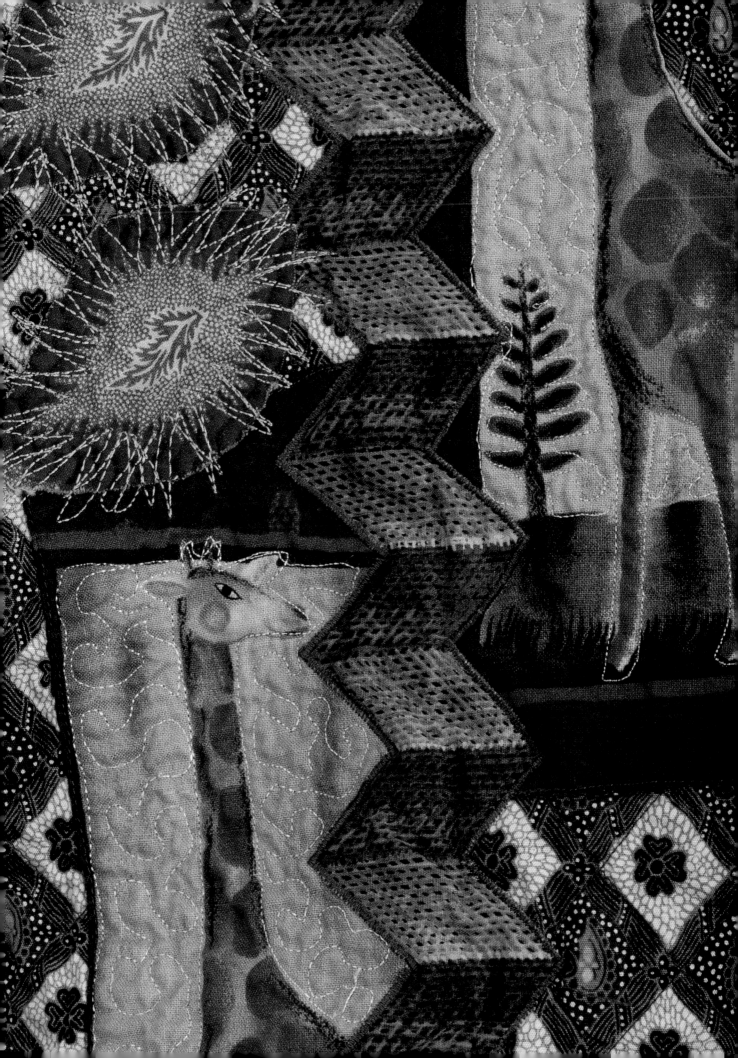

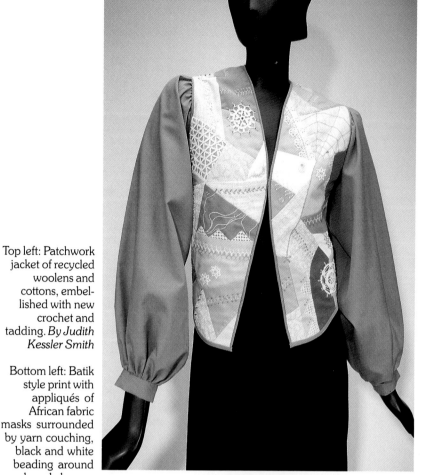

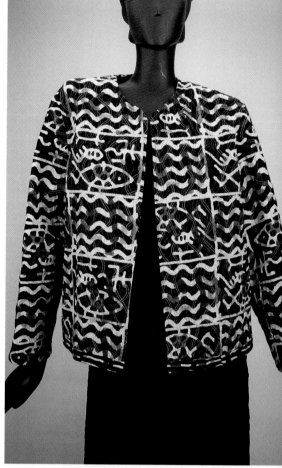

Top left: Patchwork jacket of recycled woolens and cottons, embellished with new crochet and tadding. *By Judith Kessler Smith*

Bottom left: Batik style print with appliqués of African fabric masks surrounded by yarn couching, black and white beading around neck and sleeves, bias cut binding. *By Shirley Friedland*

Top right: Jacket of bold contrast print over multiple layers of fabric with random top stitching. *By Carol Thorn*

Bottom right: Detail of top right photo.

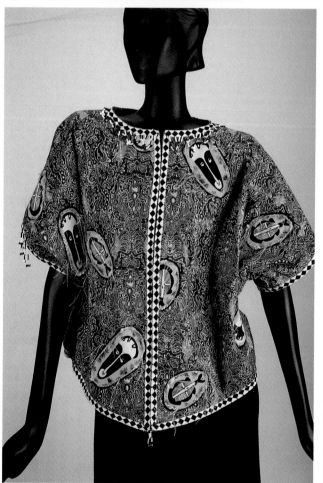

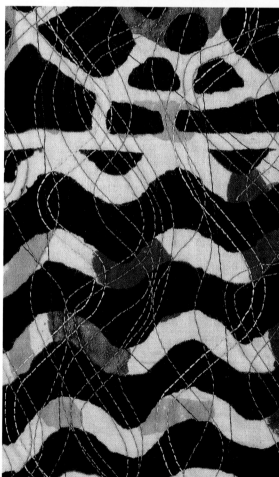

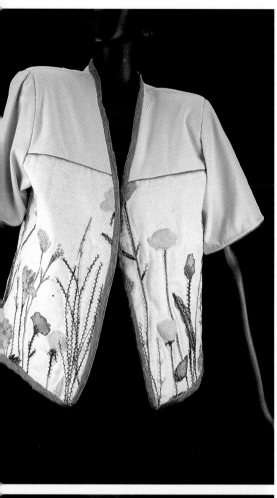

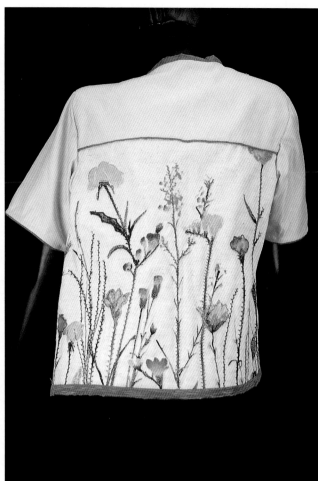

Top left: Machine trapunto flowers and leaves, with embroidery thread stitching. *By Beverlee Hileman*

Top right: Back view.

Bottom left: White jacket with hand-painted dinosaur scene, by Chris Klassen. *Courtesy Robin Herrington-Bowen*

Bottom right: Back view.

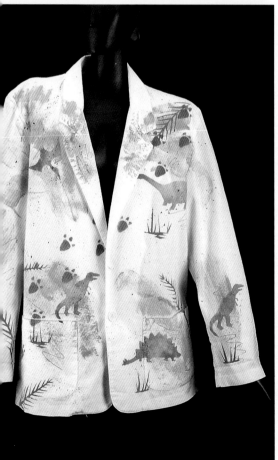

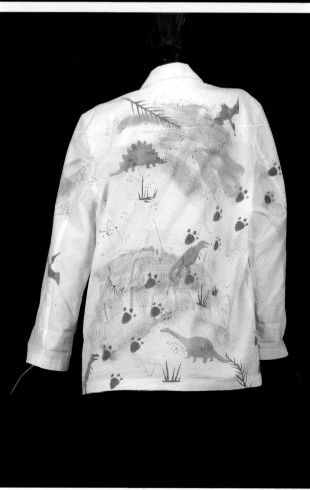

*129*

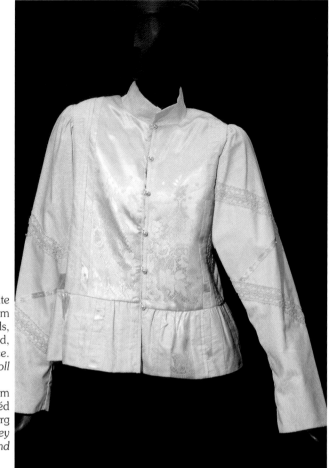

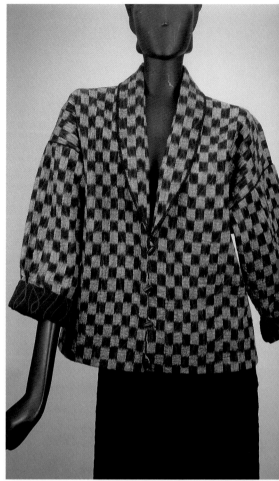

Top left: White jacket with peplum front, satin panels, machine pieced, with antique lace. *By Lois Carroll*

Bottom left: Denim jacket appliquéd with Battenberg lace. *By Shirley Friedland*

Top right: Guatemalan cotton jacket, random stitching in contrasting colors on three layers of fabric. *By Sharon Ramsay*

Bottom right: Detail of top right photo.

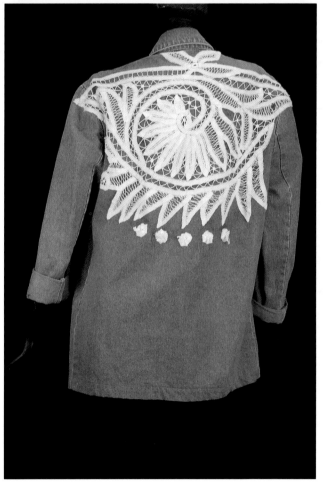

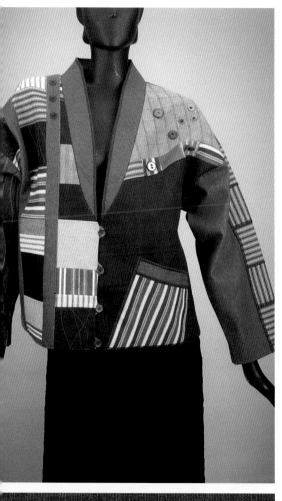

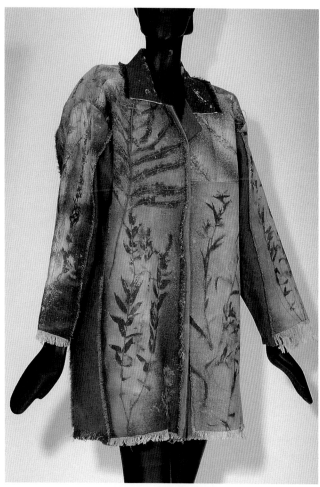

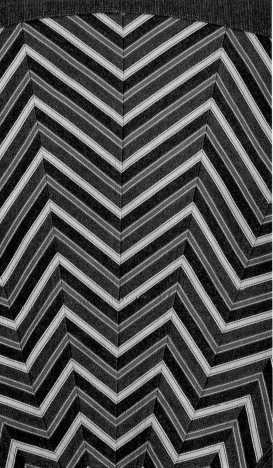

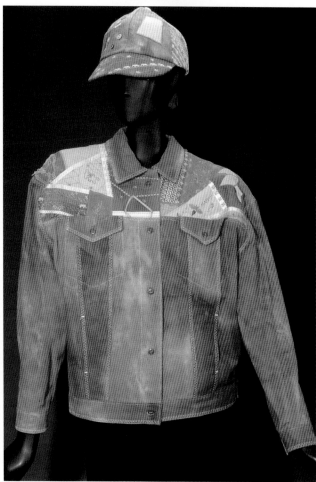

Top left: Pieced denim jacket in asymmetrical arrangement, using serge and sew techniques, decorated with random buttons, variation of a Judy Murrah design. *By Sharon Ramsay*

Top right: Blue denim jacket with plant motifs in shadow dyed bleach stencil technique. *By Beverlee Hileman*

Bottom left: Detail of back showing 90-degree angle chevron piecing technique.

Bottom right: Pink tie-die denim jacket and cap, with top stitching, trapunto, patch-work, three-dimensional appliqué, trimmed with ultra-suede and ribbons. *By instructors of Pins and Needles*

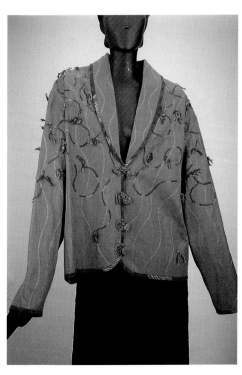

Blue linen jacket with single and twin needle random stitching, couching over lengths of a multi-colored cotton chenille yarn, tufts, covered buttons, crocheted button loops, and contrasting binding. *By Becky Olencki*

Detail.

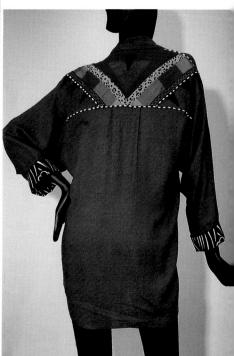

Back view of teal woven rayon jacket with strip quilting on yoke, by Chris Klassen. *Courtesy Robin Herrington-Bowen*

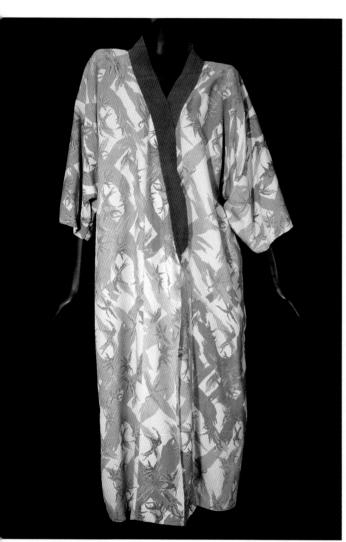

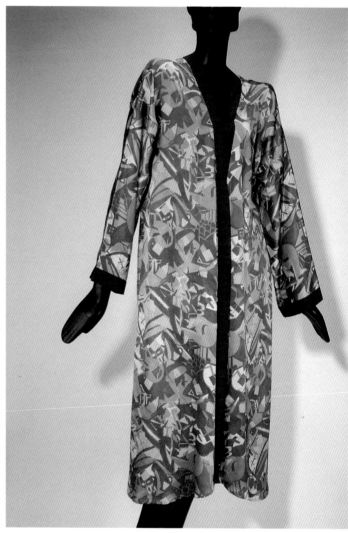

Silk broadcloth kimono, silk screened with aqua set pigment. *By Lynn Landy Benade*

"Futuristic Robe," hand silk screened on silk charmeuse, using three screens and fabric treated with fiber reactive dyes. *By Lynn Landy Benade*

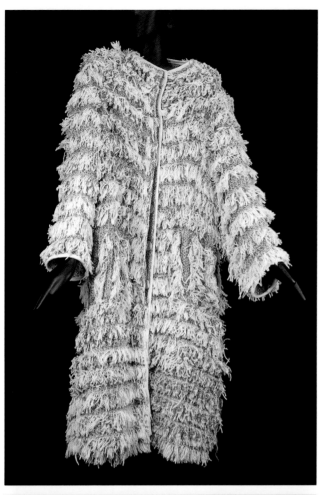
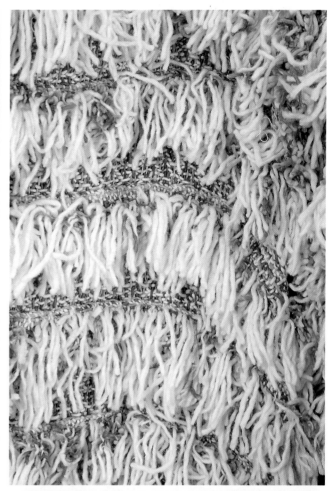
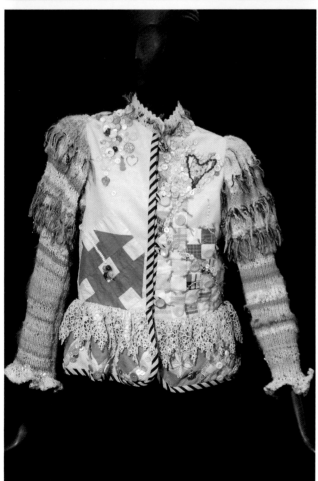
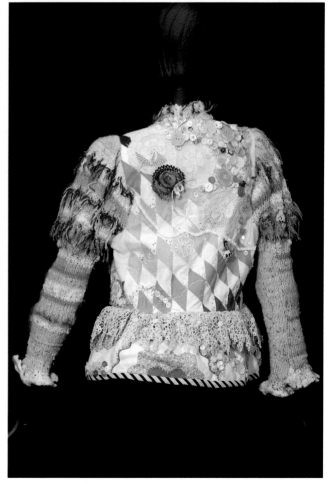

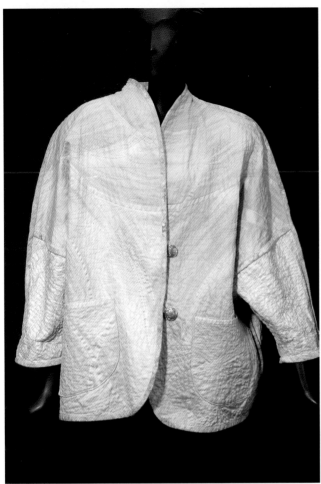

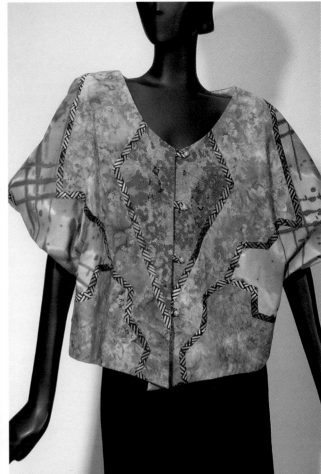

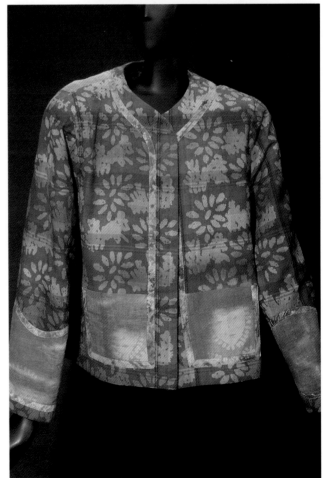

Top left: Oversized cotton jacket using free motion machine quilting with metallic thread, self bound. *By Lois Carroll*

Top right: Short jacket with caped sleeves, collage of batik fabric with bias binding separating the color blocks, antique blue buttons. *By Lois Carroll*

Right: Machine pieced commercial batik with bias binding in contrasting fabric. *By Lois Carroll*

Opposite page:
Top left: "Mink muslin," rows of cotton string creating a fur effect on multicolor cotton string knitted coat; label, Paula Sweet.

Top right: Detail.

Bottom left: "Monday Go to Sewing Circle," cotton pieced jacket with hand knitted sleeves, antique quilt blocks, lace, buttons, and found objects. *By Lois Carroll and Clare Murray*

Bottom right: Back view.

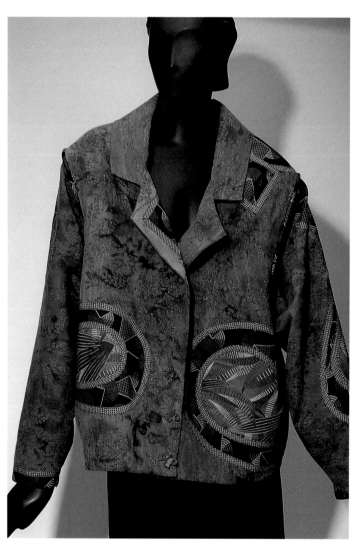 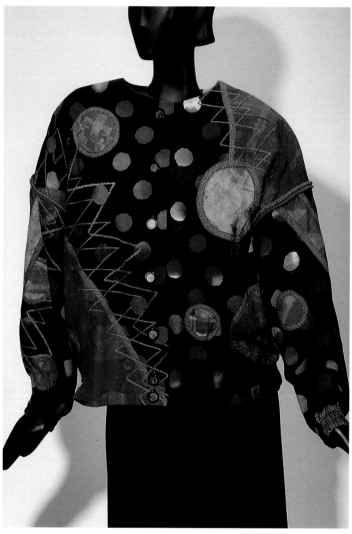

Blue commercial batik jacket with machine pieced African fabrics, with vintage Bakelite buttons. *By Lois Carroll*

"Running Around in Circles," black jacket with colorful dots, mirrored by machine pieced hand-dyed batik appliqués, with zigzag top stitching. *By Lois Carroll*

Opposite page:
Detail.

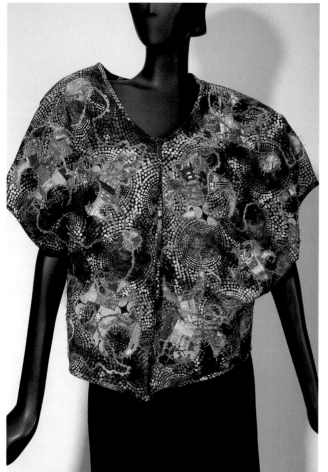

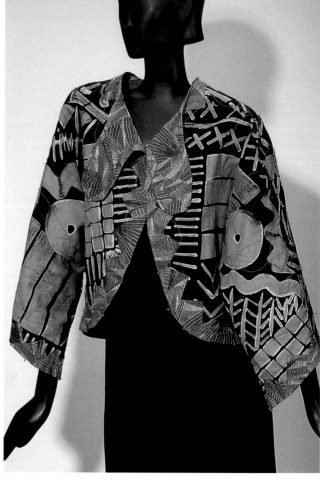

Top left: Short jacket, short sleeves, machine pieced images couched with fancy yarns. *By Lois Carroll*

Top right: Black and tan cotton African prints, with free machine quilting, triangular pieces for edging. *By Lois Carroll*

Left: Detail.

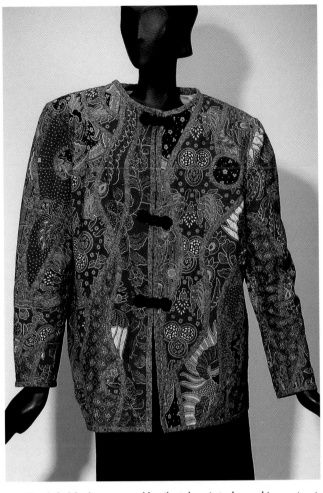

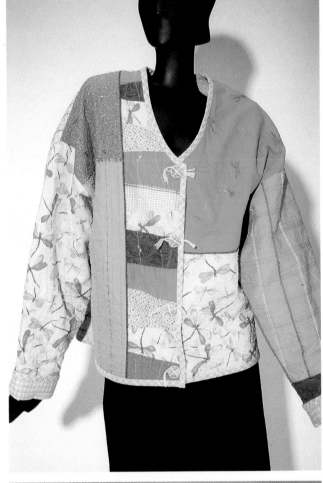

Top left: Machine pieced batik style prints, bound in contrasting color, with black frog closures. *By Lois Carroll*

Top right: "Dragonflies," cotton and linen pieced jacket, with free motion stippling, random stitching, decorative machine stitching, free motion embroidery of dragonflies. *By Becky Olencki*

Right: Detail.

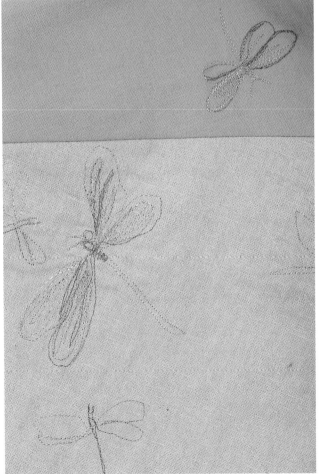

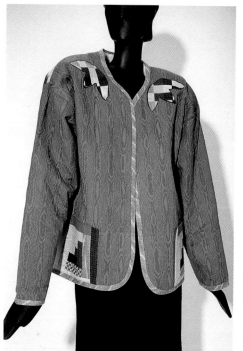
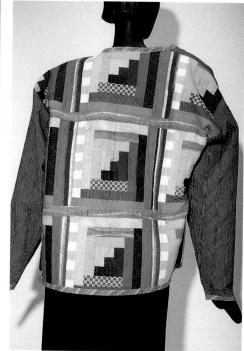

Sweatshirt jacket, made by removing ribbings and opening seams of a sweatshirt, then covering with fabric patchwork, finished with bias binding. *By Laura M. Croom*

Back view.

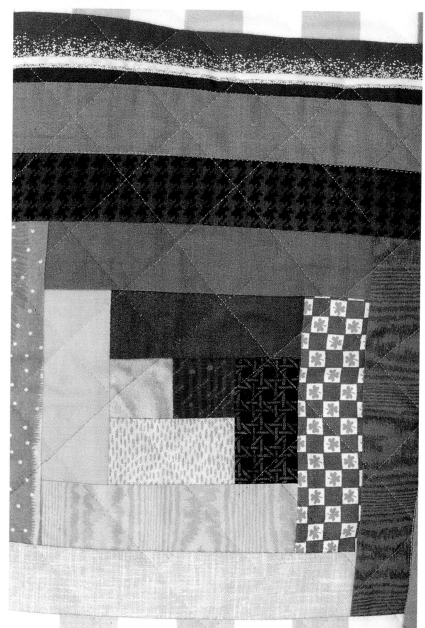

Detail.

140

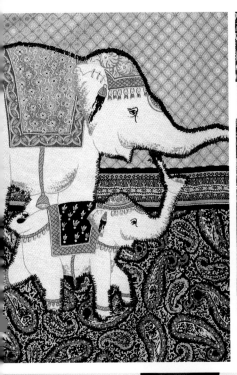

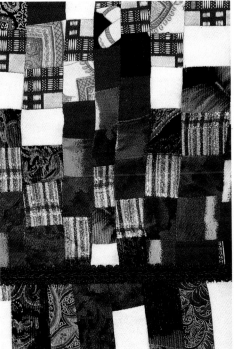

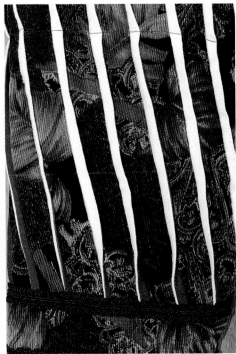

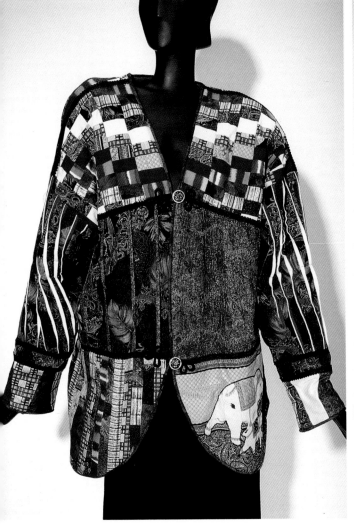

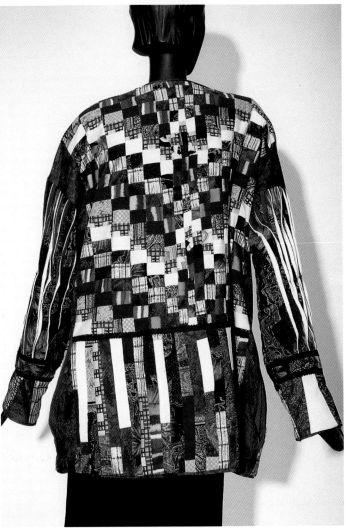

Top left: Detail.

Top center: Detail.

Top right: Detail.

Bottom left: Adaptation from *Jacket Jazz*: jacket using appliqué, tucks, pleats, bargello patchwork, with panel of planned wrinkles, fan design on sleeve bottom. *By Laura M. Croom*

Bottom right: Back view.

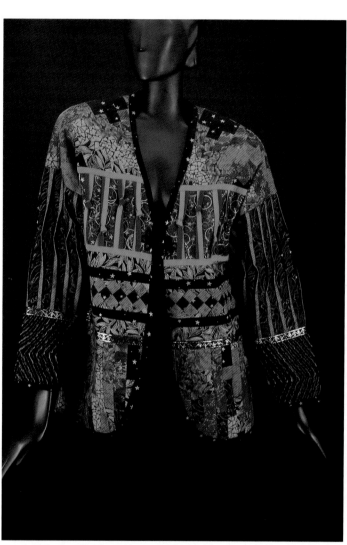

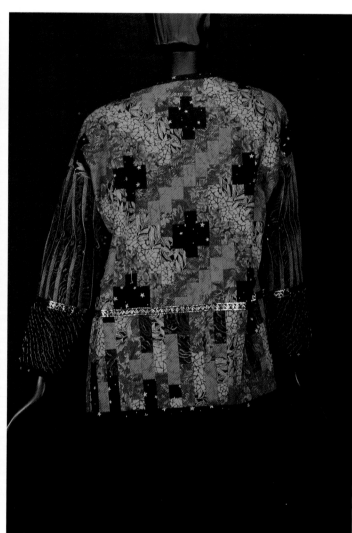

Adaptation from *Jacket Jazz*: jacket incorporating woven bargello, quilting crumbs, seminole patchwork, three-dimensional tucks, stitch and slash, braid trim. *By Bonna Williams*

Back view.

Detail.

Detail.

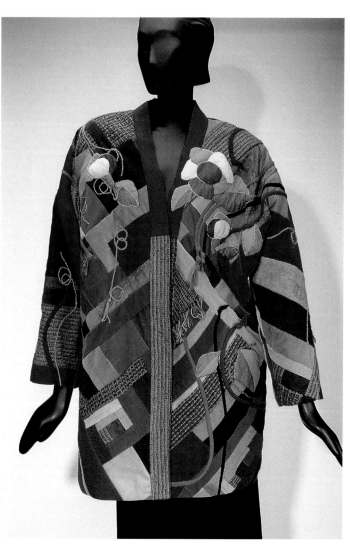
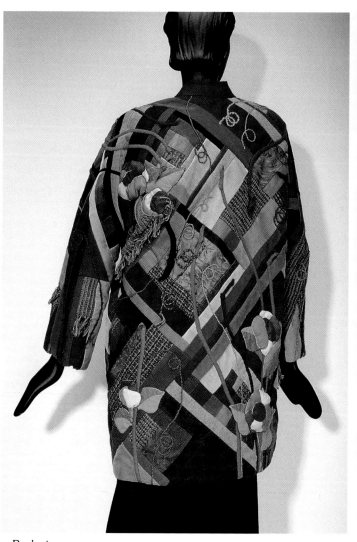

"Blossom Coat," patchwork and appliqué using recycled wools, cottons, and corduroys, with couching and cording. *By Judith Kessler Smith*

Back view.

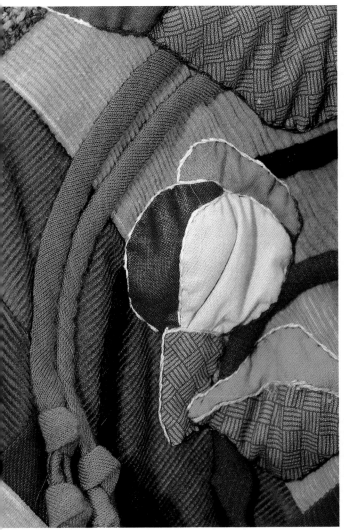

Detail.

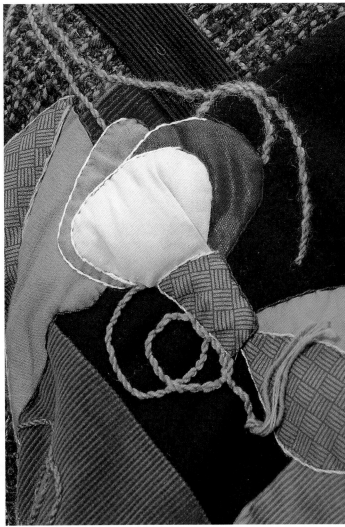

Detail.

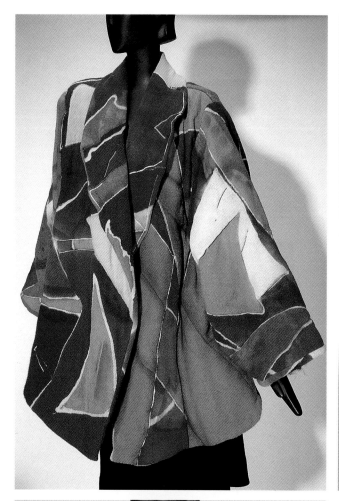

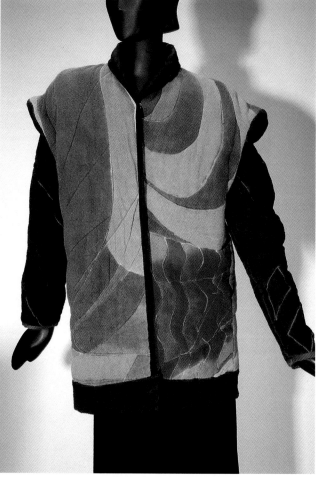

Top left: "Coat of Color," hand-painted silk with gutta resist, using procion fiber reactive dye, machine quilted. *By Lynn Landy Benade*

Top right: "Bomber Jacket," of hand-painted silk color blocks, quilted in irregular shapes. *By Lynn Landy Benade*

Left: Black hand-painted blazer with faceted nailhead studs, by Chris Klassen. *Courtesy Robin Herrington-Bowen*

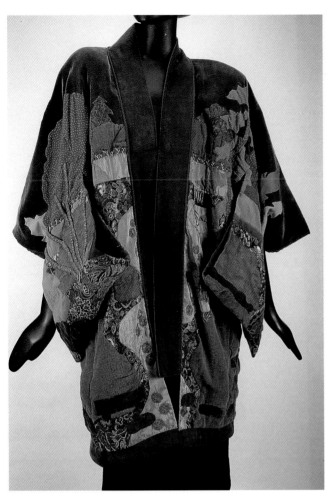

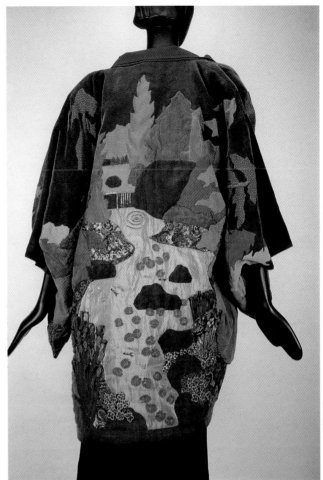

Top left: "Twilight at Meadowbrook," velveteen kimono jacket with silks, rayons, cottons, linens, nylons, and metallic brocades used in pictorial, three-dimensional, and freeform appliqués, 1995. *By Katharine Moore Coss*

Top right: Back view.

Right: Detail.

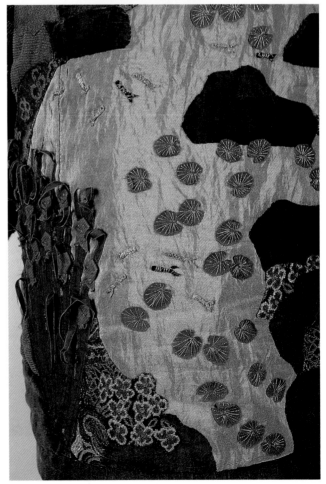

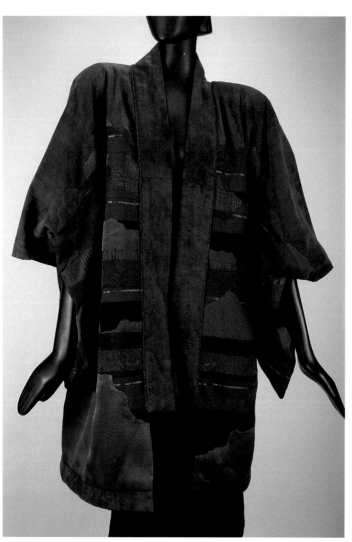
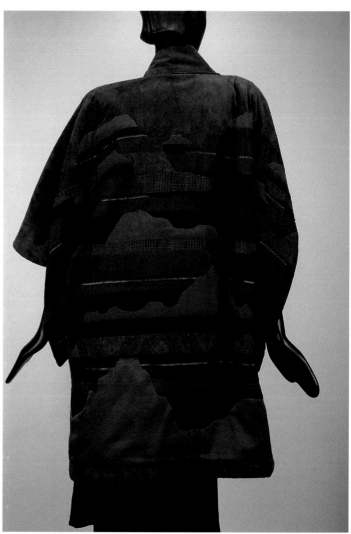

"Canyon at Rest," kimono jacket with teal suede lapels, shoulders, and insets; with rust and teal silk, rayon, and polyester appliqués, with machine and hand stitching, 1997. *By Katharine Moore Coss*

Back view.

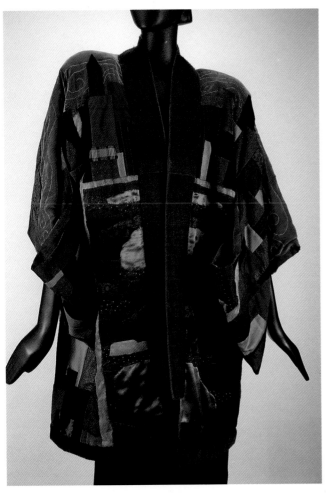

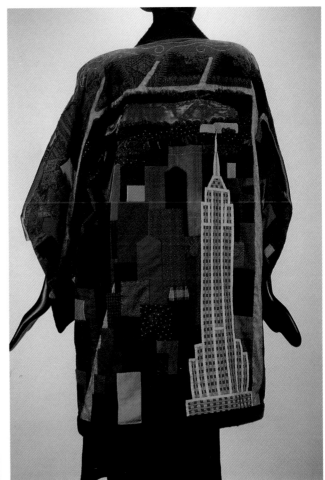

Top left: "Lonely in Manhattan," kimono jacket based on two views of Manhattan at night, in predominantly blues, purples, and charcoals, of silk, rayon, nylon, cotton, and suede; appliqué and embroidery, with beads, 1995. *By Katharine Moore Coss*

Top right: Back view.

Right: Detail.

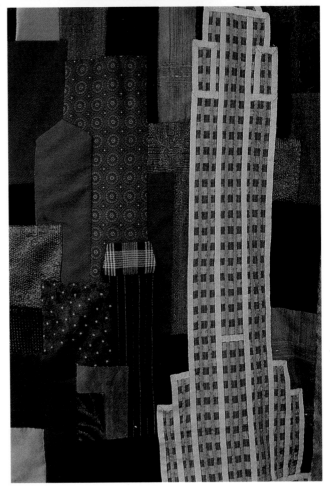

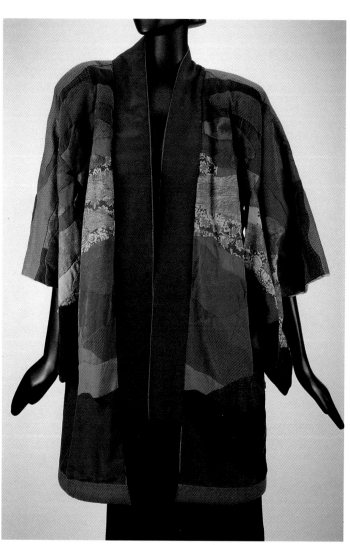 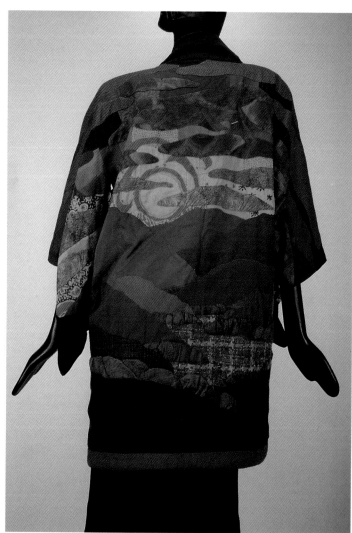

"Taliesin Sunrise," kimono jacket of silks, rayons, and cottons, with patchwork appliqué, machine and hand stitching, and hand dyed silk lining, 1994. *By Katharine Moore Coss*

Back view.

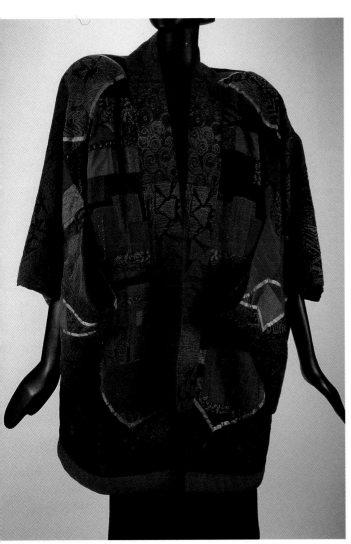
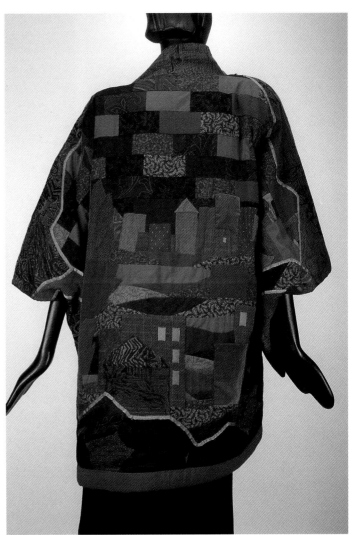

"Northridge Ramble," kimono jacket using patchwork appliqué of silks, rayons, cottons, and wools in rust, red, teal, and black, 1994. *By Katharine Moore Coss*

Back view.

# Chapter 5: Hand Knits

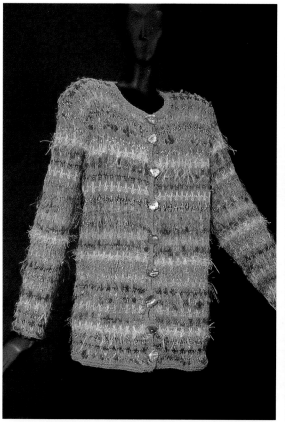
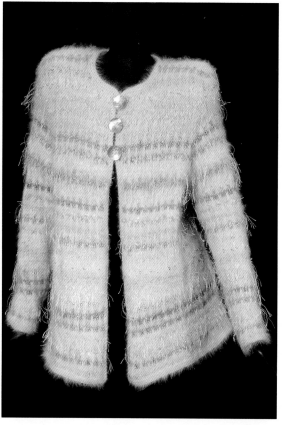

The following are designed by or are adaptations of designs made by Donna Kaminsky.

Top left: Coral cotton chenille yarn background, knit in one piece to under arm, slip stitch method, accented with cotton, silk, rayon, wool, metallic, and ribbon yarns, with knitted in beads, hand made abalone buttons.

Bottom left: Detail.

Top right: Yellow angora background, knit in one piece to under arm, slip stitch method, accented with cotton, silk, rayon, wool, metallic, and ribbon yarns, with knitted in beads, antique French mother-of-pearl buttons.

Bottom right: Detail.

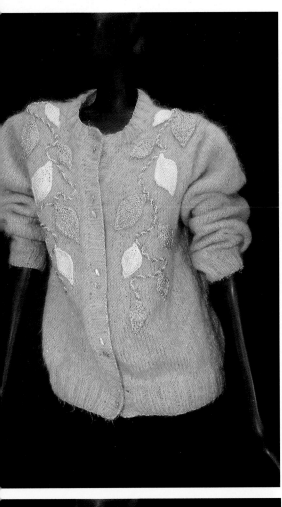

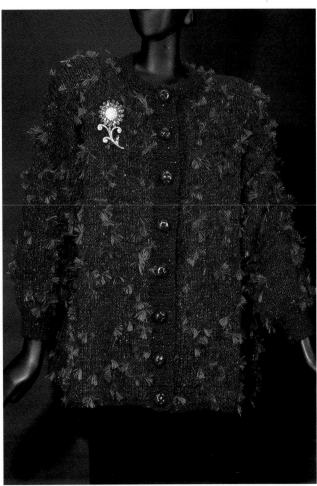

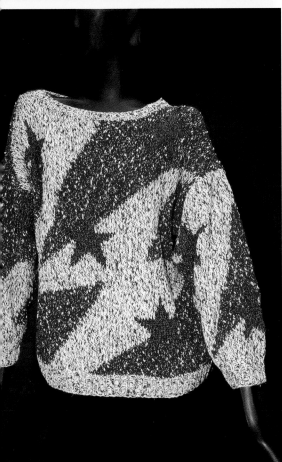

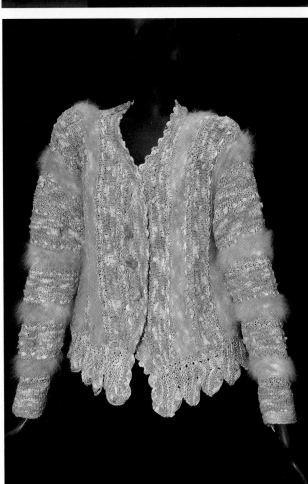

Top left: Beige mohair/alpaca blend with gold thread throughout, leaf appliqués knitted separately and joined by vines of pearl and gold beads, metal leaf buttons, pattern adapted from *Tiber Yarns.*

Top right: Burgundy hand-dyed hand-spun wool yarn, magenta metallic yarn, and butterfly fringe yarn, with antique buttons.

Bottom left: "Fourth of July," Donna's birthday; cotton yarn knitted in intarsia method, stars of blue metallic.

Bottom right: Hand-dyed yarns by Patti Subik of the Great Adirondack Yarn Co., of angora, cotton, and rayon, body knitted side to side, scalloped peplum knitted separately, front and neck edges crocheted in picot stitch

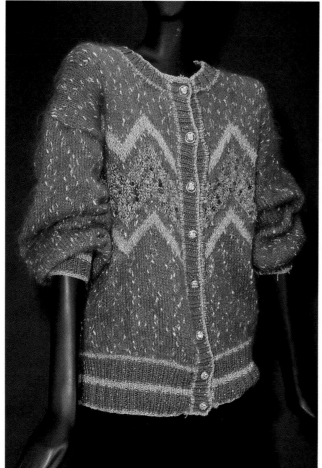

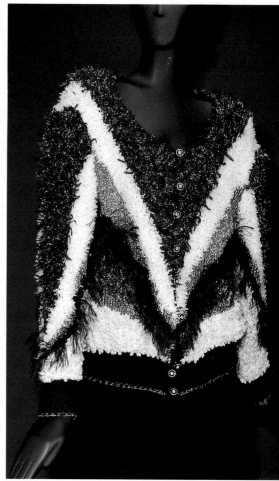

Top left: Mohair and metallic base yarns, accented with metallic and rayon with puff pompoms.

Bottom left: Detail.

Top right: Light weight cotton and synthetic textural yarns, accented with metallic yarns, body knitted in intarsia method with separate bobbins for each yarn change.

Bottom right: Detail.

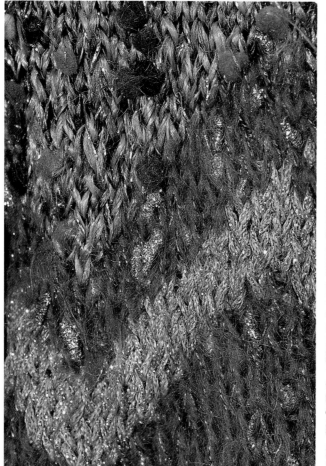

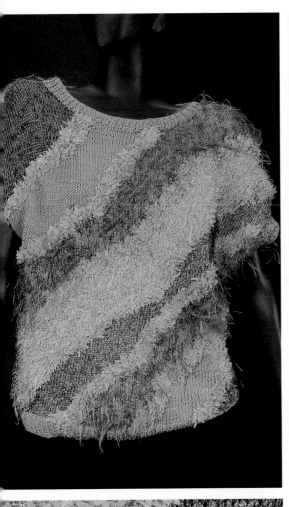

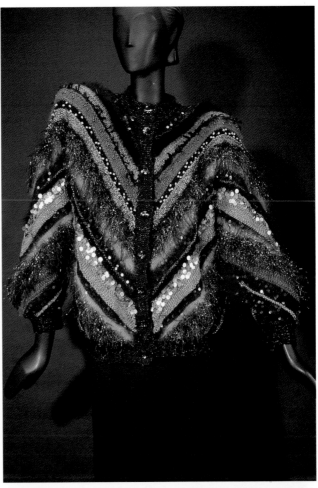

Top left: Light teal and royal blue cotton yarns with rayon, nylon, polyester, and metallic accents.

Bottom left: Detail.

Top right: Greens, blacks, and coppers of angora, wool, and metallic fringe yarns in overall chevron pattern, with accents of beads, palettes and metallic fringe yarn.

Bottom right: Detail.

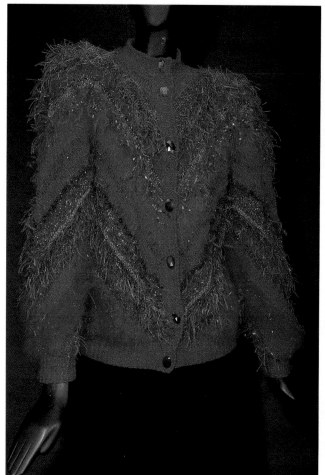

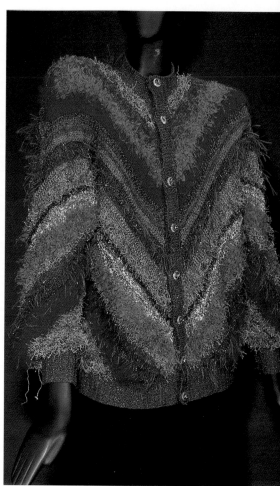

Top left: Red cotton and angora yarns, in overall chevron pattern with accents of fringe yarn, metallic, seed beads, and red faceted buttons.

Bottom left: Detail.

Top right: Hot pink, red, and royal blue cotton, angora, and synthetic yarns, in overall chevron pattern with accents of beads, ribbon, and fringe yarn.

Bottom right: Detail.

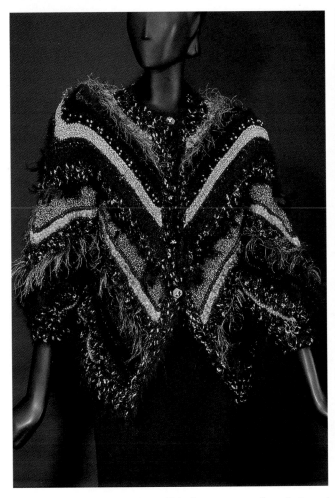

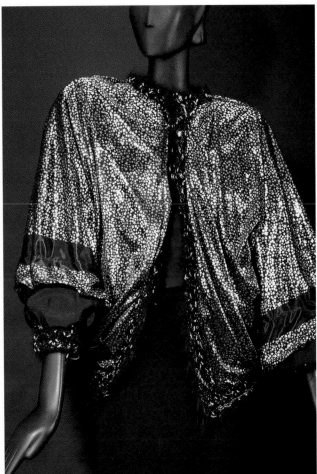

Top left: Gold and black angora, wool, mohair, and metallic yarns in overall chevron pattern, with accents of feathers, beads, sequins, and metallic fringe yarn.

Top right: Sweater reverses to black and gold lame, accented with wide bands of grosgrain, closures of gold star buttons set on black hexagonal buttons.

Right: Detail.

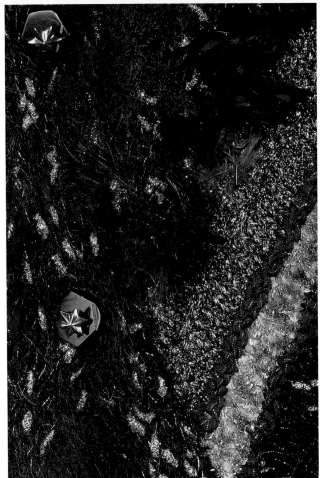

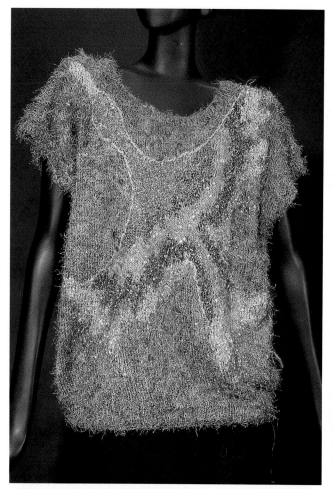

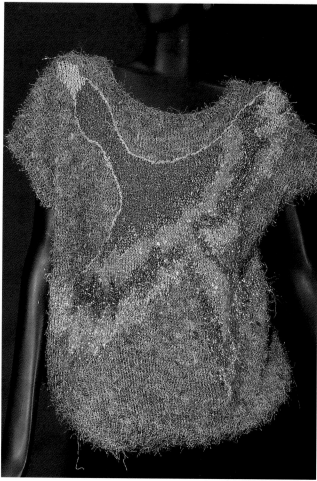

Top left: "Bird of Paradise," muted tones of blue and gold cotton, rayon, metallic, and ribbon yarns, accented with sequins and fringed yarn.

Top right: Back of sweater can also serve as front, since a different colorway is used on the second bird.

Left: Detail.

Opposite page:
Top left: "Bird of Paradise II" in cool tones, bird's eyes are rhinestone buttons.

Bottom left: Detail.

Top right: Turquoise and pink cotton, rayon, metallic, and synthetic yarns knitted in intarsia method; some yarns are multi-stranded to achieve color blend effect, accented with fringe yarn.

Bottom right: Detail.

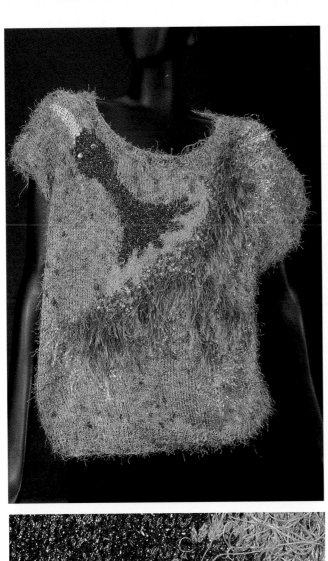
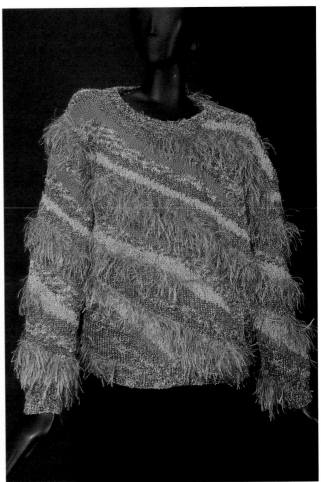
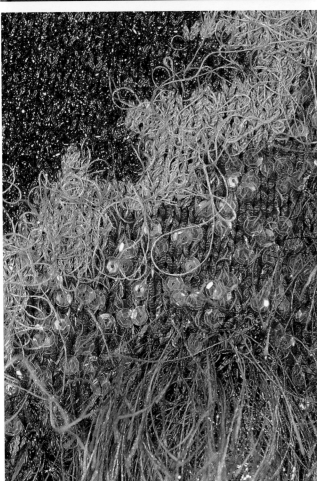
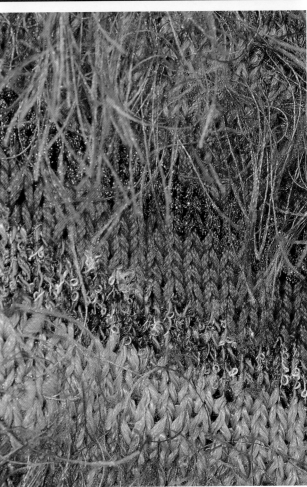

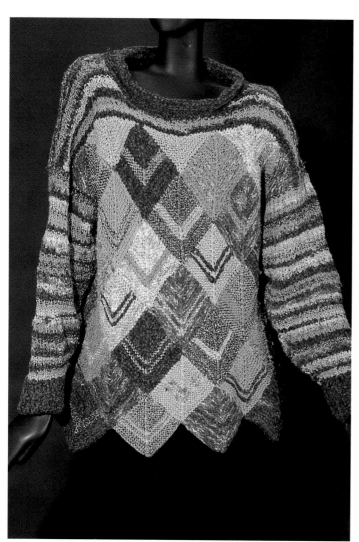

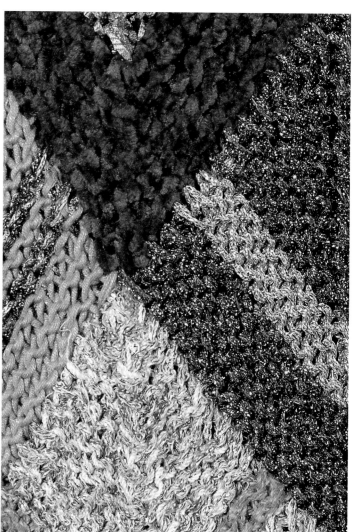

Cotton, chenille, silk, rayon, metallic, and ribbon yarns, in blue diamond pattern adapted from design by Irene York of Knitting Basket; each diamond is knitted in garter stitch by picking up stitches from adjacent diamond.

Detail.

Opposite page: "Donna's Coat," knit in trellis effect entrelac stitch, with each triangle or rectangle joined together; of 90+ yarns of angora, cotton, chenille, mohair, synthetics, ribbon, and metallics, using a combination of variegated, solid, and fringed yarns in random color arrangement; adaptation of *Prizm Yarns* design.

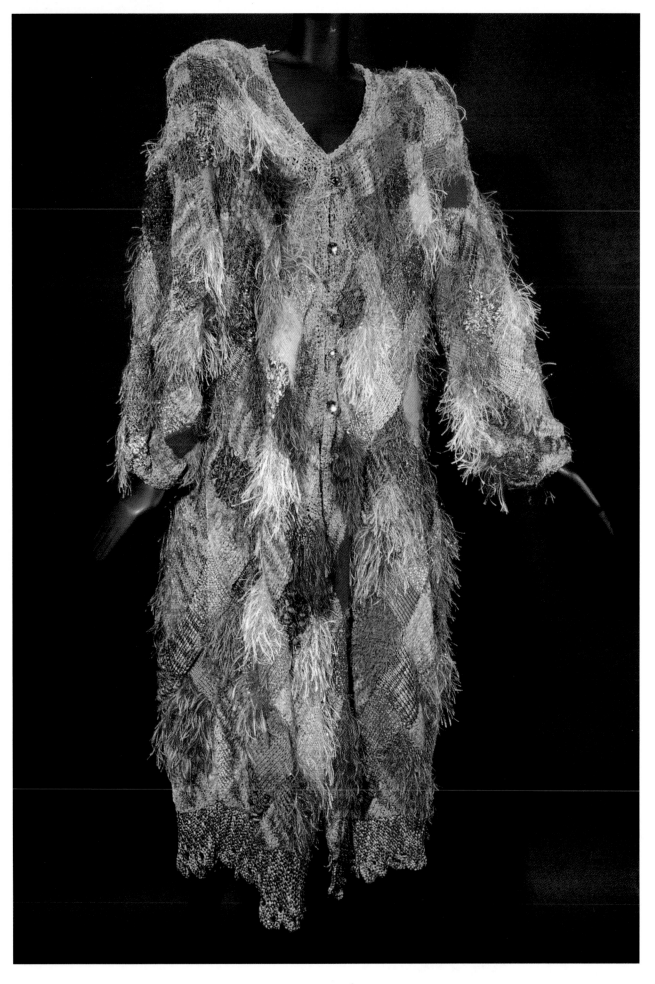

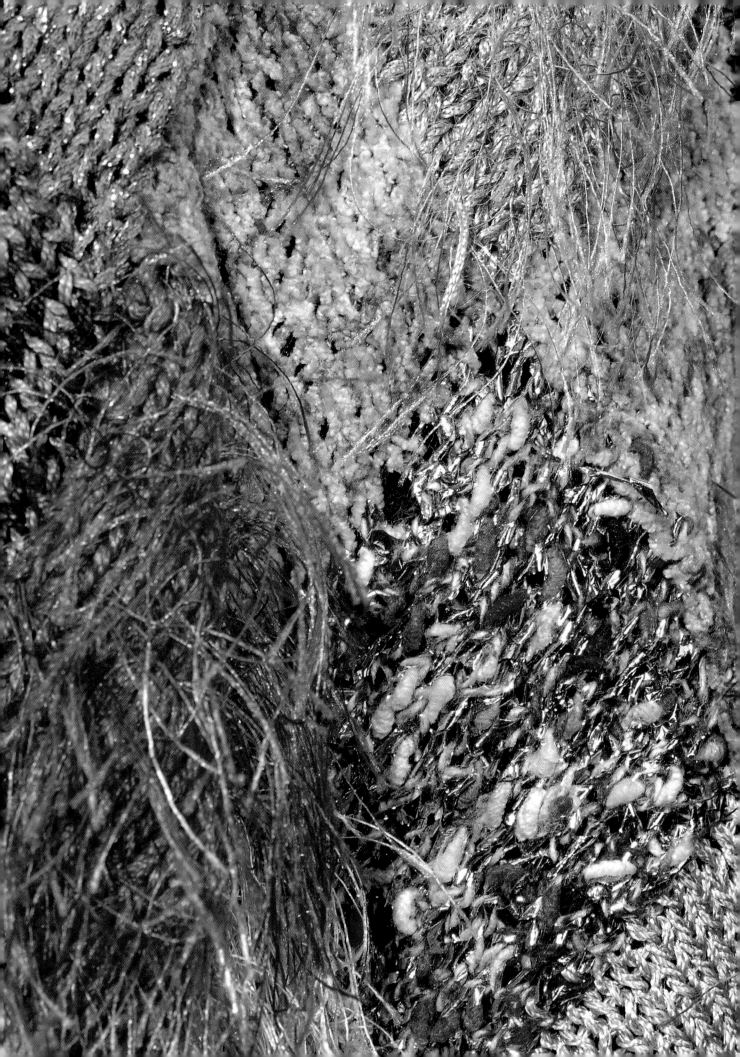

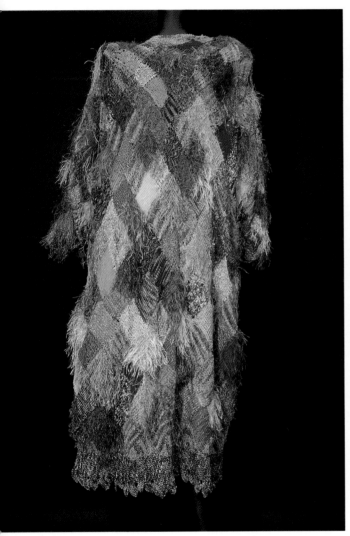

Back view.

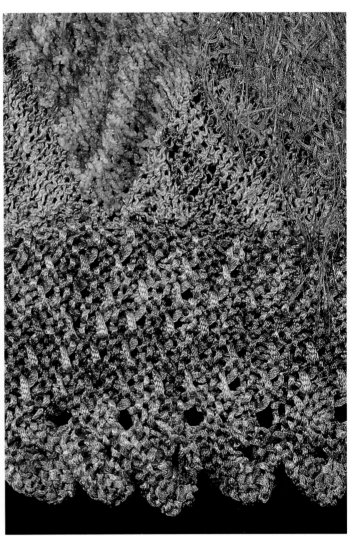

Detail.

Opposite page:
Detail.

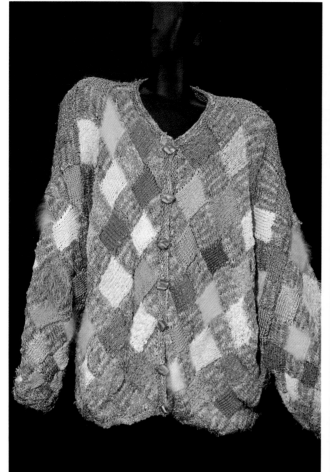

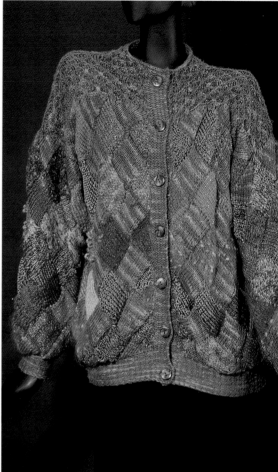

Top left: Beige, taupe, and gold angora, cotton, synthetic, and ribbon yarns using entrelac stitch, resulting in pattern of matching rectangles and invisible seams.

Bottom left: Detail.

Top right: Olive and gold hand dyed wool and silk blend yarns, dyed by Yarns by Mills; plus commercial wool, silk, mohair, metallic, rayon, and ribbon yarns knitted in entrelac technique.

Bottom right: Detail.

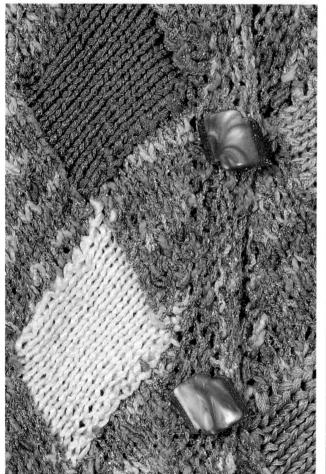

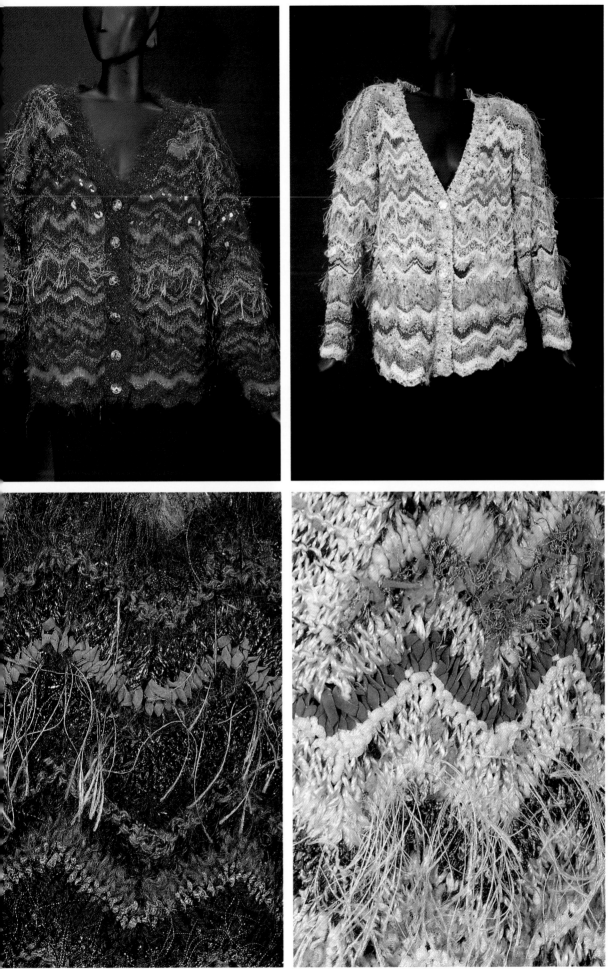

Top left: Earth tones using ripple stitch for chevron effect, accented with fringed and ribbon yarn and palettes.

Bottom left: Detail.

Top right: Earth tones of silk, cotton, rayon, synthetics, and ribbon yarns, using ripple stitch for chevron effect, accented with fringed and ribbon yarns.

Bottom right: Detail.

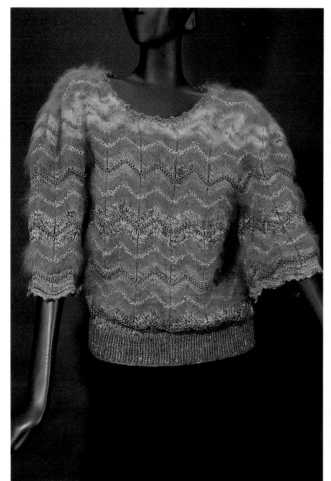

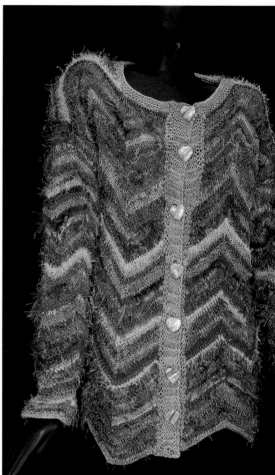

Top left: Rust angora, wool, silk, rayon, metallic, and ribbon yarns in matched chevron bands.

Bottom left: Detail.

Top right: Subdued multi-colored silk, cotton, rayon, synthetics, and ribbon yarns, using ripple stitch for chevron effect, accented with fringed yarns.

Bottom right: Detail.

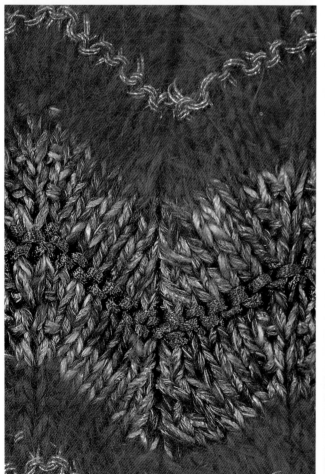

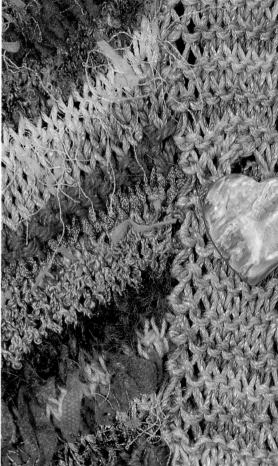

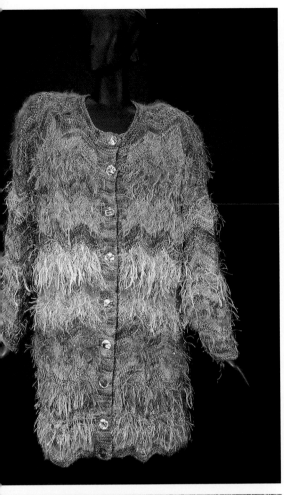

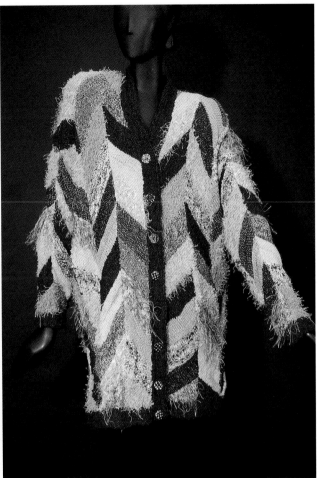

Top left: Angora, silk, wool, mohair, rayon, cotton, and ribbon yarns hand-dyed by Patti Subik, accented with commercial fringed yarns.

Bottom left: Detail.

Top right: Yellow, peach, and purple chevron made by knitting bands of color and then sewing them together.

Bottom right: Detail.

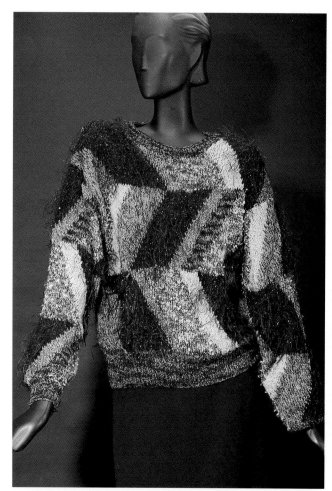

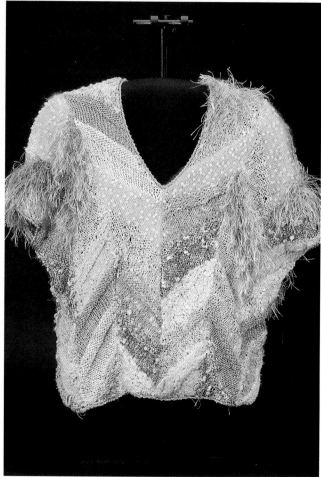

Top left: Black and tan geometric pattern of rayon, cotton, and metallic yarn, with knitted-in seed beads and fringed yarn.

Top right: Light earth tones of chevron patches, with gold and pearl glass beads knitted in, accented with fringed yarns.

Left: Detail.

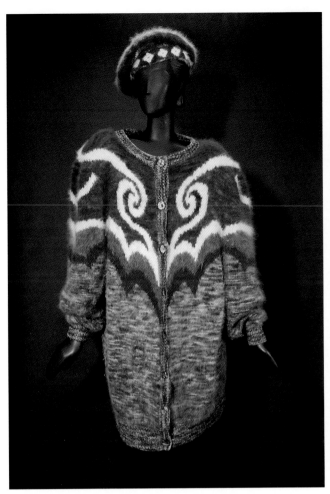

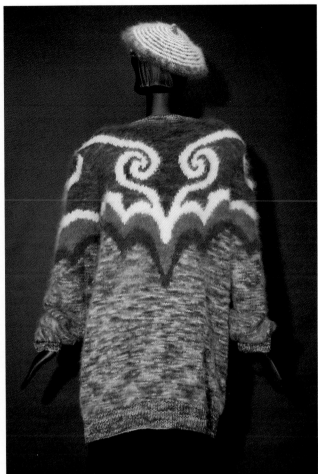

Top left: Coat with matching hat: bold design in deep colors accented with beige hand-dyed angora, with Cormo wool bands dyed by Oak Grove Yarns.

Top right: Back view.

Right: Multi-colored variegated background with fan-shaped angora pattern also hand-dyed by Oak Grove Yarns.

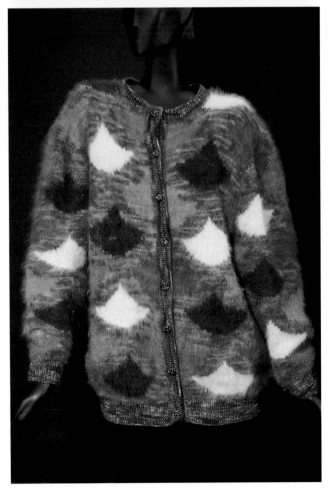

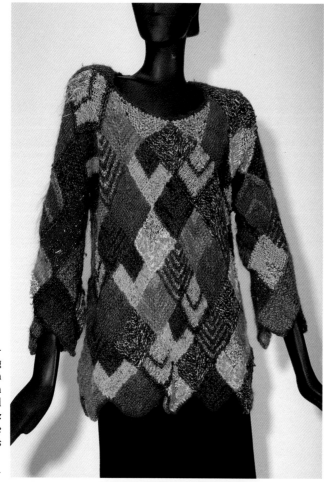

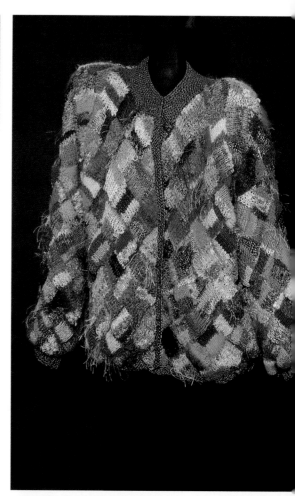

Top left: "Hop-scotch," long sweater in a variety of fibers in diamond shaped pattern. *By Liz Tekus, of Fine Points*

Bottom left: Detail.

Top right: "Bomber jacket" of multi-colored mixed fibers, entrelac technique. *By Liz Tekus, of Fine Points*

Bottom right: Detail.

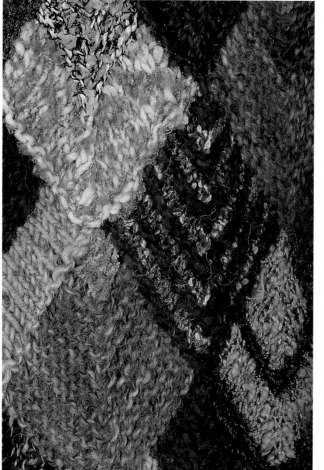

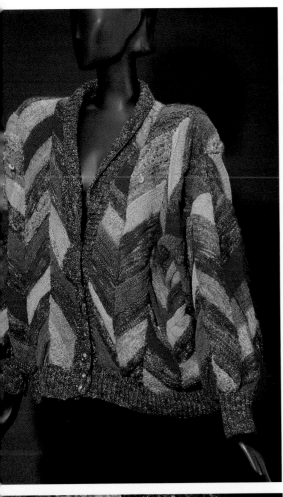

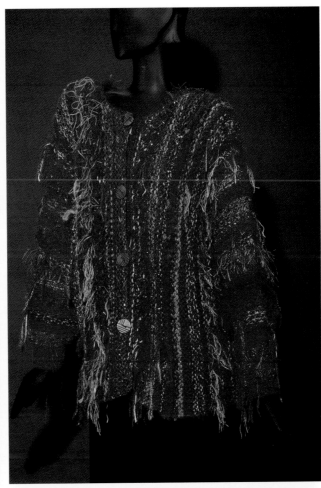

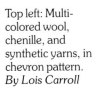

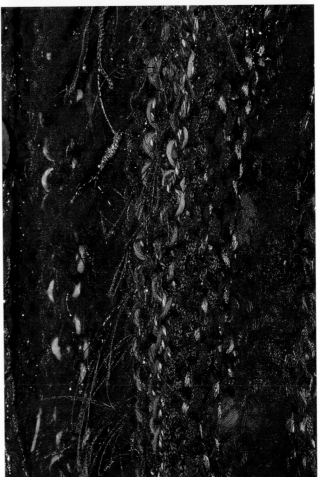

Top left: Multi-colored wool, chenille, and synthetic yarns, in chevron pattern. *By Lois Carroll*

Bottom left: Detail.

Top right: "Fiesta," knit from cuff to cuff in bright red yarns, fibers tied together and knots hang down front. *By Liz Tekus, of Fine Points*

Bottom right: Detail.

*171*

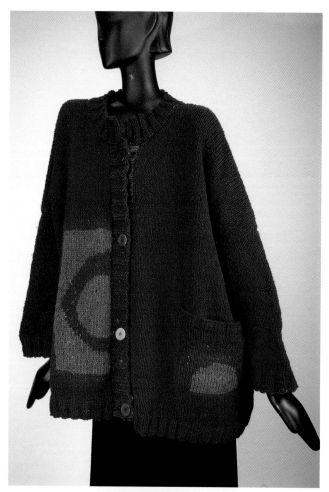

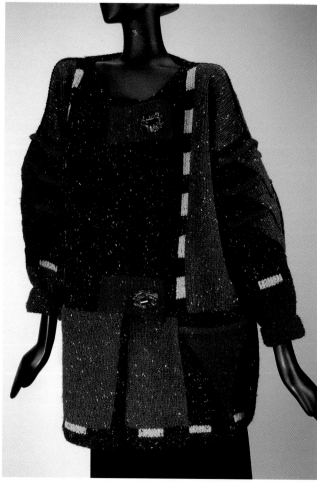

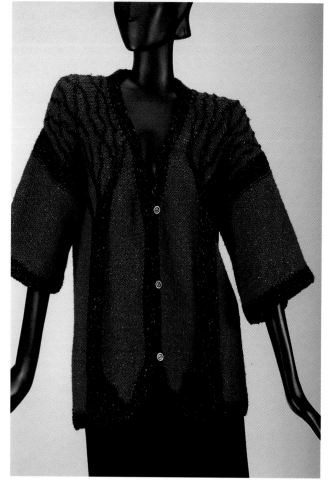

Top left: Gold and purple abstract shapes on deep red ground, designed by Sandra Miller. *Courtesy Goldie Schulman*

Top right: Geometric shapes of black, olive, purple, and red, some of variegated yarns, designed by Suzen. *Courtesy Goldie Schulman*

Left: Deep red boucle knit with dark abstract tree motifs, by Sandy D'Andradi. *Courtesy Robin Herrington-Bowen*

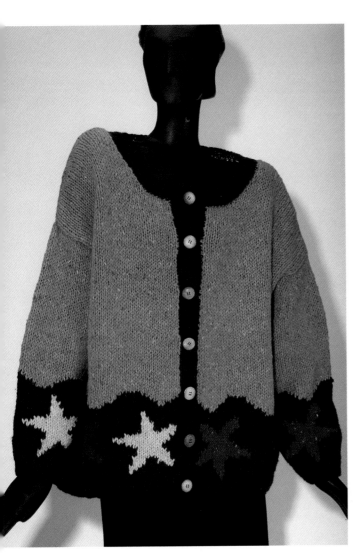

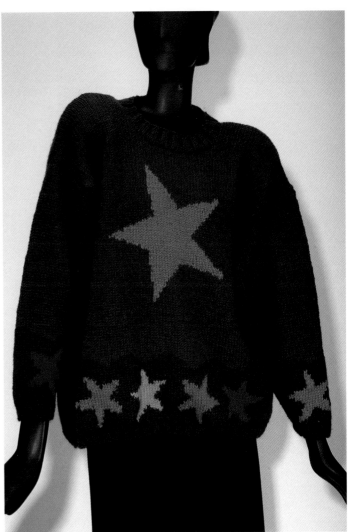

Wool yarns, entarsia technique with stars. *By Liz Tekus, of Fine Points*

Pullover with stars. *By Liz Tekus, of Fine Points*

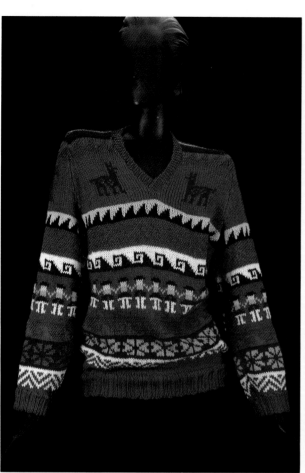

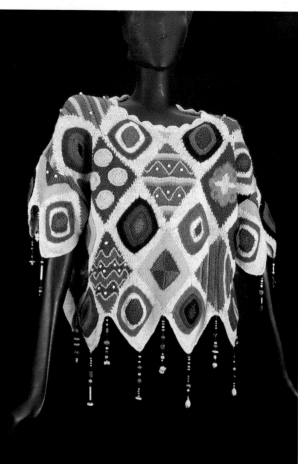

Top left: Hand knit 100% wool sweater in hot pink and blue with animal and figural motifs, made in Peru, c.1980s.

Top right: Commercial hand knit in China, c.1980s, cotton in bold geometric pattern, beading by Shirley Friedland.

Bottom: Detail.

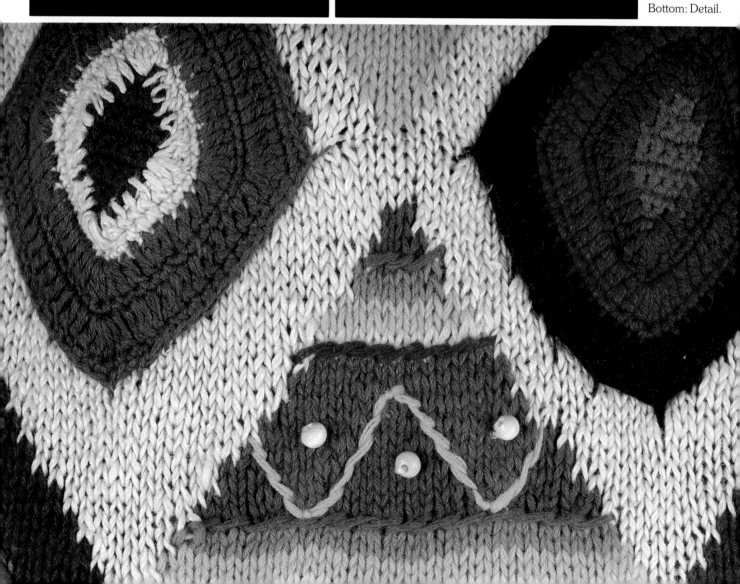

Sweater of hand-crocheted cotton multicolor medallions embellished with glass beads, label removed.

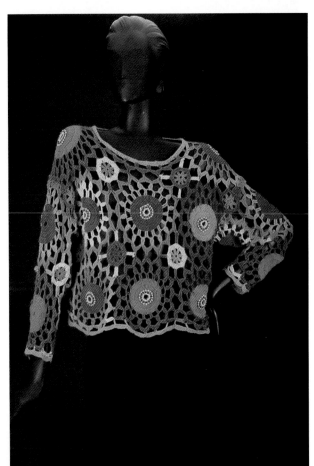

Detail.

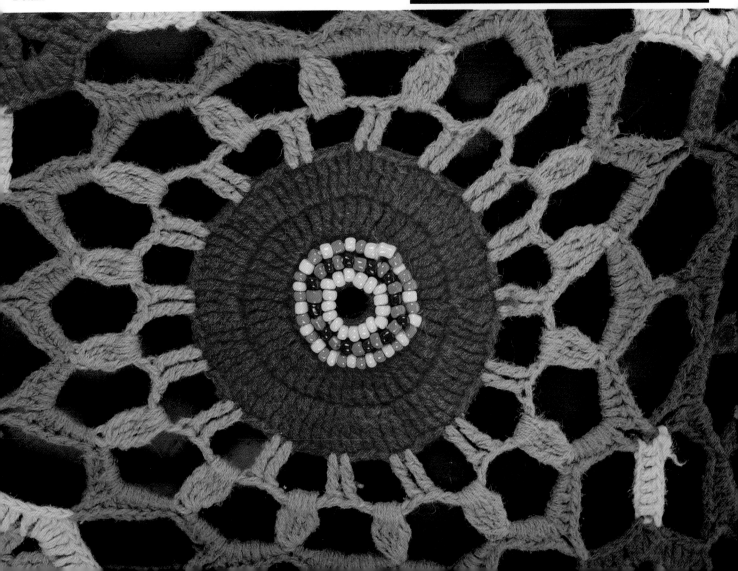

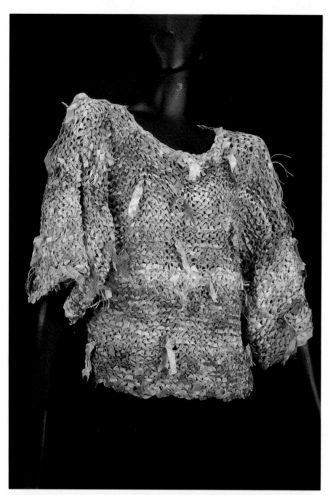

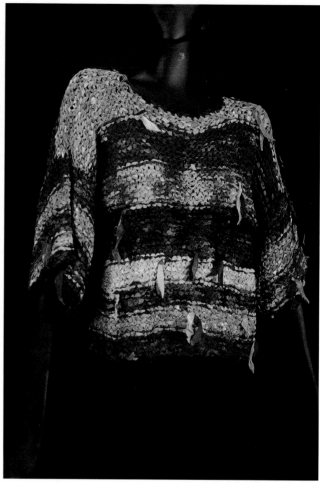

Top left: Hand-dyed ribbons knit with hanging knotted ribbons at each color change. *By Liz Tekus, of Fine Points*

Top right: Short sweater of hand-dyed ribbons knitted in rows of clear bright colors alternating with dark tones. *By Liz Tekus, of Fine Points*

Left: Hand-crocheted cotton string, bound in braided ribbon and leather, c.1960s; label, Roberto Cavalli, Made in Italy. *Courtesy Lorita Winfield*

Opposite page: Detail.

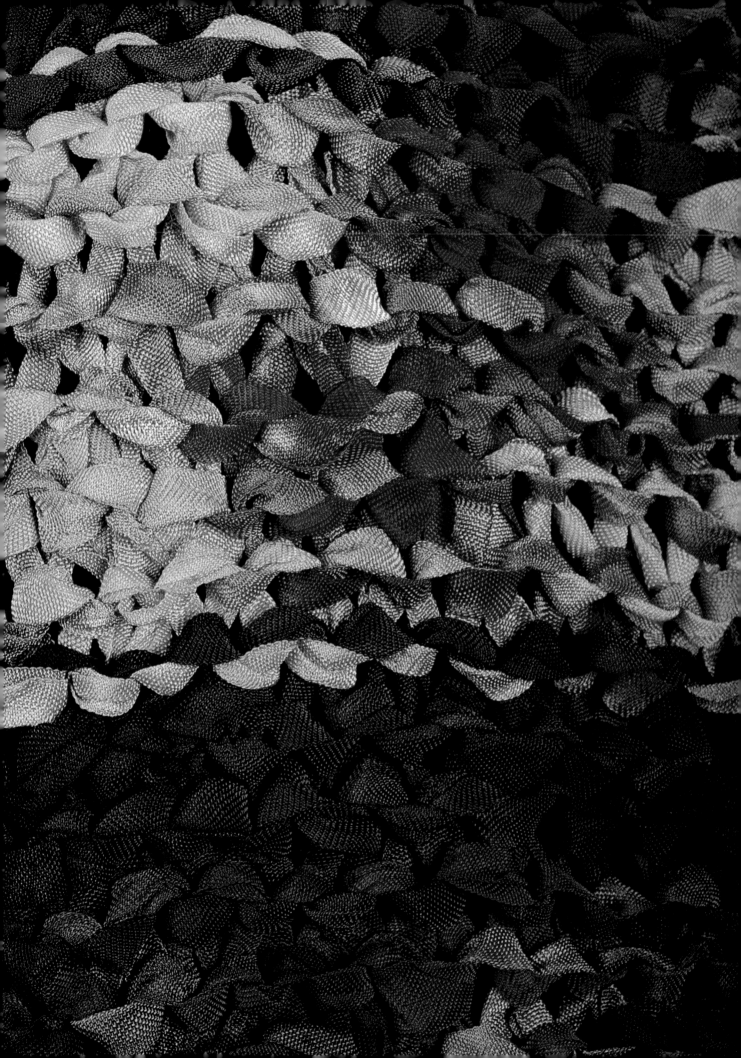

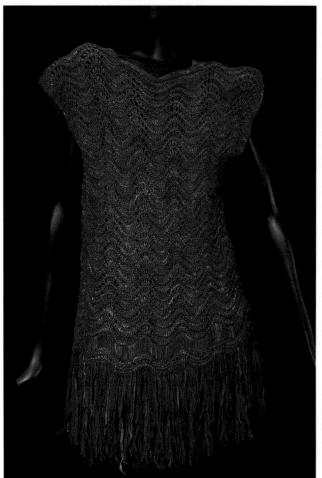

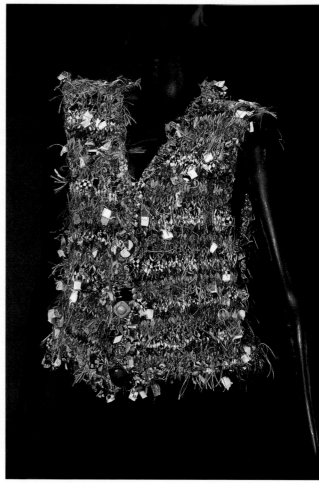

Top left: Hot colors of cotton and rayon hand-dyed yarns with ribbon fringe around bottom. *By Lois Carroll*

Top right: Vest made of torn strips of multicolor printed fabrics. *By Liz Tekus, of Fine Points*

Left: Detail.

Opposite page: Detail.

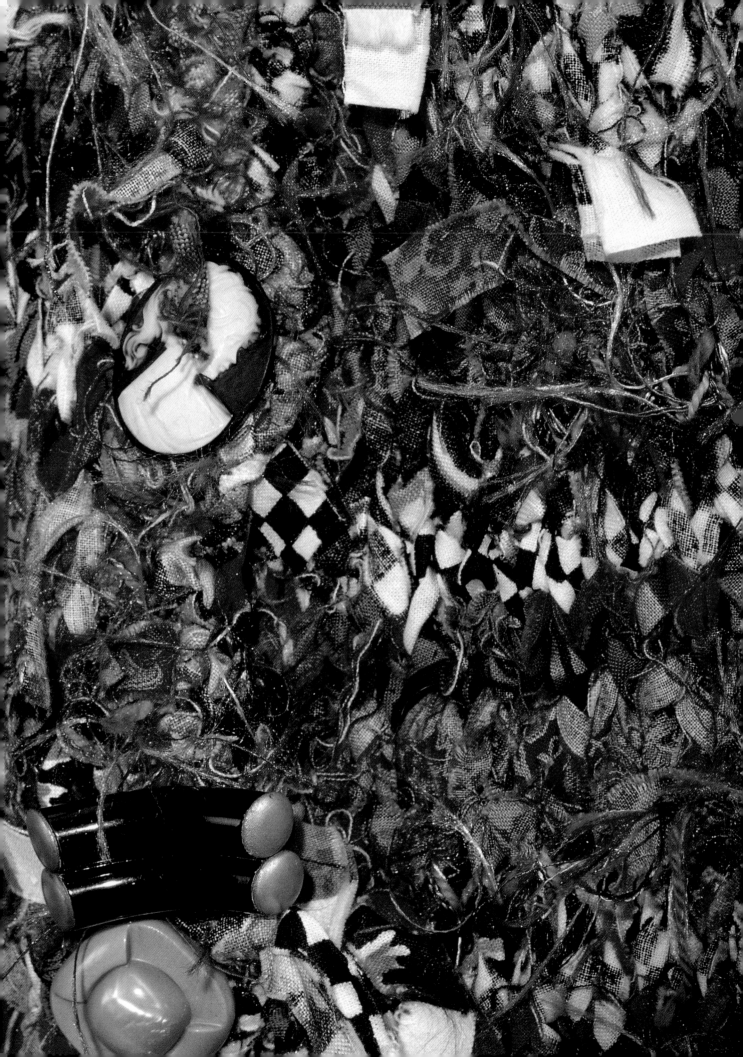

# Glossary

**Abhala** (see Indian mirror embroidery).

**Acetate** - Synthetic fiber made from acid-treated cellulose, developed by the Celanese company in 1924.

**Acrylic** - Synthetic fiber made as an alternative to wool by DuPont in 1950.

**Alpaca** - Wool of South American alpaca llama, has a soft and silky texture.

**Angora** - Hair of Angora goat or Angora rabbit made into yarn with very soft texture.

**Appliqué** - Design made by applying pieces of fabric or other material to the surface of the fabric.

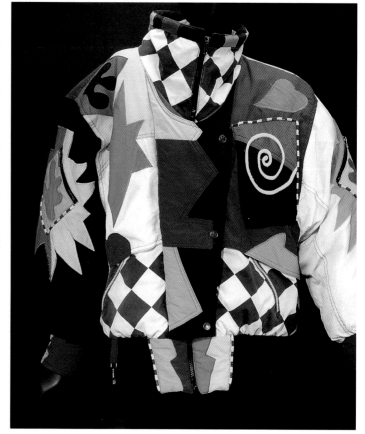

Applique - fabric on fabric.

Opposite page: Applique - crochet on knit.

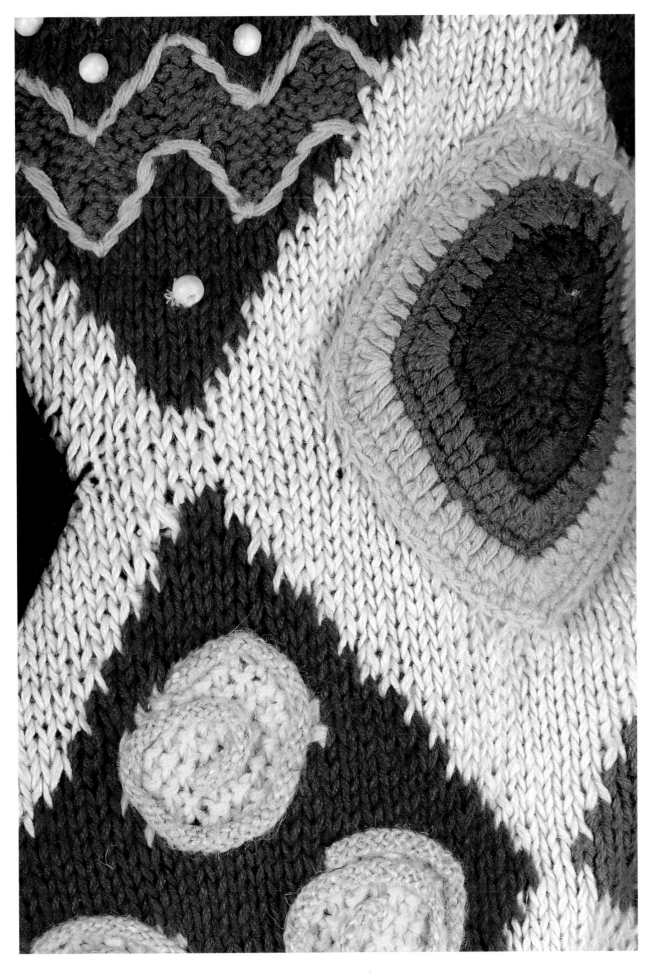

Applique - ultra-suede on fabric.

Applique - fabric on fabric.

**Argyle** - Diamond shaped design knitted with different colors to show the pattern.

**Asymmetrical closing** - Garment closing off center.

**Backed** - Sewing or laminating another material to the back of material for extra strength.

**Bargello** - Flame stitch used in knitting and needlepoint; in patchwork a similar flame effect is achieved by using small rectangles of fabric.

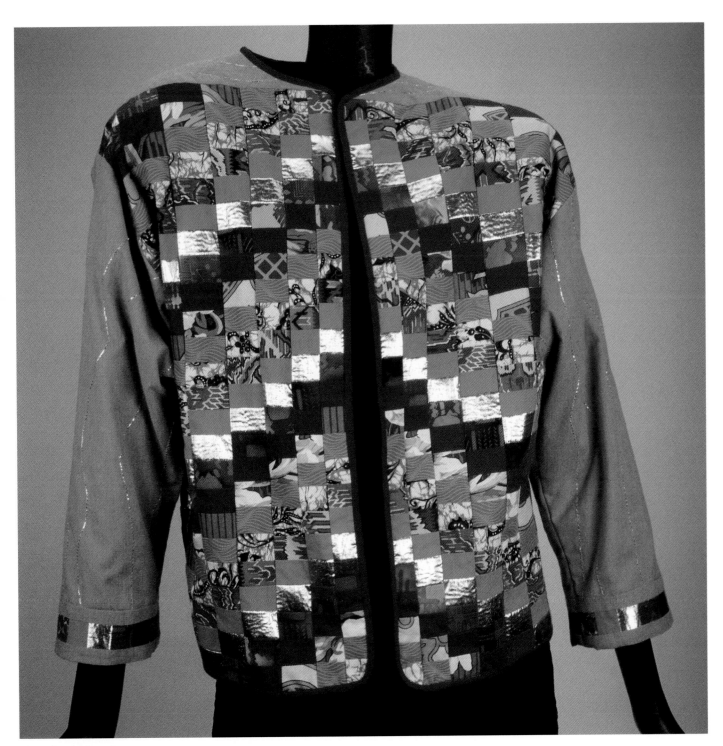

Bargello patchwork.

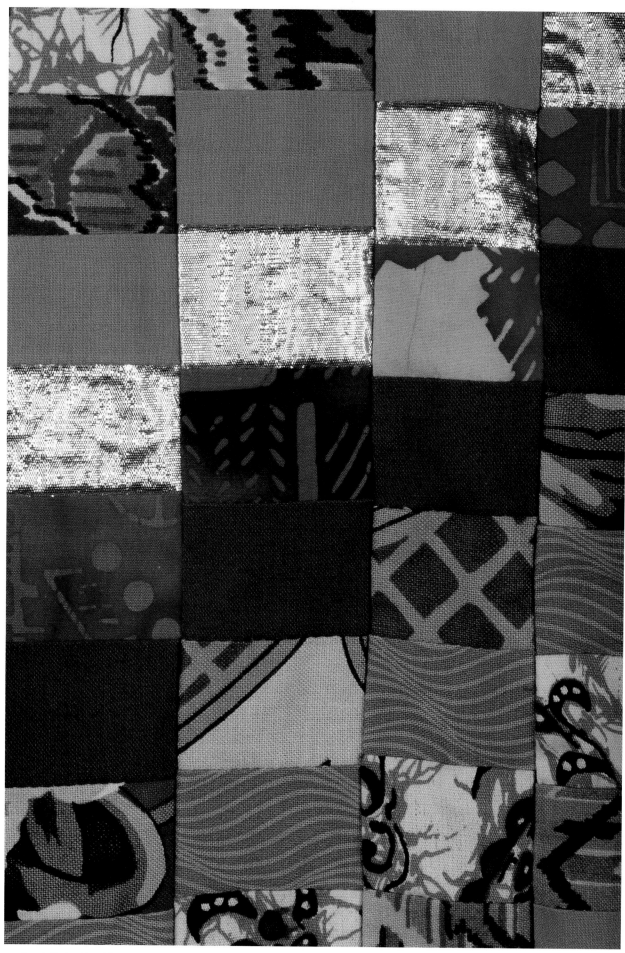

Bargello patchwork.

**Batik** - Dyeing method using wax as the resist agent; the pattern is covered with wax, the cloth is dyed, the wax is removed, leaving white areas that can be redyed for multicolored designs; originally an Indonesian technique, now used around the world.

Batik.

Batik patchwork.

**Battenberg lace** - Made of linen braid or tape, sewn together with linen thread to form a design or pattern.

**Beading** - Method of attaching beads to fabric or creating fabric using thread, such as knitting, crocheting, weaving, tambour, and hand sewing.

**Bias binding** - Bands of fabric, cut on the bias, used to edge and enclose layer(s) of fabric.

**Bias cut** - Fabric cut at a 45-degree angle to the straight or selvage.

**Bleach dyeing** - Discharge method of removing colors rather than adding them.

**Bobbin** - Spool to hold yarn or thread, for example when knitting.

**Bogolanfini** - Known commonly as "mud cloth," a painted hand-woven cloth, made in Mali. Dyes are make from mud and leaves to create traditional white patterns on black backgrounds.

**Boucle yarn** - Rough, curly, or knotted yarn.

**Cathedral patchwork** - Hand patchwork technique using large squares with precise folds to create a regular pattern of windows.

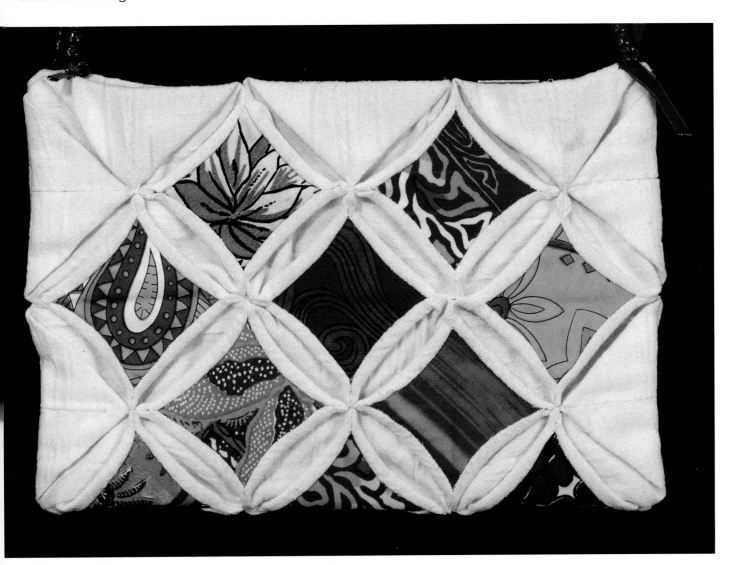

Cathedral patchwork.

**Challis** - Soft, supple, light weight plain weave fabric of wool, rayon, cotton, or polyester blend.

**Charmeuse** - Lightweight silk, cotton, or synthetic with a satin-like front and dull back.

**Chenille** - From the French for "caterpillar," because the pile protrudes on all sides.

**Chevron** - Zigzag pattern; stripes meeting at an angle to make the V shapes.

**Chiffon** - Light weight, filmy, translucent fabric of silk or synthetic.

**Collage** - Design formed by piecing shapes of various materials.

**Color blocking** - Distinct color differences in patches of fabric.

**Cording** - Strips of fabric-covered cord used as decoration or to separate sections.

Chevron, fringe yarn, metallic yarn, variegated yarn.

**Couching** - Decorative technique whereby yarn, thread, or ribbon is held onto fabric, using a zigzag stitch to secure it.

**Crochet** - Yarn, thread, or string is pulled through loops to created an openwork pattern.

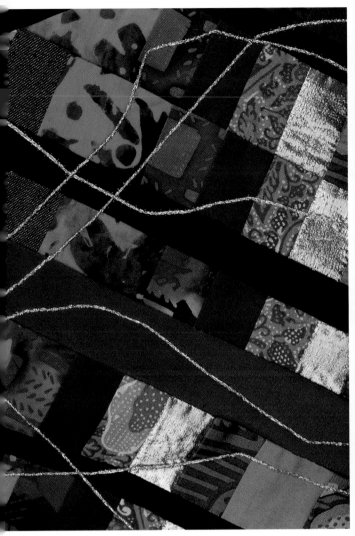

Couching on random bargello.

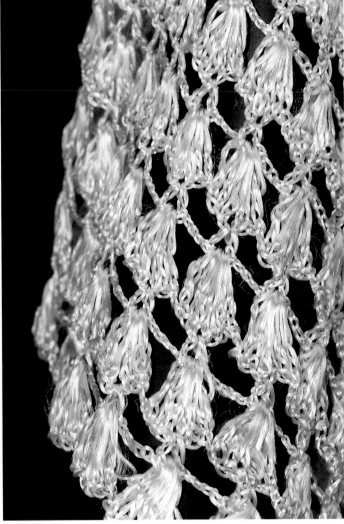

Crochet.

**Crewel** - Type of embroidery using a fine, loosely-twisted two-ply worsted yarn.

**Crimp** - Waviness in fibers.

**Cross stitch** - A form of embroidery where the stitches are worked on a grid of canvas or woven fabric, creating an X where each one crosses over.

**Denim** - Fabric with white cotton filling and a surface of cotton twill, usually blue.

**Discharge dyeing** - Bleach dyeing.

**Embellishment** - Addition of detail or decorative ornamentation.

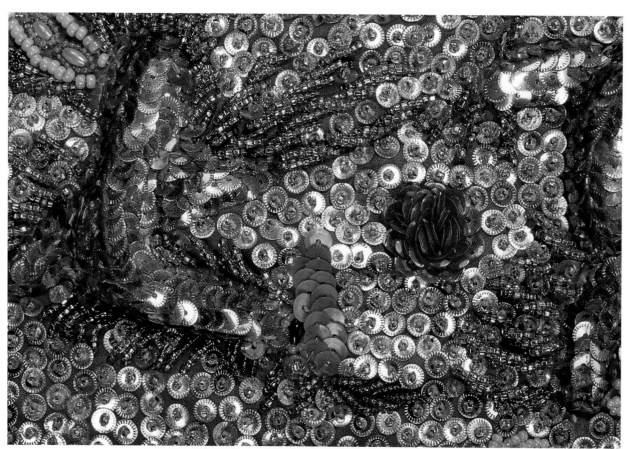

Embellishment - seed beads and sequins.

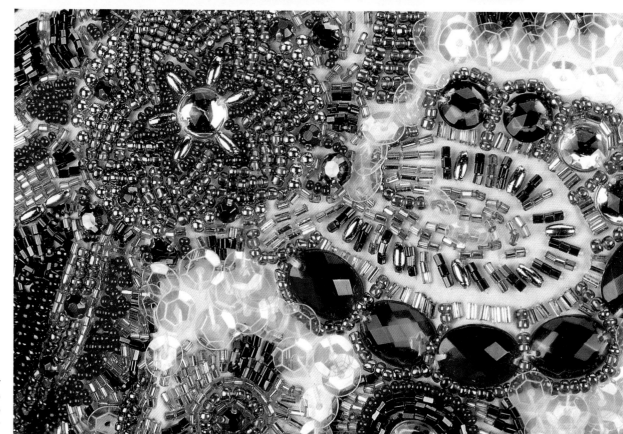

Embellishment - faceted stones, seed beads, sequins.

**Embossed** - Raised surface design.

**Embroidery** - Using thread or yarn to create a decorative pattern or design on fabric.

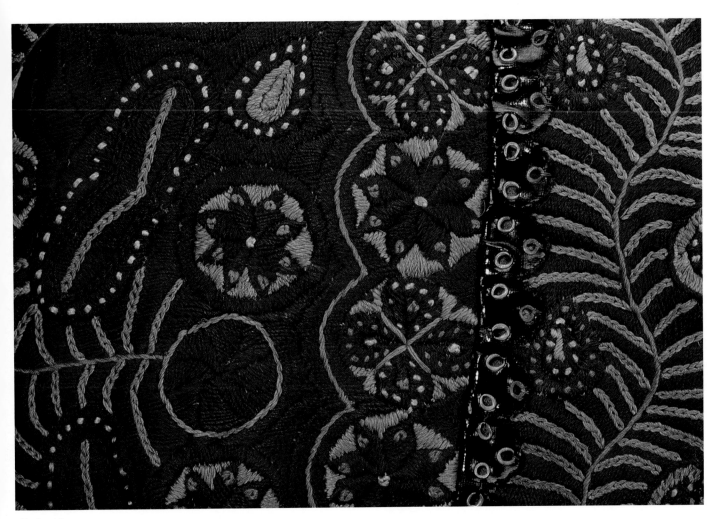

Embroidery.

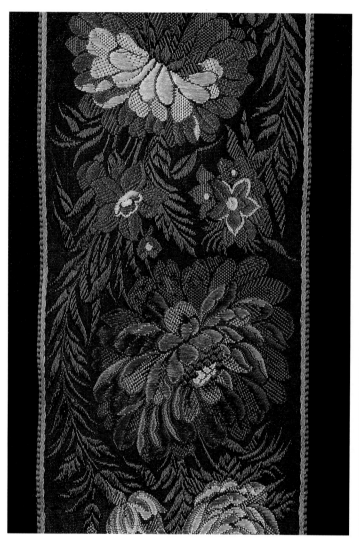

Embroidery.

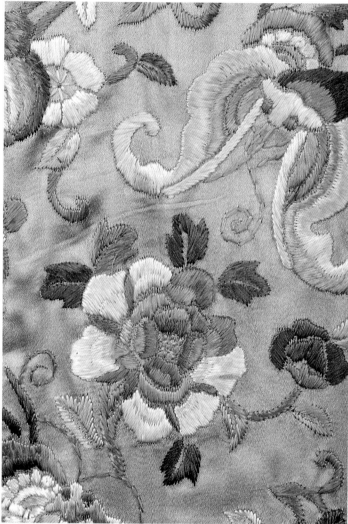

Embroidery.

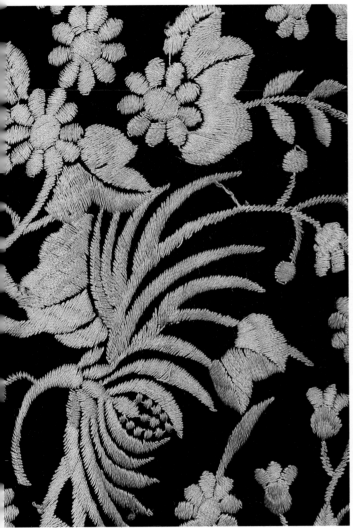

Embroidery.

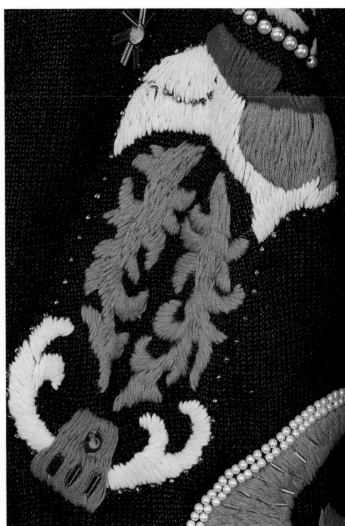

Embroidery.

**Entrelac** - Interlacing or intertwining stitch or knit where each triangle or rectangle is knitted jointly to the next.

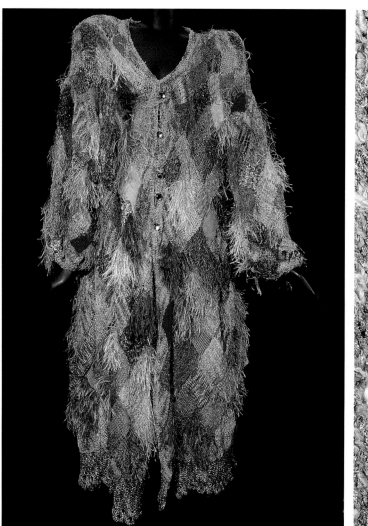

Entrelac.

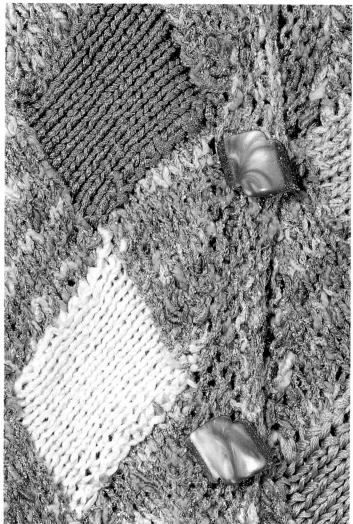

Entrelac, metallic yarn.

**Fabric** - Cloth made from either man made or natural fibers by weaving, felting, or knitting.

**Fabric printing** - Printing block with cut design is covered with color and pressed onto fabric.

**Felt** - Non-woven fabric, held together by bonding the fibers with heat, water, and pressure.

**Fiber reactive dye** - Bonds with fabric on molecular level once it is steam set and washed.

**Free motion** - Machine stippling technique used in quilting, to hold the filling between the top and bottom layers.

**Fringe** - Hanging strings or strips of various materials to create a decorative edge or border.

**Fringe yarn** - Yarn with long hairs hanging at intervals.

**Frog closures** - Fabric cord or tube made into buttons and loops, Chinese origin.

**Gauze** - Sheer, light, woven fabric of cotton, rayon, or silk.

**Gutta** - Synthetic substance used as an outline in fabric painting to prevent one color from running into another.

**Hand woven** - Loom powered by hand or foot.

**Huipil** - Sleeveless vest with cutout neck hole, made from a single piece of fabric, popular in Latin American village cultures.

**Ikat** - Resist dyeing of yarns before weaving; the pattern is resist dyed on the warp and/or weft before dyeing. The cloth is characterized by a blurred or hazy effect.

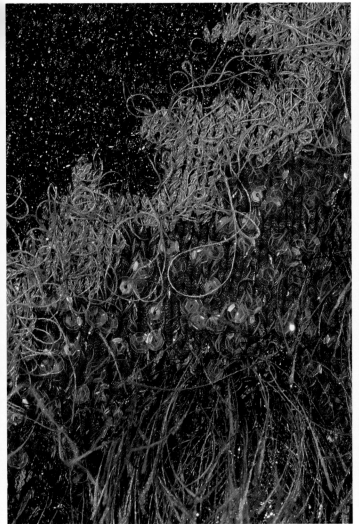

Fringe yarn, metallic yarn.

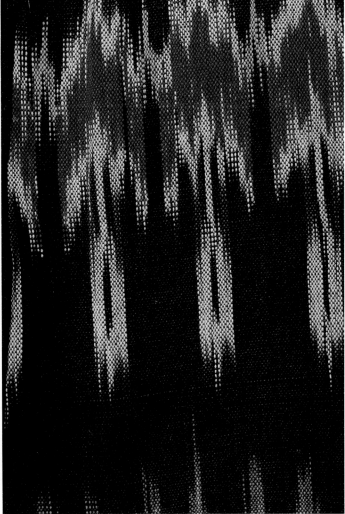

Ikat.

**Indian mirror embroidery** - Small mirrors are framed and secured as fabric decoration by the shisha stitch.

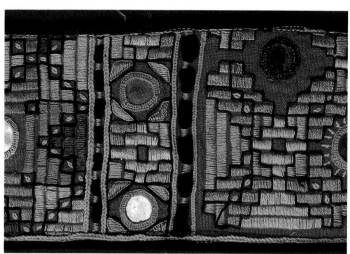

Indian mirror embroidery.

**Inserts** - Fabric or other material is placed between two cut edges of fabric.

**Intarsia** - Decorative color motif knitted into a solid color.

**Japanese paste resist** - Sweet rice paste used to contain the spread of fabric dye.

**Kente** - Royal cloth of the Ashanti people of Ghana whereby narrow strips are woven in complex geometric patterns; the strips are then arranged to form richer more complex designs. It was originally made from thread from unraveled European silk cloth.

**Knit** - Joining loops of yarn by hand with knitting needles or by machine to create fabric.

**Kuba cloth** - Beaten bark or raffia with painted or printed designs, especially in Zaire.

**Lamé** - Textile in which the warp or filling uses metallic threads.

**Laminated fabric** - Two or more layers of fabric completely joined together, usually by heat.

**Layered fabric** - Two or more fabrics piled onto each other and stitched together to achieve a decorative texture.

Layered fabric.

Layered fabric.

**Mohair** - Wool of angora goat, yarn has a loose and fluffy texture.

**Mola** - Reverse appliqué using three or more layers of fabric; colorful designs cut through various layers and hemmed; made by Indians from San Blas Islands, off Panama.

Mola reverse appliqué.

**Lurex** - Plastic coated aluminum threads, impervious to tarnish.

**Metallic thread** - Core material coated with metal or synthetic to resemble metal; used as decorative accent or for metallic cloth.

**Mosaic** - Small pieces of colored glass or other material, arranged to form the design.

**Mother-of-pearl** - Iridescent material, the inside of seashells, such as from the oyster.

Mola.

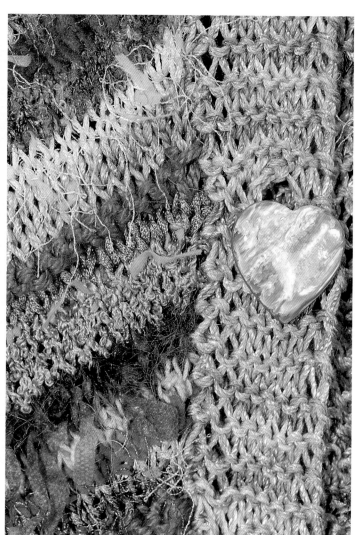

Mother-of-pearl, ribbon, variegated yarn.

**Mud cloth** (see bogolanfini).

**Multi-stranded yarn** - Strands of differently colored yarn combined to give a multicolor effect.

**Natural fiber** - Occurring in nature: cotton, wool, silk, linen, flax, ramie, and rayon.

**Needlepoint** - Embroidery on canvas, usually with uniform spacing of the stitches to create a pattern or design.

**Netting** - Thread worked into an open meshed fabric.

**Paillettes** - Flat shiny sequin-like discs with one hole, so they are secured only at one point.

Multi-stranded yarn.

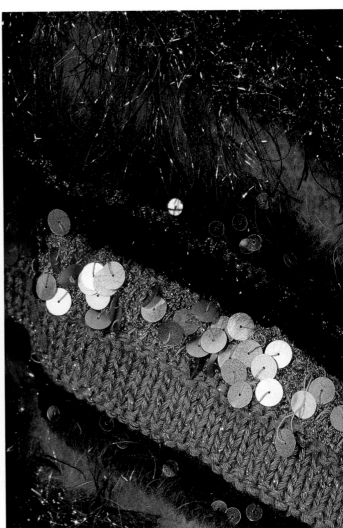

Paillettes, fringe yarn, metallic yarn.

**Patchwork** - Pieces of fabric in contrasting colors, patterns, or shapes pieced together to form a new fabric.

Patchwork.

Patchwork.

**Peplum** - Short flounce or extension of a garment below the waist.

**Picot** - Series of small loops on the edge of a fabric.

**Picot yarn** - Loop yarn.

**Pieced** - Addition of small sections of fabric to form a pattern or design.

**Pintucking** - Stitching fabric in lines or rows, using twin needles, to make narrow tucks.

**Point d'esprit** - Fine netting with small knots.

**Quilting** - Fabric sandwich with top layer of patchwork sewn onto bottom or backing layer of fabric, with filler in between the layers and random or patterned stitching to secure the layers.

**Raffia** - From younger leaves of several species of raffia palm of Madagascar and areas of Sub-Saharan Africa, made primarily by the Kuba people of Zaire. The size of the finished cloth is determined by the length of the fiber used for the warp and weft.

**Random bargello** - Bargello flame pattern is altered and not symmetrically placed.

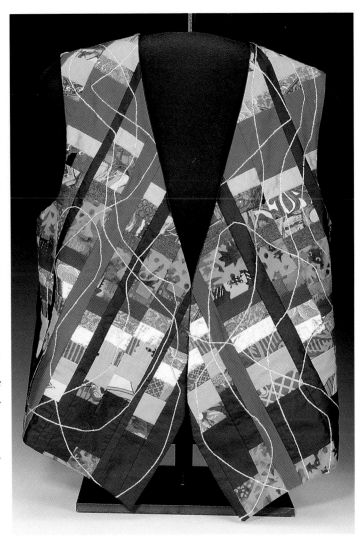

Random bargello.

**Random stitching** - Decorative stitching that does not follow a set pattern.

**Raw silk** - Natural fiber made from the silkworm cocoon before the gum is removed; coarser and duller than silk.

**Rayon** - Natural cellulose-based fiber, though also considered to be the first man made fiber.

**Recycled fabric** - Used garment is disassembled to reuse portions of the fabric for another purpose.

**Resist dyeing** - Method or device to protect parts of a cloth while allowing other parts to receive the dye; batik and tie-dye are popular resist methods.

**Reversible** - Finished on both sides, so the garment can be worn on either side.

**Ribbon** - Narrow strip of fabric with finished edges used for weaving, knitting, or trim on garments.

**Ripple stitch** - Pulling the stitches up and down to create waves, especially in knitting.

**Seed beads** - Tiny glass beads.

**Selvage** - Finished edge of woven fabric to prevent raveling.

**Seminole patchwork** - Pieced fabrics creating a geometric design, originated by the Seminole Indians.

Seminole patchwork.

**Sequins** - Small iridescent discs used to embellish fabric.

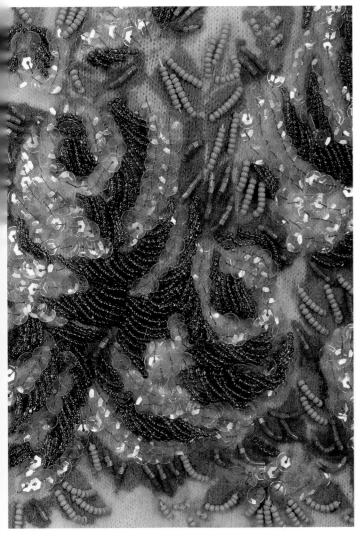

Sequins, seed beads.

**Shadow dyeing** - Objects, such as leaves, act as templates to prevent bleach from acting on the area.

**Silk** - Soft, lustrous natural fiber, product of silkworm cocoon.

**Silk screen** - Printing method using a framed mesh cloth with the design painted on the screen; a squeegee forces the color onto the fabric.

**Slip stitch** - Used to decrease a row of knitting.

**Stenciling** - Repeatable design created with a thin sheet of cardboard or other material that has been cut out to receive color.

**Strip piecing** - Arrangement of fabric strips, which are sewn together to create a design.

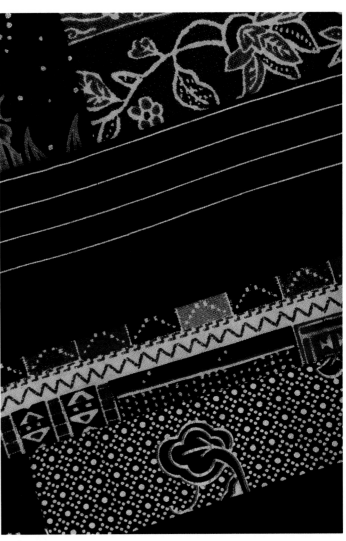

Strip piecing.

**Stump work** - Raised or embossed.

**Synthetic fiber** - Man made fiber, such as acetate (1924), nylon (1938), metallic (1946), acrylic (1950), polyester (1953), triacetate (1954), Spandex (1960).

**Tambour** - Method of beading or embroidering, using a hook on the reverse side to pull through threads to create a chain stitch.

**Tapestry** - Decorative textile woven over vertical warp threads.

**Textile** - Woven cloth. All textiles are fabrics, but not all fabrics are textiles.

**Tie-dye** - Resist method in which areas of the cloth are tied in knots or with string, allowing the untied areas to receive the dye.

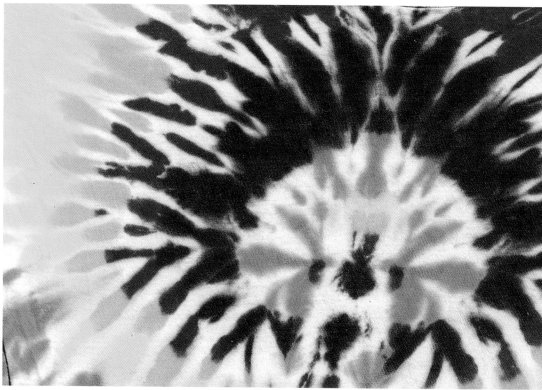

Tie-dye.

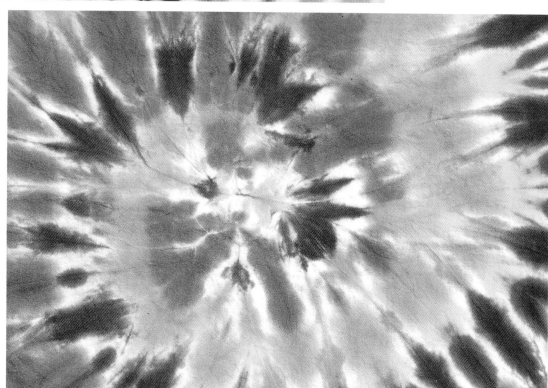

Tie-dye.

**Top stitching -** Decorative stitch on the face of a garment.

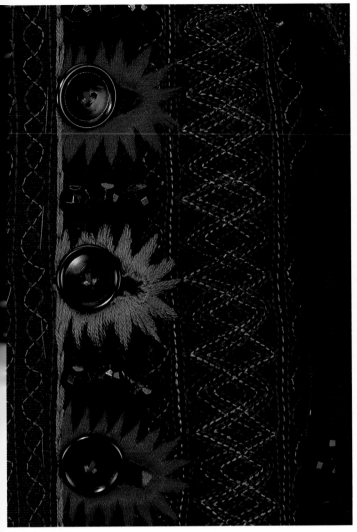

Top stitching.

Variegated yarn, entrelac, fringe yarn, metallic yarn.

**Trapunto** - Partially quilted fabric with single line of stitches, stuffed from the back in designated areas.

**Tulle** - Fine net with hexagonal mesh.

**Twin needle stitching** - Two needles attached on a machine, stitch simultaneously.

**Variegated** - Yarn, thread, or ribbon dyed from one color to another on the same strand.

**Waffle weave** - Squares or rectangles appear on both sides of the fabric by allowing both warp and filling yarns to float at fixed intervals.

**Warp** - Set of yarns placed lengthwise (vertically) in the loom to create the lengthwise thread in a woven fabric, or textile.

**Weaving** - Interlacing threads to form a textile. After forming the warp, the weaver goes over and under at right angles with the weft.

**Weft** - Horizontal woven threads, from selvage to selvage.

# Bibliography

American Fabrics. *AF Encyclopedia of Textiles*. 3rd ed. Englewood Cliffs, New Jersey: Prentice-Hall Inc., 1980.

Battenfield, Jackie. *Ikat Technique*. New York: Van Nostrand Reinhold, 1978.

Birrell, V. L. *The Textile Arts: A Handbook of Fabric Structure & Design Processes*. New York: Harper & Row, 1959.

Bonesteels, Georgia. *Patchwork Potpourri*. University of North Carolina Press, 1997.

Brunner, Debrorah. *Crazy Rags*. Privately printed, Bathell, Washington: That Patchwork Place, 1996.

Boyce, Ann. *The New Serge in Wearable Art*. Radnor, Pennsylvania: Chilton, 1995.

Deyrup, Astarith. *Getting Started in Batik*. New York: Bruce, 1971.

Dale, Julie Schafler. *Art to Wear*. New York: Abbeville, 1986.

Dittman, Margaret. *Fabric Lovers Scrapbook*. Radnor, Pennsylvania: Chilton, 1988.

Edie, Marge. *Bargello Quilts*. Privately printed, Bathell, Washington: That Patchwork Place, 1994.

Elliot, Marion. *Painting Fabric*. New York: Henry Holt & Co., 1994.

Falick, Melanie D. *Knitting in America*. New York: Workman Publishing, 1996.

Fassett, Caffe. *Glorious Knits*. New York: Clarkson N. Potter, 1985.

Fischer, Pauline, & Anabel Lasker. *Bargello Magic*. New York: Holt, Rinehart & Winston, 1972.

Gostelva, Mary. *A Complete International Book of Embroidery*. New York: Simon & Schuster, 1977.

Hall, Dorothea. *The Quilting, Patchwork, and Appliqué Project Book*. Secaucus, New Jersey: Chartwell, 1986.

Innes, Miranda. *Fabric Painting*. London: Collins & Brown, 1996.

Lane, Rose Wilder. *Women's Day Book of American Needlework*. New York: Simon & Schuster, 1963.

Lawther, Gail. *The Complete Quilting Course.* London: Quarto, 1992.

Mashuta, Mary. *Wearable Art for Real People.* Martinez, California: C & T Publishing, 1989.

Meilach, Dona Z. *Contemporary Batik and Tie-Dye.* New York: Crown, 1973.

Michelson, Carmen, and Mary-Ann Davis. The *Knitter's Guide to Sweater Design.* Loveland, Colorado: Interweave Press, 1989.

Murrah, Judy. *Jacket Jazz.* Privately printed, Bathell, Washington: That Patchwork Place, 1993.

Ohms, Margaret. *Ethnic Embroidery.* London: Batsford, 1989.

Rhodes, Marge. *Needlepoint: the Art of Canvas Embroidery.* London: Octopus, 1974.

Roberts, Sharee Down. *Creative Machine Art.* Paducah, Kentucky: American Quilters Society, 1992.

Rush, Beverly, & Lassie Wittman. *The Complete Book of Seminole Patchwork.* New York: Dover, 1982.

Smitley, Roselyn Gadia. *Wearable Quilts.* New York: Sterling, 1993.

*Threads.* A Taunton Magazine.

Wingate, Isabel B. *Fairchild's Dictionary of Textiles.* New York: Fairchild, 1970.

Yarong, Wang. *Chinese Embroidery.* New York: Harper & Row, 1987.